We Who Can Fly

We Who Can Fly

Poems, Essays and Memories in Honour of Adele Wiseman

Edited by Elizabeth Greene

CORMORANT BOOKS

The publisher gratefully acknowledges the support of the
Canada Council, the Ontario Arts Council,
and the Department of Canadian Heritage.

Cover design by Pekoe Jones.
Cover photo by Sandra Rutenberg.
Printed and bound in Canada.

Cormorant Books Inc.
RR 1
Dunvegan, Ontario
Canada K0C 1J0

Canadian Cataloguing in Publication Data
Main entry under title:
We who can fly : poems, essays and memories in
honour of Adele Wiseman
ISBN 0-920953-99-9

1. Wiseman, Adele, 1928-1992--Criticism and
interpretation. I. Greene, Elizabeth, 1943-
II. Wiseman, Adele, 1928-1992
PS8545.I85Z94 1997 C813'.54 C97-900896-4
PR9199.3.W54Z94 1997

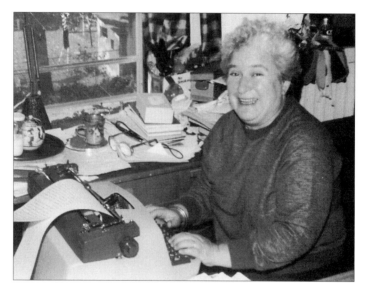

Adele in her study, fall, 1982.
Photo courtesy of Arlene Lampert.

CONTENTS

We Who Can Fly

Acknowledgements

A book like this is the creation of many people, not only those whose work appears in these pages, but also those who provided a network of support while the writing was being done.

Many people encouraged me at all stages of this project. I would like to thank Margaret Bell, Mary Cameron, Mary Alice Downie, Joanne Page, Donna Pothaar, Pat Rae, Barbara Schlafer, Kenneth Sherman, Margaret Smart and Rachel Wyatt for support, belief and encouragement from this book's conception to its completion. Mary Cameron, Faizal Forrester and Joanne Page read drafts of my introduction and essay for this book. Their comments were both perceptive and supportive. I am grateful to my late colleague Tom Marshall for introducing me to Adele Wiseman's novels and for encouraging my work on her. Rachel Wyatt gave me advice on how to proceed and suggestions for contributors. I am especially grateful to Tamara Stone for her excellent, clear-sighted advice throughout this project.

It is a tribute to the friendship Adele inspired that so many of her colleagues and fellow writers agreed unhesitatingly to contribute to this book, and wrote so wonderfully as they remembered her.

Several of the pieces in this book have appeared previously. Excerpts from my introduction appeared in the *Prairie Fire* special issue on Jewish writing (1996). Sylvia Fraser's and Miriam Waddington's tributes and Michael Greenstein's "The Fissure Queen" were first printed in the fine Adele Wiseman issue of *Room of One's Own*, edited by Ruth Panofsky. Kenneth Sherman's seminal article on *Crackpot* first appeared (in a slightly different

version) in *Waves* and his poem, "In Memoriam," was published in *The New Quarterly*. Rachel Wyatt's "Adapting *Crackpot* for the Stage" introduces the published version of her play. Gabriella Morisco's interview, "The Charm of a Non-Orthodox Feminism," forms part of her book *I profeti della terza solitudine;* I would like to thank her for preparing the English version included here. Margaret Laurence's letter is from the Margaret Laurence–Adele Wiseman correspondence and appears by permission of Jocelyn and David Laurence, Tamara Stone, John Lennox and Ruth Panofsky, and the University of Toronto Press. "Goon of the Moon and the Expendables" was first published in *The Malahat Review* in 1992; I would like to thank Tamara Stone for permission to include it in this book. I thank Tamara Stone further for the great privilege of reading Adele Wiseman's unpublished papers in the York University Archives, and for permission to quote from them.

I am grateful to Queen's University for an Advisory Research Council grant and for a sabbatical leave in 1994–95.

It was a pleasure to do research in the York University Archives, presided over as it is by the spirit of Margaret Laurence. I would like to thank the staff of the Archives for their helpfulness and for creating an atmosphere of quiet and friendliness.

I would like to thank Sandra Rutenberg for permission to use the photographs she took of the 1992 Ban Righ Foundation Council Meeting. I would also like to thank Carol Holmes, Arlene Lampert, Rachel Wyatt and, especially, Tamara Stone, for permission to use their photographs in this book.

Finally, I wish to thank the many students in my Selected Women Writers and Contemporary Literature classes at Queen's (there are at least a thousand of them) who responded so warmly to Adele Wiseman's *Crackpot* and whose desire to know more impelled me to undertake this book. Special thanks to Donna Beckstead, Jennie Cunningham, Faizal Forrester, Janice Kirk, Andrea Mortson, Elizabeth Phillips and Pegeen Stopford for their continuing interest and good questions.

INTRODUCTION

I first met Adele Wiseman at the Kingston train station in the spring
of 1982. As I waited, I realized with misgiving that we hadn't given
each other much information. Somehow we both thought we would
recognize each other, but as person after person flowed past, I be-
gan to wish I'd suggested draping my hat with red ribbon. The last
person off the train was a short, unpretentious woman in a black
coat. For a moment I was breathless at the gap between inner and
outer. So this was the remarkable writer whose sentences carried
such authority, looking comfortably white-haired and middle-aged,
competent, sharp, observant. Her style had nothing to do with
1982. She could have been standing on a train platform in 1910,
1930, 1950 or the year 2000, in Russia, Italy, England, Florida.
She seemed very familiar to me, partly because she reminded me of
my mother, partly because I recognized some of her mannerisms,
her way of being in the world. If she had lost her luggage, she
would have raised the roof until she got it back. That seemed reas-
suringly familiar, too. Luckily, she was carrying everything with
her — she was someone (I thought from those first moments) who
tended to carry a lot with her. She was unaccompanied, but she
didn't travel alone.

I had read Adele's novels the previous winter as part of my
preparation for organizing a two-day conference on Canadian

women writers and women's consciousness sponsored by the Ban Righ Foundation at Queen's University (now the Ban Righ Centre for Continuing Education). In contrast to many contemporary writers, Adele writes sentences as solid and well constructed as a Victorian armchair — very un-Victorian, though, in that they are full of surprises, and if you skip one clause you may miss a crucial twist of plot. I was even more impressed by her memorable flesh-and-blood characters, by her compassion and her moral vision. The Ban Righ Foundation, a centre for mature women returning to school, runs on a shoestring. My budget allowed $200 for a keynote speaker. When Adele accepted my invitation, I went straight to the Foundation with her letter, and we all whooped with joy. Her arrival on the platform that cold April day was the culmination of months of planning.

I remember the day I spent with Adele as one of constant conversation. We talked about everything, but especially writing and teaching, and we rippled easily from seriousness to laughter. I felt she recognized that I had made hard choices in my writing and my teaching and honoured me for it. Working with her unpublished writing in the York University Archives, I can see now that she had made hard choices herself. She did the writing she had to do whether or not it led to external rewards. For her, the price of integrity was often discouragement. But she spent her life on writing that will last, no matter what the fashion.

Her talk that night on her mother's dolls, unearthed from her luggage in all their vividness and singularity, was not what any one of us expected, yet we all realized that what she was saying, unpretentiously, seemingly offhandedly, was wisdom. We all knew that what we were experiencing was authentic and irreplaceable, and Adele drew us together in a way that lasted through the second day of the meeting, and even after she had returned to Toronto.

I saw her again the following year. I was in Toronto with my then husband and five-year-old son, and she asked us all to dinner. We sat on her screen porch, overgrown with wisteria, and ate rather tough steaks which Adele's husband, Dmitry, had barbecued. Again there was the effortless, sparkling conversation. I sat

next to the poet Robert Zend, and we talked about the twentieth century being a period of exile, and about his regrets that his children would never know their extended family, that the fabric of life they had been born to had been torn from them. Adele's daughter, Tamara, was there with a friend. She was fourteen then and had a very definite presence. For me it was an evening inside art, a place I longed to be but didn't often reach.

Adele showed me her house, which was impressively (and, I now gather, uncharacteristically) neat as a pin. Many of her mother's dolls were gathered companionably in a glass bookcase; some were on the walls. I remember the small, slant-roofed third-floor room where she wrote.

Two incidents from that visit stand out. My son was then in a therapeutic nursery school with a behaviourist bent. When I used behaviourist techniques on him in Adele's presence, she made it quite clear, without saying a word, that she thought I was wrong. The next year, I wrote her that my son had been pessimistically assessed, and she wrote back rather sharply asking who had been doing the assessing. Those instants made me feel freer to follow my instincts in motherhood (and made me more resistant to "expertise" of the sort that Adele depicts so well in "Goon of the Moon and the Expendables").

We visited Adele briefly the next day on our way to a garden party. I was wearing a red dress which I liked and Adele admired. My husband made a disparaging remark, and Adele gave him a look, to which he was predictably impervious. That look was my first hint that my marriage was in trouble, although it was years before it actually dissolved. I left Adele feeling sad. As it happened, I never saw her again. Perhaps I felt that she had seen into the tangle of my life and the difficult years that lay ahead. Perhaps also I realized subconsciously that there were cracks in her own marriage: inexplicable sadness when I leave a house usually signals that to me.

I had hoped to see Adele again when I was accepted to the May Studios at Banff in 1992. Trying to balance teaching, mothering and writing in spare moments against the background of a

crumbling marriage had left me isolated, and I felt that she was one of the few people who could give me guidance about my life and my writing. But just a few weeks before I left for Banff, I learned that she had stomach cancer. I bought a card and passed it around to my students, who wrote get-well messages and praise of *Crackpot*. (Unfortunately, the address I got from a 1991 Banff participant proved to be one move out of date, so I don't know whether all those warm wishes ever arrived.)

At Banff, I felt Adele's spirit very strongly. The sort of conversation I had experienced so briefly with her, about anything, everything, swooping and soaring like ravens, was the norm at the May Studios. I also felt the shadow of her illness, and spent a good deal of time walking and grieving, not just for Adele but for so many of my friends who had died over the past ten or twelve years, and perhaps also for the end of my marriage. I tucked my wedding ring in a suitcase the night I arrived in Banff and never put it on again. I realized that the crush of my life hadn't left me much time to mourn and that, like Lucinda in Adele's last story, "Goon of the Moon and the Expendables," I had stuffed my feelings away. I first read "Goon of the Moon" at Banff and was struck again by Adele's brilliance as a writer, her great insight, her high seriousness.

I heard more news of Adele's illness through Rachel Wyatt, who conferred with her by phone every week during the May Studios. I wrote Adele cards, but she was much too ill to answer. Two days after we all got back from Banff, Adele died, quietly, according to Arlene Lampert, her death as courageous and exemplary as her life had been.

I was someone who barely knew Adele, yet she made a great difference to me. These pages show that she had a gift for making a difference, a gift of vision and belief that helped friends, fellow writers and students arrive where they had hoped.

Adele Wiseman is a much-loved writer. She is also still a very neglected writer. Part of the problem is textual. *The Sacrifice, Crackpot, Memoirs of a Book Molesting Childhood* and the children's books

are in print as I write this (August 1996), but Adele's memoir of her mother, *Old Woman at Play*, has been out of print for some years, and a great part of her work, including her play *The Lovebound*, and most of her poetry, remains unpublished. Partly because Adele's work is so difficult to access, it is also difficult to assess. In an age of proliferating criticism, she has attracted comparatively little secondary work.

An added difficulty for the critic is that Adele never stepped in the same river twice. Everything she wrote was different. "Where I'm going you haven't been," she told a writing workshop at the University of New Brunswick, and exploration was one of her values. *The Sacrifice*, published when she was twenty-eight, is a classic novel; everything else she wrote is more experimental, more eccentric, reaches farther into her artistic territory. *Crackpot*, published when she was forty-six, is more ambitious, with a stately rhythm of inevitability beneath its sometimes quirky surface. *The Lovebound*, unpublished and unperformed, bears witness to the tragedy of a shipload of unwanted Jews, a little told story at the edge of the Holocaust. Adele's other play, *Testimonial Dinner*, privately published, is about finding a resolution to the contemporary problem of rootlessness, especially Jewish rootlessness, partly by coming to terms with the past, both ancestral and historical (Sir John A. Macdonald and Louis Riel are both characters), partly by committing to the present and future through a child, through plans.

Adele's memoir of her mother, *Old Woman at Play* — published in 1978, when she was fifty — mixes biography and autobiography as it considers the creative process from the perspective of doll-maker (Adele's mother, Chaika Waisman), writer (Adele) and artist (Tamara). *Memoirs of a Book Molesting Childhood*, Adele's collected essays, ranges from the personal to the literary to the political and suggests that, for Adele, the three are intertwined. She also left a body of lyric poetry, written from 1981 to 1986, almost all unpublished (see my essay in this book for a more extensive discussion), and a long poem, *The Dowager Empress*, which is probably now in the York University Archives, but which was still in storage during my research for this book. There are also a

handful of short stories, each memorable in its own way; two children's books, *Kenji and the Cricket* and *Puccini and the Prowlers;* an unpublished puppet opera, *Someday Sam,* and some unpublished essays. This is an impressive body of work showing a rare command of form, ranging as it does through fiction, drama, creative non-fiction and poetry. Because so much is out of print or available only in archival manuscripts, it is almost impossible at this point to discuss the whole of Adele's literary achievement.

A third impediment to critiquing Adele's work is, paradoxically, that she knew precisely what she was attempting and provides her own critical/theoretical framework in *Old Woman at Play, Memoirs of a Book Molesting Childhood* and interviews. In *Old Woman at Play* she writes:

> ...I remember suddenly and vividly my own utter conviction, from that moment so far back in childhood that I can no longer locate it, when I knew that I was meant to be a writer, that my writing was going to bring truth and understanding and love to the world and make everything and everybody happy and perfect. (47)

Although Adele is partly smiling here at the naïvety of her ambition, she never abandoned the serious core of her project, and no one could say better what she was attempting. A serious writer changes the way we see, draws us closer to the good and settles for nothing less than the truth. Given the demands Adele placed on herself, it is hardly surprising that she wrote "only" two novels, two plays, three books of non-fiction, a handful of short stories and a body of poetry.

Any reader of Adele's creative non-fiction will understand that her artistic credo is complex. (This is also evident from the fiction, especially *Crackpot,* but there the principles are embodied in the text rather than set down directly.) In creating character she also "aims for the highest" ("Memoirs," 29):

From the real, lived-in world too each generation of

creators draws the models for its myth figures. It is common knowledge that Rembrandt sought models for his Christ and his Apostles in the young Jews of his town. So, far less consciously, do human beings of every generation make myths of each other. (*Old Woman at Play*, 63)

Adele is writing about her mother's childhood stories here, but her own characters are larger than life in their vitality and their ability to claim their space — as David says of Hoda at the end of *Crackpot*, "She occupies her past. She inhabits her life." Adele tends to choose names for her characters that evoke biblical counterparts: Abraham, Isaac, Ruth, Moses, Danile, David, Josh. One of Adele's great achievements in her fiction is to create characters who at once resonate with myth and heroism, yet are so marginal that they would remain unnoticed, even scorned, if seen only from the outside. Her sense of the mythic qualities of her characters is inseparable from her sense of their difference — a difference that begins with Jewishness in a world which is often anti-Semitic. She set out, from the first, to be a Jewish writer:

I knew very early that someone had to tell the other important stories, to provide the antidote to the poisonous errors, lest the whole glorious writing enterprise founder forever short of fulfilment. And here I was, growing up just in time. ("Memoirs," 8)

The truths Adele wanted to bring the world were first of all truths about Jews. Almost all her central characters are Jewish and exemplify Jewish values, such as the importance of the family and children within the family. Some of her values are not, strictly speaking, Jewish, but (as we know from *Old Woman at Play* and *Memoirs of a Book Molesting Childhood*) stem from her experience within her own family: her love of story-telling, the almost necessity of a sense of humour. Inextricable from her determination to be a Jewish writer is her decision to write about anti-Semitism, whether it

occurs in Winnipeg or Toronto, or as part of Canadian policy in Ottawa, or in its most violent and terrible forms, in pogroms and in the Holocaust.

Michael Greenstein and Gabriella Morisco discuss Adele's work within the tradition of Jewish writing. Greenstein places Adele in the context of both Canadian and American Jewish writing, while Morisco chooses Adele, Mordecai Richler and A.M. Klein to represent the "third solitude" in Canadian writing. The several articles on Adele's use of the Kabbala in *Crackpot* also explore her debt to one aspect of Jewish tradition. In Morisco's interview in this book, Adele differentiates between herself and male Jewish writers such as Mordecai Richler and Saul Bellow, suggesting that they are writing about Jews who are no better and no worse than anyone else, which is not exactly what she wants to do. In fact, her moral vision springs from her characters, so that while Danile or Hoda or other characters may be somewhat short on worldly wisdom — or even nutty — they are essentially good. Evil belongs to those who snub or harm others, through uncaring, or snobbery, or anti-Semitism.

Often Adele shows the price of being Jewish. Abraham, in *The Sacrifice*, has lost his two brilliant older sons in a pogrom as they were coming home from school for the holidays. Lazar, in *Crackpot*, has lost his family in the Holocaust and climbed over their dead bodies to reclaim his life. Chaika Waisman, in *Old Woman at Play*, talks matter-of-factly of pogroms; both her parents, Adele's maternal grandparents, died in the Holocaust. *The Lovebound* is about a ship full of Jews fleeing Germany, who are never allowed to land, and who are returned to Germany. The play stops before the ship docks, but we know from history that tragedy lies beyond its ending. The shadow of the Holocaust echoes through Adele's poetry. In one poem she asks, "Have I earned my life today?" and one theme of her poetry is the necessity of bearing witness. In an interview with Mervin Butovsky, in April 1985, she said, "I see myself as a writer with a mission.... To me it has always seemed to be the mission of most Jews in the diaspora and that is to correct the vision of the gentile world.... So I don't see myself simply as a

writer, I see myself as someone who writes in order for the record to affirm certain kinds of reality." This too is part of the obligation of her heritage.

Gradually it becomes clear, especially in "Goon of the Moon and the Expendables," that the "certain kinds of reality" Adele is affirming are not just Jewish but belong to the general experience of marginalization. She is not writing just about anti-Semitism but about any sort of "anti," any callousness towards people because of the label they bear (rather than because of any of their essential qualities). In an unpublished, undated fragment of an essay, she writes (all italics are hers):

> RACISM, the kind which we are presumably discussing here, is *one of the ways by which humanity divides itself against itself;* it enables one group of human beings to objectify, distract and ultimately deny equal privilege and equal humanity to other groups of human beings and to representatives of those groups who come within their power.
>
> It is useful to ask oneself, what do people get from racism. It is a simple way of, in crudest terms, *uniting the pack.* It defines *us* by defining otherness, *them.* Racism is a kind of psychological territorialism. It defines *them* as whatever we don't want to be, don't like. It is a geography of identity which annexes for the group or race, the most desirable inner space, the most elevated moral nature, simply by naming it so. *Whatever we are is best.* Whatever you are is less, lesser, worst.

What began in Adele's work as a tension between Jewishness and anti-Semitism becomes an exploration of the margins and the marginalized, of anyone dismissed by the mainstream. Gabriella Morisco calls this a fascination with "deformed" characters, since for Adele those at the extreme margins of our society are the mentally and physically challenged, the temperamental loners, the

characters she depicts in "Goon of the Moon and the Expenda-bles." Adele writes in "Memoirs of a Book Molesting Childhood," "It took me a long time to realize that the world of knowing has to be opened by the key of caring" (8). The basic opposition in her work is between caring and callousness. Caring blossoms into understanding and love; callousness hardens into blindness and prejudice, erasure and destruction.

Contained within that framing polarity is tension within the central characters. Adele says in the interview with Mervin Butovsky that, in writing *The Sacrifice* and *Crackpot*, she asked herself "what is the best possible reason for the worst possible deed" (8). She adds in a later interview with Bruce Meyer and Brian O'Riordan that both novels "dance on the edge of that chasm between what is permissible and what is possible." Adele knew clearly that part of the drama in her books comes from the struggle between her chosen characters and the indifferent or hostile world outside, but that another part comes from the intense inner lives of the characters themselves, who have a strong, individualized value system and who make "an informed choice" with "awareness," as Adele says of Hoda.

Although Michael Greenstein and Ruth Panofsky have made important beginnings in establishing a critical and bibliographical canon, Adele Wiseman is still the best critic of her own work. She knew what she wanted to do as a writer, and she did it. Her comments on her own work are incisive and powerful, and it is difficult to go beyond them.

Though I met Adele twice and corresponded with her at intervals, I know her mostly through her books. I have taught her in company with writers like Virginia Woolf, Katherine Mansfield, Sylvia Plath, William Carlos Williams, Allen Ginsberg, Ted Hughes, Margaret Drabble, Adrienne Rich, Zora Neale Hurston, Alice Walker, Alice Munro, Margaret Atwood and Margaret Laurence, and Adele more than holds her own. Why shouldn't she? She intended to be a writer whose work lasted, and she succeeded.

One thing that marks her as a serious writer is her firm moral base — although her story "The Country of the Hungry Bird" shows that art can be compelling without that base (as she says in both the Butovsky interview and the Morisco interview). In the long run, the sense that the writer has reached deep into the well of truth helps carry his or her work through years and fashions to the future. Christie in *The Diviners* speaks of "the strength of conviction," and this strength is essential to Adele's work as well as to Margaret Laurence's.

Two things especially identify Adele as a contemporary writer — her celebration of difference, and her belief that "Canada, like the rest of North and South America, has been founded by someone taking something away from something else" (Meyer and O'Riordan, 119). Both of these themes are part of her exploration of the margins, a distinctively late-twentieth-century journey, and her affirmation of their value. Other techniques that are notably contemporary are her use of fragmentation and her choice of story-tellers as important characters (Abraham in *The Sacrifice*, Danile in *Crackpot*, Josh in "Goon of the Moon and the Expendables").

In addition, Adele is one of the great creators of character. Abraham in *The Sacrifice*, Danile and Hoda in *Crackpot* and Josh in "Goon of the Moon and the Expendables" are all an unforgettable mixture of myth, naïvety, and flesh and blood. From the outside they may be unprepossessing or, like Danile and Hoda, a mixture of traits. Certainly none of them would be gushed over in magazines like *People*. But within their world — and in their own 'innerspace' — each of Adele's characters is important, partly because each is connected to something larger by stories. (Adele says in the Meyer and O'Riordan interview that part of her project in *Crackpot* was to contrast Hoda, who has "a strong personal myth," with David, who does not (122).) All of her central characters long for love; all have a definite view of life and a definite physical presence. In fact, all of her characters, central and peripheral, are real down to the last cell.

Most people who love *Crackpot* say to me, "Oh, the scene where she sleeps with her son!" Adele takes some enormous risks in

her writing as she explores what she calls the "edge of that chasm between what is permissible and what is possible. [...] the best possible reason for doing the worst thing" (Meyer and O'Riordan, 122). This too is a sort of exploration of the margins, and lifts the novels, with their frequent celebration of ordinary life and affection, into high drama.

Finally, Adele has enormous mastery of the English language. As she moves between inner and outer in her creation of character, so she moves easily between high and low styles, between lyric and comic, between tenderness and slangy adolescent toughness. Some of her many-jointed sentences in *Crackpot* which contribute at once to characterization, plot and story line, are almost miracles of suspension. One of the problems of writers at the end of the twentieth century is to access language which has not been vitiated by commercialism. Adele does this partly by setting her works back in time, partly through her use of Yiddish — which appears in her novels to be a gentler, more affectionate language than contemporary English — and partly through her commitment to the margins. Most of her characters either would never have been exposed to media English or would have ignored it. Her poetry, unfashionable with its echoes of classic tradition, ranges from the high style to the sharply colloquial, with often brilliant rhymes.

From centre to surface, Adele was an enormously gifted writer who also worked hard to ensure the polish and coherence of her fiction, essays, plays and poetry. Margaret Laurence wrote her (after Viking had rejected *Crackpot*): "I don't believe and never have believed that you were writing for any one generation, Adele...." (quoted in Panofsky, 64-65). Adele not only "inhabited her life," she also brought her talent to dazzling fruition through painstaking revision, risk and exploration.

Bronwen Wallace writes in "A Simple Poem for Virginia Woolf":

> ...but that's what got me

started I suppose wanting to write
a gesture of friendship
for a woman for a woman writer

I began this book as a tribute. I was encouraged by the warm reception hundreds of my students gave *Crackpot* and by their wish to read more about the author. I was also encouraged by the generosity of my co-presenter, Janice Kulyk Keefer; the chair, Julie Beddoes; and the audience when I read a paper on Adele at a session of the Learned Societies meetings in 1993.

I was guided partly by the knowledge I had gained about Adele from her colleagues at Banff during the May Studios, 1992, partly by the moving memorial service for Adele in June 1992, partly by Ruth Panofsky's fine special issue of *Room of One's Own*. A book like this is an experience in serendipity: Clara Thomas, whom I met in the York University Archives, scribbled Gabriella Morisco's address on a piece of paper for me. I happened to be in a workshop at Sage Hill led by Ven Begamudré, who had worked with Adele at Banff. Tamara Stone, Adele's daughter, suggested names of contributors, corrected errors and gave the book its title.

Originally I expected the book to be a fairly equal balance of memoir and criticism. There is very little criticism of Adele's work elsewhere, and the only book on her before this one is Ruth Panofsky's excellent bibliography. As it evolved, the collection tended to mirror its subject in being creative, unpredictable, hard to classify. The result is a portrait of the artist from multiple angles, a weaving together of varied visions and voices. Many of the pieces are works of art in their own right and show that, if Adele was critically neglected, she was appreciated and cherished by the community of writers, both established and novice.

The memories by Joyce Marshall and Miriam Waddington span decades of friendship. They, with the tribute by Sylvia Fraser, are written by peers, recognized writers of roughly Adele's generation. Mary Lou Dickinson's piece shows Adele's generosity and supportiveness extended to a talented, unknown student, unwavering over years. Ingrid MacDonald and Caroline Adderson also

show Adele's supportiveness to younger writers. In all cases, Adele was not swayed by labels ("published," "unpublished") or by the opinions of others. She trusted her own judgement and stayed true to her beliefs. In these pieces we also see Adele creating the community that meant so much to her.

The poems by Kenneth Sherman, Seymour Mayne and Anne Michaels show Adele as "inspirer of poetry" (in Lenore Langs' phrase) and catch her essence in a way that no prose can.

Arlene Lampert evokes Adele's talent for deep friendship, her warmth, her need to give and to be connected to others.

Tamara Stone's memoir of her mother shows Adele's courage in fighting the battles later life brought her, and suggests the toll those battles took.

Rachel Wyatt, who worked closely with Adele at the May Studios from 1986 to 1992 and succeeded Adele as Director of the Writing Programmes, told me that Adele very much wanted documented what she and her faculty had accomplished at Banff. This emerges obliquely from the pieces by Don Coles and Colin Bernhardt, and more directly in the memoirs by participants Caroline Adderson, Ven Begamudré, Stella Body, Mary Lou Dickinson and Ingrid MacDonald — and in the interview with Mary Cameron and Steven Heighton. Although the Banff experience differs for each participant, I think the transformation and clarification Mary Cameron talks of must be central for most.

Rachel Wyatt's "Adapting *Crackpot* for the Stage," Colin Bernhardt's memoir and Margaret Laurence's letter emphasize Adele's love for drama and draw our attention to her two plays. I am especially glad to be able to include a letter from Margaret Laurence in this collection, since she and Adele were lifelong friends, and since her work and Adele's are inextricably entwined.

Ruth Panofsky's sketched account of Adele's writerly activities gives a sense of the vitality and fullness of her life, while Lenore Langs' memoir documents Adele as innovator and creator of community, as well as inspirer of poetry.

Gary Geddes gives a vivid picture of Adele in China and reminds us how central *Old Woman at Play* is to Adele's work.

I have included four critical pieces here. Kenneth Sherman's article, originally a review of *Crackpot*, is seminal and shows an intuitive understanding of the novel. Michael Greenstein is the foremost critic of Adele Wiseman's writing. His earlier work places her in Canadian and American Jewish literary traditions. The article included here begins to explore *Crackpot* in light of postmodernist theory and criticism, an important vein. Adele is postmodern not only in her use of "cracks," "fissures" and fragments, but also in her "ex-centricity," in her resistance to authority, and (related to ex-centricity), in her exploration of the margins. Reena Zeidman writes about Adele's debt to Jewish biblical tradition in her "Seventy Faces to a Sacrifice." As far as I know, Dr. Zeidman is the first critic to bring deep scholarly knowledge of the Bible, Jewish commentary and the Kabbala, all in the original Hebrew, to a reading of Adele's work. This too is a fruitful area for further exploration. My own piece on Adele's poetry and her last story, "Goon of the Moon and the Expendables," is an examination of Adele's creative process and some of her central themes, including marginalization.

I am delighted that so much of Adele's own voice appears in this book. Gabriella Morisco interviewed Adele in the spring of 1991, and makes it clear that Adele was the best authority on her own work, as well as an incisive, intelligent, powerful woman whose mind flew with the agility she so admired. I am deeply indebted to Tamara Stone for allowing me to include "Goon of the Moon and the Expendables" and lines from Adele's poetry in this collection. Even more than the admiration of her friends, colleagues and people whose lives she touched, Adele's writing says best why she deserves our attention. It is my hope that this book will turn readers back to her other books and help gain her the recognition her writing merits.

E. G.
Kingston, August 8, 1996

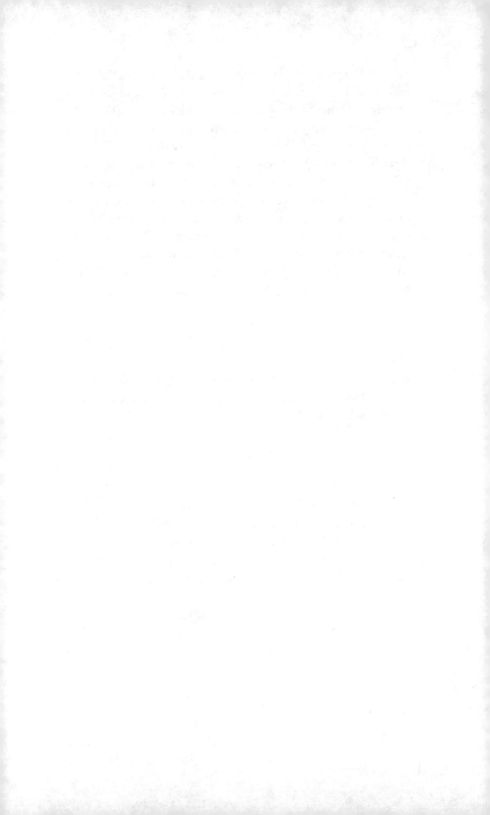

SELECTIONS FROM THE POETRY
Adele Wiseman

Those of us who fly
know currents
learn tricks from birds
the skill to navigate
the invisible. . . .

Write, as some fish, for revelation.

A good part of the art of self-defence
is to survive what you are learning.

Never has it been promised that what you learn
will be what you wanted to know.

Whoever hid
the no in know
sure knew.

Being a collector
gives you the illusion
you can live forever

Head time, as we all know, is different from clock time.

Memory is fragile
Some doors simply close
Entries and exits disappear

Living begins in currents of the heart.

The truth's not only what, but how you know.

1. Always obey dissatisfaction.
2. The greatest uncertainty
 is not in the setting out
 but in the moment before completion.
3. The moment of most intense dissatisfaction
 precedes the final synthesis.

Every mother is delivered into fear.

1973. Graduate Studies.
Drafts of reviews,
fragments of attempted poetry
scattered on my kitchen table.

I spent days that spring
cracking the code of your novel,
deciphering Danile, the father loving
but blind,

his estranged daughter
charged with experience:
that heart-rending narrative
which brought a redemptive myth

to the cold streets of Winnipeg,
reprieving the darkness
with shards of light
that we too were cast in

the first time we met
under the sun-splintered shade
of towering maples
on Bernice Lever's backyard patio.

When I raised the penury of the artist
as if it were some holy banner,
you, pragmatic, countered

with the Chinese injunction:

"Eat first — poetry second."
In profile, physique
and close-cropped hair
I likened you then to Gertrude Stein

for I was reading correspondents
into every tone and gesture,
preparing myself
for a life on the line.

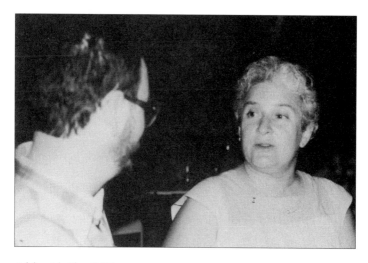

Adele with Alan Belkin.
Photo courtesy of Tamara Stone

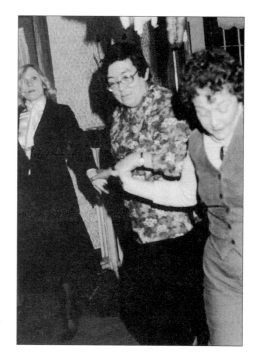

Sylvia Fraser,
Margaret Laurence,
and Mary Perlmutter.
*Photo courtesy of
Arlene Lampert.*

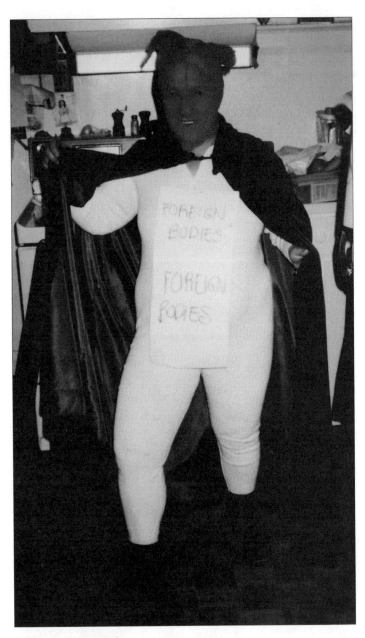

Adele as a Foreign Body.
Photo courtesy of Rachel Wyatt.

I met Adele Wiseman for the first time at a queer little writers' conference (perhaps "get-together" would be a better term for it) that was held at Kingston during the summer of 1955. Frank Scott had scrounged some funding from an American foundation and there we were, a somewhat job-lot bunch (there weren't many writers in Canada at that time) — Frank himself, Irving Layton, Morley Callaghan, Miriam Waddington, Hugh Garner (who was too shy to go to any meetings or parties and spent the whole period drinking in his hotel room), Earle Birney, Louis Dudek and others known and unknown.

Adele turned up on the second or third day. She'd come from Europe, where she was living and writing, to visit her family in Winnipeg and was on her way back, to London, I believe — a slim trim little figure, as I remember her. "But I was always barrel-shaped," she said in her usual self-deprecatory way when I told her this some years later. I insist on the accuracy of my memory: there was nothing barrel-like about the neat, slender little person of those days.

None of us had ever heard of her but word quickly got round that she'd just finished a novel and that it was good. As indeed it was, we discovered the following year, when the novel in question, *The Sacrifice*, was published, won the Governor General's Award (which was just a medal at that time) and became one of the classics of our literature.

Two things stand out in my memory. One of my friends told me she'd asked Adele what her book was about and Adele had replied that it was "about people." My friend thought this was a

silly and rather childish way of evading her query. I myself thought, and still think, that it was a perfect response to the question writers find most unanswerable and dislike above all others.

The other incident is the one that went down in literary history as "the night Adele slept in a car." Is it still known, I wonder. It should be. She found herself locked out one evening — most of us slept in a students' residence and were obliged to keep what Frank Scott called "children's hours" — and instead of panicking, searched along the street till she came to an unlocked car, got in, curled up, as she was tiny enough to do, and slept the night away. Miriam Waddington thinks that this happened the night Adele arrived at the conference. I myself am fairly sure that it wasn't till a day or so later. At any rate it happened. I remember the buzz of talk at breakfast next morning and Adele describing it all quite coolly, as if it were a perfectly natural thing to do.

This is all I've kept from that occasion — I don't think we had more than casual talk together: an impression of Adele as an independent and exceedingly enterprising young person who was said to have written a book.

I didn't see her again for twenty years. She'd lived meanwhile in Italy, England and Montreal. She'd published her second novel, the wonderfully sprawling *Crackpot*, had married and had a daughter, Tamara, and was living in Kleinburg, just outside Toronto. She was no longer so pencil-thin and had of course developed a stronger and more idiosyncratic sense of herself and who she was. Our friendship developed slowly, as good friendships so often do, and it wasn't till she'd moved with her family to what I always think of as her big hospitality-house on Rushton Road in Toronto, the scene of so many wonderful parties, that we began to see a good deal of each other and to know that we were friends.

That's one of the things I remember most warmly about Adele: her gift for friendship, for nurturing, for sharing. You could say that she ran a little promotion agency for her friends and their work. Nothing was ever too much trouble. When people from other countries — Britain, Italy, France — who were interested in Canadian writing came to town and looked her up, that was the excuse

for one of her parties so that her friends could meet this person too. There'd be a quick clean-up of the downstairs, which, with a budding artist and a writer-in-residence, tended to accumulate papers of every sort — these Adele, who was the first to admit that she was "not Toronto's keenest housewife," simply stuffed into garbage bags and lugged upstairs. A great deal of food would be prepared in what could only be described as an exceedingly inconvenient kitchen and there we'd be, sitting at the long dining-room table, talking, reaching round one another for food, later milling about in the living-room and the kitchen, which despite its clutter tended to be a rallying-point for guests.

I miss these parties as I miss her unfailing interest in what I was writing, about to write, had had published, hoped to have published. Even in the last painful months of her life this interest never grew less. When a young Italian woman who was planning to write about the work of Gwendolyn MacEwen came to see her, Adele remembered that I was writing a memoir piece about Gwen and, though she was far too ill to arrange one of her parties, she introduced the young woman to me over the telephone.

This is a hint about Adele as helpful and enthusiastic friend. There is also Adele as fighter. The two things overlap since many of her fights were on behalf of her friends — when she thought their books had been attacked or they'd been neglected or misunderstood. Once again nothing was ever too much trouble. She didn't dash off little notes to counter neglect or bad reviews, or some injustice to a friend or to herself. She wrote at considerable length, the composition of her letters often taking many days.

She liked occasions and was always ready to turn them into celebrations. When Helen Weinzweig's *Basic Black with Pearls* was published, Adele sat up late with Tamara, cutting out letters to spell the title and gluing them to the back of big black T-shirts, so that a group of Helen's friends could wear them in her honour. (I have mine still.) And when Rachel Wyatt's *Foreign Bodies* was launched at a local restaurant, a number of us marched in clad in men's underwear, with antennae affixed to our heads and stockings pulled over our faces. (There was a moment's panic when several of

those present thought we were a hold-up gang.) There were always several people involved in these jokes but the ideas and most of the work were Adele's. And now that she is gone, occasions seem scarcely to exist since there's no one to turn them into celebrations.

She also wrote jingles for birthdays and other festivities. She and I once arrived late at a party given for a visiting Australian writer because Adele refused to leave the house till she'd completed the long jingly poem she proposed to read to the guest of honour — and did read with considerable panache, when we finally made it to the party at eleven o'clock.

This was Adele's life, what she described in one of her essays as "the acting out of days" — celebrating with friends and nurturing their careers, bringing up her daughter, struggling to earn money during the frequent periods when her husband was out of work, flinging herself into disputes of different kinds, many of which, I used to feel, were considerably more protracted and energy-consuming than they needed to be.

All this time, the years of our friendship, she wasn't doing much writing. She did write *Old Woman at Play*, the marvellous and subtle analysis of the creative process based on the dolls her mother made — "totally original, totally individual, hauntingly evocative" are Adele's words for the fanciful little figures her mother concocted out of all sorts of bits and pieces, first as gifts for children stricken by the polio epidemic that attacked Manitoba and the north in 1950, later for the sheer imaginative joy of their making. From these, and the book, Adele evolved what she called her "doll shows," at which she displayed and discussed some of her mother's dolls. She also wrote the essays, personal and critical, which were published as *Memoirs of a Book Molesting Childhood*. Both these books give a vivid sense of Adele as person and fighter, the sort of life that was given to her and what she made of that life. Rereading them lately, I found the resurrection so painful — all the quirks and oddities, the warmth and generosity, the triumphs and doubts — that again and again I had to stop reading.

But except for a short story or two and a couple of plays, she didn't write any fiction during those years. "And I'm supposed

to be a fiction writer," she said to me on several occasions.

There was too much else to do, too much that she felt had to be done, which prevented her from finding the clear block of time she needed. We used, as writers often do, to discuss our writing methods. She was what I would call, for want of a better expression, a "binge writer," pressing right through a piece of work in a great burst of energy, night and day if necessary. She seemed not to do as much revision as some of us do; much of the cutting, pacing, arranging and rearranging of material she used to complete ahead of time in her head rather than on the roughly put-together page. Nor did she write notes. When I told her that I had to write everything down, even the most tenuous and tentative thought, because otherwise it would be lost to me for ever, she said that when a thought "went away" — her exact words — it always came back with something added to it, rather as if it had taken a dive into some rich soup of impressions and insights.

At the end of her life she did return to fiction, returned so magnificently that, grateful as we are to have this final gift, our gratitude is tinged with regret that she didn't go back to fiction earlier or have a longer time to live. I remember meeting her on Bloor Street in early January of the year she died. She was walking Osker, her much-doted-upon miniature schnauzer. By then she was already gravely ill and in great pain. The Rushton Road hospitality-house and her marriage were over, and she was living in a little house on Brunswick Avenue, the sort of workman's cottage that survives in diminishing numbers on a few Toronto streets; she'd been delighted to learn that it had been a station on the Underground Railroad in U.S. slavery days.

I walked with her, rather slowly, and as we walked she told me she'd promised a story to *The Malahat Review* and was already three or four days beyond the promised date of delivery — not an unusual thing in a writer's life. She finished the story, "Goon of the Moon and the Expendables," and it was published shortly before she died. I was enormously impressed by its combination of sheer force and guts and the most delicate sensitivity, and I'm endlessly glad that I didn't wait till next day or next week or sometime

when I'd managed to arrange my thoughts in presentable form but called at once to tell her how much I liked it. I'll always remember how her voice, which had sounded a bit weak and faraway, instantly came to life. Coming from me, she said, such praise meant a lot to her. (A typical Adele response, shifting part of the praise back to me.) The story, she told me, was a belated act of contrition to a young man suffering from cerebral palsy from whom she'd fled in terror in her youth, when all he was trying to do was ask her to dial a phone number for him. She was a bit uncertain, she said, about the beginning. Had I found it too mysterious and confusing? I assured her that it was perfect and, like all the rest of the story, I honestly feel that it was.

It was also arranged during this call that in a few days, when she'd recovered from the strain of next day's trip to the clinic, I'd bring round some murder mysteries I'd been saving for her. But a few days was too long. The little stack of undelivered paperbacks reproached me for many months.

I miss her. I miss going to the phone and hearing her rather breathless voice speak my name. No one has ever pronounced it with quite that note of eagerness and excitement. I can recall it distinctly though I know I'll never hear it again.

II
Sylvia Fraser

Adele Wiseman and I met in 1975, after she had reviewed my second novel, *The Candy Factory*. What had pleased me most about her critique was that it taught me something about my book that I didn't already know. Usually, by the time a manuscript is published, few surprises about content remain; however, Adele was not only one of the English language's finest writers of prose, she was also one of its most incisive readers, with critical intellect balanced by her generous ability to appreciate any artistic work on its own terms.

Having met on literary turf, Adele and I became good friends; otherwise, I would never have made it through her personal radar system. Though she was highly accessible to the downtrodden, I was deep into my Lady of Shallot period — a *faux* princess, trailing chiffon, and living with a prince in a white penthouse. Adele, by contrast, was forthright and foursquare, a compact and earthy presence, always on the side of the underdog against privilege and injustice. Because of our differences in style, Adele never knew quite what to do with me once I had breached her inner circle. The usual judgements didn't seem to work. Perhaps this was why she showed to me a side of herself that she usually concealed, a wistful side that wanted to believe in the trappings of the Cinderella fairy-tale — about which I seemed to possess insider information — instead of in life's harsher, more mundane moral realities.

My benefits of friendship with Adele were always far more obvious than hers with me: she became my literary mentor — no honorary appointment. Over the years, she cheerfully read a series of desperate and groping manuscripts served up in plastic grocery bags, supremely undaunted by chapters that rolled over and died or else took off in several directions at once, able to see far better than I where all this compulsive typing could be leading. Adele's criticisms, tactfully delivered over soup and deli food in her cluttered kitchen, were pithy rather than detailed. On reading an early draft of my memoir *My Father's House*, she commented: "You're

trying to write two books at the same time. You keep expanding my mind when I don't want it expanded." Of course. Suddenly, the vague dissatisfactions of other readers found focus. I completely rewrote that book on the basis of Adele's two sentences.

Even while dying of cancer, Adele insisted on reading my latest manuscript-in-progress. Understanding how guilty yet how grateful I felt, she thanked me for what she insisted was a privilege. Nor did her sponsorship stop with the printed page. Always Adele could be counted on to be a blabbermouth where it did some other writer the most good. When she found something she liked, she broadcast it to everyone with a boosterism as full-hearted as her artistic midwifery.

Adele's own literary legacy was diverse, gutsy, original, passionate and of the highest quality. Though fiercely proud of her own standards, she lived in constant self-rebuke that she hadn't produced a larger body of work, and especially that elusive third novel. Yet always at the core of her existence was her reverence for the creative process. She respected the artistic potential of everyone, no matter how humble the chosen medium. This was beautifully expressed in her appreciation of the dolls her own mother made out of old stockings, buttons and even a fish tail or two. Those dolls were the centrepiece of Adele's most personal book, *Old Woman at Play*, a lyric to creativity and to its source and nurture in her own matriarchal line. As she sang in those pages: "I am here to trace and celebrate the most generous impulse, and the most mysterious process known to man, the impulse to create, the process of creation."

Through that celebration Adele became muse and advocate for several generations of artists, both as head of the Writing Programmes at the Banff Centre and in various university posts. Feisty, stubborn, full of easily triggered moral outrage, she gloried in fighting "up" to secure more money, more attention, more dignity for the embryonic artists in her charge. Significantly, on one occasion when she found herself attacked from below, she became paralysed with guilt and indecision, unwilling to recognize that underdogs, too, have teeth.

In the final years of her life, Adele became a migrant worker, passing from one teaching position to another, overextending the generosity with which she allowed her own creative talents to be invested in others, trailing a houseful of belongings — outsized hunks of furniture, thousands of books, hundreds of her mother's dolls, dozens of her daughter's artworks — adding, through the sheer bulk of this unsorted past, a tragicomic quality to the usual definition of writer-in-residence. And then, in the spring of 1992, when it looked as if she had at last severed her debilitating ties, cleared for herself a livable space, assembled her computer for concentrated work on that third novel, cancer began its accelerated invasion. Yet it was only in her terminal months that a handwritten sign appeared on her front door: "By Appointment Only."

During that time of physical indignity and pain, my mutually assigned role was to be optimistic about Adele's chances of recovery and to satisfy her curiosity about various mystical beliefs which she knew I had been exploring. Early on the morning of June 2, as I was bicycling towards a meditation class, it came to me rather sharply that it was time for me to speak directly, instead of elliptically, to Adele about her own death, recently confirmed to be impending. Even as I mulled over those thoughts, Adele lay collapsed on her kitchen floor, in transit from this life to whatever there might be of another. Sadly, I had assumed we would have more time.

I remember Adele with gratitude for the richness and maturity of her spirit, yet the image I carry in my heart is not of the cheery friend met over tea in a Queen Street eatery or of the forceful literary icon in the magic red fedora, galvanizing an audience. The image I see is that of a far more youthful Adele, with shoulders slightly hunched forward and arms dangling at her sides, like a child in a too-tight snowsuit, a smile of angelic sweetness spread across her face. This child was, I now realize, always with us, always hoping for recognition, her vulnerability obscured by the fact that Adele, the advocate of others and always obliging friend, was just a bit too quick, a bit too decisive, in speaking over this patient little person, instead of for her.

III
Miriam Waddington

Our friendship began in 1955. We met at a Canadian writers' conference in Kingston. It had been organized by F.R. Scott and Malcolm Ross, who were influential enough to persuade the Rockefeller or Ford Foundation to fund the conference.

Adele and I met one morning in the women's washroom. Adele had arrived from Montreal the night before, too late to get a room in the residence, and she'd had to spend the night in someone's car. I took it for granted that she had not spent it alone, and proceeded to surround the incident with all sorts of romantic nonsense. Adele was so taken aback — as she told me years later — that she didn't have words to deny it. We often laughed about it afterwards, especially since she still remembered the discomforts of that night.

Adele was then living in Montreal and teaching at Macdonald College in Ste. Anne de Bellevue. Her novel *The Sacrifice* had just been accepted by Macmillan's, and Kildare Dobbs, her editor, was glad to spread the news at the conference. Adele and I saw each other after that in Montreal, but our friendship really became close later, when she married and together with her husband, Dmitry Stone, moved to Toronto, where I too was then living.

Adele had a genuine talent for friendship. She was loyal and generous and unfailingly good-tempered to the very end of her life. When cancer crowded her insides to the point where she couldn't digest her food, she never complained. Not that I think her lack of complaint was praiseworthy — I don't. When people suffer they have every right to complain, and I believe they should. But Adele didn't want to waste time talking about illness. For her, as for Chekhov, life was the holy of holies. If I asked about her treatment and its progress she would tell me, but she never initiated a discussion about it. Sometimes, as in the last months of her life, the changes in her treatment raised all our hopes. I have since thought that it isn't possible for us to accept the imminent death of

someone close to us. We all knew that Adele's illness would kill her sometime. But that sometime was far off; never now, not this week, this month or even this year.

Adele and Dmitry moved to Toronto in 1969 and their daughter, Tamara, was born that same year. Adele photographed her baby lying beside my book, *Say Yes*, which also came out in 1969. Adele loved being a mother, and of course she nursed Tamara and also looked after her husband and his three sons from a former marriage. She even managed to do some work on her novel *Crackpot;* she was revising and editing, and exploring publication possibilities. McClelland & Stewart published the novel in 1974.

I lived in Toronto until the summer of 1992, and whenever I drove through the city in the years before and the months immediately after Adele's death, I kept remembering my drives to visit all the different houses where she had lived. First in Willowdale, then the family moved to Jane and Wilson. Later they rented a house in Kleinburg, and finally, in the seventies, they bought their house at 324 Rushton. When they parted — a few years before she died — Adele moved into her last home, a sweet Hansel-and-Gretel house with a garden near the university.

Wherever she lived, right to the very end, Adele was the epitome of Russian-style hospitality. Sick or well, she was forever cooking for, and feeding people, and in the early days her husband used to enthusiastically barbecue all kinds of delicious things. And not only on a conventional barbecue. Sometimes he would roast a small pig or part of a sheep by some mysterious process in a pit in the ground. Those were happy times for us all: good food, brimming glasses of wine and lively talk about books and writing. Sometimes I think of the English queen who said the word "Calais" would be inscribed on her heart when she died. In the same way, I think all the streets and roads of Toronto between my house and Adele's will be inscribed on my heart when I die.

Adele's parents came to live on Rushton Road with Adele and her family. Dmitry remodelled several downstairs rooms for them, and when Mrs. Wiseman eventually became bedbound, Adele nursed her faithfully and with her usual good temper. She still was

always available to friends and to every writer who wanted to bring work to her, for Adele never turned anyone away. She was totally accepting of people who wanted to write, whether they could or not. She was much cleverer than me about politics and the world, but I was much more severe and critical of the work some of these beginners brought to her.

After her mother died, Adele began to travel all over Canada and Europe to give readings and speak at conferences. In the last years she was often absent from home. One year she commuted to Montreal as the writer-in-residence at Concordia, another year it was to Windsor, and still another to Prince Edward Island. She usually came home for Christmas, and her friend Margaret Laurence would always arrive from Lakefield to cook the Christmas turkey. Those dinners were memorable: a dozen people or more, babies, parents, grandparents, artists and would-be artists. All would sit at the table while Adele bustled about, looking after everything and everyone. There was also a Passover seder in the spring, much like the Christmas dinner except that the menu and rituals were different.

I believe that Adele's own writing suffered because she gave so much to other writers. Towards the end of her life she was forced to adopt a schedule where she worked most of the night, beginning at midnight, in order to obtain the quiet she needed. I doubt if she ever fully caught up on her sleep. Her writing did not suffer in quality — but she surely would have produced more if she had not been so available to other people. Still, Adele would have said that people are a big part of life, and she could never deny life or the creativity in others.

She had even less time after she was appointed head of the writing studio at the Banff School of Fine Arts. Her presence there will never be forgotten; she made it possible for all the writers who were accepted by the studio to receive scholarships covering their total expenses, and by her own example she created an atmosphere of warmth and comradeship. Above all, she gave the gift of time — four to six weeks — to a group of writers who received what every writer/artist dreams of: unlimited and uninterrupted time to work

in one of the most beautiful settings in the world.

Adele was a writer to her very core. When, in the 1950s, I was asked to review *The Sacrifice*, I accepted with a certain amount of dread. I liked and admired Adele and I valued our friendship, but I was afraid I might not like her novel. What if I didn't? Fortunately *The Sacrifice* was a joyful surprise. It was beautifully, classically written, did not distort or exploit its Jewish content and was brilliant in its psychological insight. I breathed a sigh of relief that I could have the same feeling for her writing as I had for her person.

What was Adele trying to do in her books? I believe that she was always trying to find new ways to say what she had to say. She experimented with various forms. First it was through novels, later through plays, and finally in her last years it was through poetry. She didn't show me her poetry — probably for the same reason that I didn't show her my stories. Through it all she was trying to discover a particular truth or truths about life. She did it not only through the use of various forms, but also by experimenting with voice and new identifications. Always, in everything she wrote, there was the point, the red dot of a newly discovered truth. And she had this advantage: she wrote out of the continuity of the Jewish tradition as well as the Canadian one. The ethic of our secular Jewish background drew us together, as did our childhood in Winnipeg spent in the same austere climate and landscape. There is something both strict and direct in Judaism, and something equally strict and direct about the prairie. No obstruction to seeing, no place to hide. And when you are searching for truth there's no need to hide, for all your energies are devoted to the task, and are absorbed by the work itself.

I miss my friend Adele. At night I have long conversations with her. I love to hear her complex analyses of every situation under the sun, especially when she talks about editors and publishers and the function of writers in our difficult and troubled world. And in our difficult, troubled and beloved country. She talks not only about writers, but about *women* writers, and not just women writers, but *Jewish* women writers — and she breaks that

down further, to *older* Jewish women writers. A triple whammy. We still talk a lot when I'm alone just as we did when we lived in the same city. Now we are both in different cities, I in Vancouver (a whole other country) and Adele in the city of air and spirit. But wherever you are, Adele, I hear your voice, and I hope you still hear mine.

IV
Mary Lou Dickinson

When EIizabeth suggested that I write a piece about my friendship with Adele Wiseman, I didn't think at first that she could be serious. I had always been on the periphery of "the tribe." Surely Elizabeth didn't mean me. But she did.

Where to begin? I didn't know. My friendship with Adele was spread over seventeen years, with infrequent visits and somewhat more frequent telephone conversations. She initiated me into the tribe of writers by accepting me. She introduced me to others...Margaret Laurence, Sylvia Fraser, Timothy Findley...as if I belonged. I was in awe of all of them. Of Adele herself. I still am.

I met Adele when I was studying at the University of Toronto in 1975 for my Master's in Library Science, soon after separating from a sixteen-year marriage, with no career to fall back on. I didn't want to be a librarian, even told a friend then that I was in the wrong profession.

"Of course you are," M. said. "But you can make a living at it."

I find these recollections in my journal for 1975, highlighted with a yellow marker. I have gone back there to discover how I first met Adele. For a course on Canadian publishing, Dean Francess Halpenny suggested I speak to the writer-in-residence at the university. Around the same time, I was submitting stories and realized I might be able to show them to this person. So it was that on October 2, 1975, I met Adele in her office at Massey College.

My notes that day are "...AW has a theory about women writers and divorce and I fit into it. The man being threatened syndrome. I saw what an assault on my mind my marriage was. We talked about mourning. About finding we could cope alone. About her late marriage, at forty. I liked her. Also met Marian Engel on my way into Adele's office. And chatted. I had met her years ago as a student at McGill."

My next journal entry about Adele comes a few days later, on October 9. "Met AW again. Her mother's dolls on the wall.

Tamara, age 6, cracking nuts. 'You like kids,' Adele commented. She seemed pleased to have me see her as a mother, to have her daughter there. Phyllis Grosskurth dropped by to give Adele a copy of Hugh Hood's latest book. After she left, Adele commented that she saw themes connecting my stories, themes I wasn't aware of. And she spoke to me as a peer.

"'I don't know where you'll go,' she said. 'You're striking off somewhere new, as each writer must.'"

The implicit assumption that wherever it was, I would go. Out onto the high wire. I felt, nonetheless, anxious about leaving my novel. How could I leave my paltry prose with the woman who had written a work as brilliant as *The Sacrifice*, a novel which I had been reading again?

"How will you feel if you don't leave it?" she asked.

And "Ciao." That was how all our conversations and meetings ended. Ciao.

On November 5, I called Adele about the paper for my course. She'd read my story "Which One Are You?" and liked it.

"You do that going back and forth between reality and unreality well," she said.

I commented that the story (five pages) was probably a distillation of all the work she had of mine (the discarded novel).

"Then it was worth it," she said.

"Four years for five pages?" I asked incredulously.

"Yes," she said.

On November 20, she commented again on my story. "People send me what they call experimental and all it is is fragments," she said. "This is really experimental."

Adele encouraged me to begin to submit again. Especially my last two stories (both later published). Said it didn't matter that I wasn't prolific. "As Margaret says," she said, "we have to talk to each other. We're members of the same tribe." In December, she called to say she was dropping a list of outlets for short stories in the mail.

"Ultimately I expect you'll use all of what emerges from this traumatic time," she said. "Sifted and grounded. It won't get

easier, but you won't stop writing."

"How do you know?"

"Well, you haven't yet."

She introduced me to a professor of philosophy, Bas van Fraassen, who was also writing fiction (with whom I shared stories for a number of years, as well as our early acceptances and rejections).

In February, Adele mentioned that she'd received the latest issue of *Waves* and that a friend of hers had read my story while waiting for her at the "fat clinic" and thought it very good. We arranged to have lunch in the refectory at Massey College in a couple of weeks. This was shortly after both my father and grandmother had died within a few days of each other and my mother had had a heart attack. I suppose I marvelled that I was somehow managing.

"Of course," Adele said. "You're tough. You're a writer."

In March I had lunch with her at Massey College. Tamara was also there. We're becoming friends, I thought. In April we had a lovely, relaxed chat in the courtyard. She showed me her review of *Bear*, told me about a conversation with Jack McClelland. Afterwards, we went across the courtyard in the wrong direction. She suddenly noticed.

"I was following you," I said.

"That's disaster," she said.

And so the journal entries recur down through the years. June 1976: Adele and Tamara picked me and my two children up in her old Citroën, Monique, to take us to her home to celebrate my birthday and Tamara's (within a day of each other). Being in her home environment, bright colours everywhere and junk in the basement, gave our friendship a new dimension. She — bright, kooky, nervous — spoke my language. And I enjoyed the fact that we talked as writers and as friends. About writing she said, "There isn't any 'only' way to do it...like starve and write. There are probably almost as many ways to write as there are writers. And being high-strung seems to go with the territory."

In August I saw her on television and mused that she'd be

a difficult person to interview, so much more intelligent than the interviewer. Later that month, she offered a fair number of criticisms of two stories I'd written in Vancouver.

"They simply don't stand up," she said.

Other people had let me off easily, but not Adele. At the same time, she nonetheless encouraged me to write a review for *Waves* of a collection of short stories by Jack Hodgins they had sent me.

A year or so later, in 1978, she agreed to give me a grant reference. In February when I had the application and called her, her father had just died. She didn't want me to mail it to her; instead she asked me to drop it off, and I learned about the Jewish custom of visiting a family sitting shiva.

In October, 1978, when I was about to take a holiday in England, she was preparing for the doll show. We talked about neither of us doing much writing.

"Come back refreshed," she said.

When I returned, I saw the show *Old Woman at Play*, celebrating her mother's work with dolls, exploring creativity. A very moving experience, with her mother and Tamara there as well. There were good reviews of Adele's book with the same title, and we talked about them when I visited her.

Early the next year, Adele was touched by my mother's comments about her book and thought they would cheer up her mother, who was receiving cancer treatment in Princess Margaret Hospital. Later, when her mother was in remission, we saw each other at the "So You Write, Too" conference at Harbourfront. I noted her comment that the end of a novel was a question and the novel itself an answer. Also one about the threatening nature of original work because of "the hurting areas that the artist always feels compelled to explore."

In July I went to hear her read. In September, when I saw her again, Dmitry had lost his job, but she sounded in reasonably good spirits. She was trying to decide which grant to apply for, as something to keep them going. Hoping they wouldn't have to lose their house.

By November I had made the difficult decision to leave a full-time job to write. I'd known for a long time I'd have to do it and had been frightened. But the time had come. I couldn't stay so long that all my creativity was stifled. When I called Adele, she checked to see that I had a financial cushion and then told me I'd done the right thing.

"Thanks," I said. "I take that as a vote of confidence." Although I worried that thus far all my friends seemed to think I'd done the right thing.

"There'll be plenty who won't," she said. "And they'll tell you all the reasons why as well."

We both laughed. And I knew that was why I wasn't telling everyone yet. She told me then that Dmitry had found a job and that she'd applied for two levels of grants. She was also willing to act as one reference for a short-term grant application I'd decided to submit. I told her I'd keep my fingers crossed for her, for the longer grant in particular.

"We'll keep our fingers crossed for each other," she said. "But not so hard we can't write."

In January 1980, I learned that Adele's mother had died. I guess I still didn't entirely understand about going to visit the family sitting shiva, because I didn't go. But I kept seeing her mother sitting in the kitchen of Adele's house. Eyes shining on one of the stages where Adele was doing the doll show. So wholly lacking in pretension as she sat surrounded by her dolls and her daughter and her granddaughter. I called later, wrote later. At the end of January, when I got a letter from the Canada Council, I phoned Adele again to tell her I had the grant.

"Do it," she said.

In March, Adele and I had lunch at a small restaurant downtown called The House of Noodles. She talked about me as a writer seeking my own voice. She told me that Marian Engel was in Australia and that she wasn't well, had a form of glandular cancer which could, however, be kept under control. Apparently she was working on three books at once while Adele's method was to write down only what she had already carefully worked out in her

head. Margaret, on the other hand, apparently dashed off a draft as quickly as possible and then worked on it. Adele found it more painful to work with a draft, preferred to move in a different way. All of this apropos of telling me to work in whatever way was comfortable for me. And, most exciting of all, she'd received the grant she'd applied for, *la crème de la crème*. The three-year one. She treated me to lunch.

"My grant is bigger than your grant," she joked.

A few months later, when I felt I was beginning to make some breakthroughs, Adele cautioned me not to waste my excitement, to get it into the story. In September she told me that it sounded as if I was accomplishing, and that I'd have to learn to sit. "Learn to suffer," she laughed. I asked if it was worth it and she said it was. And suggested I submit one story. She told me later in the month that Jane Rule had taken two years off to invest in the stock market to make enough money to retire and write. I said that I'd keep on writing until I either ran out of money or stopped growing. She said that if I stopped because I ran out of money, that would only be temporary.

She told me that she might be going into hospital for what she said was routine gynecological surgery. She still wanted me to send some stuff I'd written. In December, when she was in Mount Sinai awaiting surgery, she told me Margaret was coming to stay with Tamara. She asked to see a story I'd written about a woman thief. I told her I'd show her in the new year. She told me I should be reading fiction rather than books about how to write it.

In June she was busy getting ready for a trip to China. In September my mother met her at a reading and Adele said, "Tell her to keep writing." When I next saw her, she reminded me that it wasn't volume that counted, that we worked like poets, polishing lines, polishing paragraphs. The next year came and we continued to have our shared moments. She commented that I was part of a new generation of women, one who could, with grown children at home, put her pack on her back and travel Europe alone, as men used to.

"Gutsy," she said.

Outwardly she was an exuberant, joyful person, yet at the same time she was strangely insecure. When from time to time, I expressed my fear that I might go crazy, her comment was that, as for her going crazy, she only feared someone else might begin to notice.

Ciao.

At lunch in a restaurant on Yonge Street, in June of 1982, she showed me a notebook she'd begun to carry, to jot down ideas. She talked of the decreasing amount of time left to her with new awareness. Then a call in February, 1983, to say she was up to her ears with trips and trying to bring in enough money to make ends meet. She would leave for Europe on Friday, and was off to Victoria and then Kingston when she returned. After that, in the summer, she hoped to find some time for her own work before going to Concordia as writer-in-residence for the fall term.

That summer I mentioned to her that I frequently came across her comments in my journals and that almost invariably they were wise.

"Do you know the life history of wisdom?" she asked. She proceeded to tell me that it went through several transformations. "When first minted it's not readily recognized as the clichés of tomorrow," she said.

In December I had a small group in, including Adele, Dmitry and Joy Kogawa. Oddly enough, it was the first time Adele had been in my home. A few months later, in March of 1984, Adele introduced me to Margaret Laurence at an opening at a small art gallery, then left the two of us in animated conversation, a long chat in which Margaret was incredibly supportive.

A few months later, I told Adele I felt I was stepping off into a void.

"Good," she said. "That's where it starts to happen."

"What do I do there?" I asked.

"Create a new world," she said.

In September of 1984, Adele, Jim Polk and Susan Walker agreed to act as references for a Canada Council grant. When I didn't get the grant, Adele told me that Helen Weinzweig hadn't

published her first book until she was in her fifties.

At the beginning of 1987, Adele talked about Margaret dying. She had cancer and had recently broken her leg. "She's keeping a journal," Adele said; apparently it was Margaret's way to alleviate the stress. Only two days later, I heard that Margaret was dead. Only sixty. And on the radio, her voice. An announcer said that in reading her books we learned about ourselves. At the memorial service Adele and I hugged, unable to believe there would never be another Margaret Laurence novel.

In March, Adele called to tell me she'd taken over W.O. Mitchell's job as head of writing at Banff and wondered if I'd be interested in "workshopping" there. Shortly after, we got together, and even though there was no way I could participate in the workshop then — too long, too expensive — I was glad to see Adele, Tamara and Dmitry.

A few months later, I received an invitation to an open house to see some of Tamara's work. And was amazed to see the scope and variety of what she, at eighteen, had already done. A gifted artist. Adele was off imminently to be writer-in-residence in P.E.I. For three months. The cover of her book, to be out in October, was on the wall with Tamara's work.

Then the terrible waiting in 1988 when Adele found she had a brain tumour, the ten-hour operation which she described to a small group of friends, including Gay Allison and Geoff Hancock, around a table on her back porch during the summer after. Beads of perspiration formed on her forehead as she told where the surgeon had made the incision and how her scalp had been lifted back and holes drilled so he could scrape away all of the tumour from the nerve to her eye. I felt horror and wonder, and was immensely grateful that she was sitting there looking as healthy as if nothing had happened. She could see, she said, but she still had no smell.

Yes, and so many more moments yet awaited us in spite of yet another brush with mortality. The day Adele called, after months when I didn't know where she was, to say she had a book for me. Could we meet for dinner? So we did, at a Chinese restaurant down on Dundas Street where the book she gave me, Willa Cather's *Not*

under Forty, lay on the table between us. I asked if I could take her picture and she asked instead that the waiter take one of both of us. She talked about the "aloneness" of being a writer. She thought when she first went to Banff that she wanted to help as many writers as possible. She now felt she wanted to help those who came to recognize that they had to deal with their aloneness and go back and sweat it out on their own.

"It takes very sensitive resource people," she said. "Ones who don't impose their vision on an emerging vision."

Other times also, talking about her separation, had I met anyone?, our work, always our work, until the summer of 1991, when I met her on Bloor Street with Tamara and she told me that she'd had a recurrence of a tumour in the pelvic area after an operation a year earlier, that she hadn't called yet because she'd wanted to tell me in person.

Only two days later, I met her again, walking her dog, Osker, and we talked for an hour. She told me that the doctor had said she had only a year to live, but she intended to live much longer. After all, at just over sixty she was in her prime, said she. She asked me to visit her soon in the little house on Brunswick Avenue she'd recently moved into, where I saw her not long after for what I didn't realize would be the last time. We sat amongst her books and talked about people we knew and the writing we were doing. And death and dying.

"Why didn't you tell me sooner about meditation?" she asked.

"I tried," I said.

For some reason, that sent us into gales of laughter.

She said she still thought my French material, on my early years in a northern Quebec frontier mining town, would one day be a book. She told me about her story "Goon of the Moon and the Expendables," which would soon be published in *The Malahat Review*. She knew I'd applied to Banff, for which her efforts had by then made scholarships available, and I think she still thought she would be there. It would give us time in a different way than we'd ever had before.

But when I finally arrived at Banff in the spring of 1992, for six weeks of writing in the mountains, Adele, still the director, was too ill to be there. Nonetheless, her messages arrived regularly via Rachel Wyatt.

Then, two days after my return to Toronto, before I could see her again, Adele died. I had left a message on her machine on Monday evening, a message she never heard because she'd slipped away earlier that morning. On Tuesday I read about it in the newspaper and immediately called Tamara. This time I didn't hesitate in going to visit the family sitting shiva, and Joy Kogawa and I went together to the tiny house on Brunswick Avenue, where I had last sat with Adele in her book-lined study a few months earlier. Afterwards I went to Chris Kerata's office, where I heard about Adele's last weeks and learned that Chris would take Adele's beloved Osker. Later, a memorial service in downtown Toronto. I sat with Joy, spoke with Elizabeth, Rachel, Don Coles, Colin Bernhardt, sure Adele was still with us. Yes, her spirit lingered. Six months later, a psychic whose name I found in a book by Sylvia Fraser told me I had a sister in spirit.

In the fall of 1993 I received a note from Tamara, in Boston finishing her art courses, inviting me to the unveiling of Adele's tombstone. So on a cold, windy day I stood with family and friends in the Jewish Cemetery on Roselawn Avenue while Adele's tombstone, the bronze scroll on top of it sculpted by Tamara, was uncovered. The men wore the traditional yarmulkes on their heads as we stood huddled together under the grey sky, listening to the rabbi intone in Yiddish and English. I caught something about Adele's use of words and her courage. Yes.

So now these memories. For a sister in spirit. For her daughter, Tamara, also my friend. For the tribe.

And ciao, Adele...in your own words, your "spirit's stars defy [your] death, claim still a place to glow."

V

Ingrid MacDonald

Adele was exactly my mother's age, and she and I had an affection-
ate connection as Young Writer meets Old Writer. She always greeted
me with a cheery "Hey kid" and if there was a fragility under her
fierceness, I did not get to see it. When topics turned towards the
personal, Adele had a lovely way of smiling, raising her eyebrows
with Chaplinesque innocence and shrugging. The sensitive topic
evaporated, and that was that.

She wore a splendid red wool fedora. On the occasion of
our first reading at Banff, she welcomed us into her penthouse
suite. She stationed herself in a wing-back chair, her legs swinging,
not quite meeting the floor, proud and upright like a little king.
Platters of cheese and fruit were served though many of us had just
eaten. She made a splash in the kitchen by airpopping popcorn
and forgetting to place a bowl under the spout of the machine.

A spectacular Alberta could be seen through high win-
dows of her penthouse, mountains and backlit clouds moved like
cinema in the loft and Adele said, looking above with a satisfied
twinkle, "This is my place."

Words can hardly convey how passionately, how intensely,
fiercely, irrevocably Adele raged against the shoddy treatment of
artists. Banff gave her a place not only to be a writer, but to extend
to other writers a utopian opportunity: to be a writer, to be fed,
housed, given community and respect.

Underneath her happiness at Banff, one could glimpse
the shadow of lesser experiences. She had just resigned from her
post as writer-in-residence at the University of Windsor, after a
winter of inadequate residences. Artists — "the adjudicators, in-
terpreters, and witnesses of any civilization" — were suffering the
encroaching losses of economic backlash.

Adele's experience at Windsor was a clear conflict between
the arts and the fiscal meanness of an increasingly soulless admin-
istration. She composed a letter — which was to epistles what the
marathon is to running — describing her discontent. At age sixty-

two, rather than being welcomed or celebrated as an author, she was "shunted from place to place to place to place to place." The construction of the university's new business administration building personally affronted her; it rose in the sky above the university like "a great growing claw."

After Banff, Adele returned to Toronto, to medical tests that revealed a poor prognosis. She let go of the small apartment she kept on St. George Street and rented a little cottage on nearby Brunswick Avenue, a street with gingerbread gables on brick Victorian houses, a few minutes' walk from the many cafés and bookstores on Bloor. It is a writers' neighbourhood, where Jane Jacobs, Margaret Atwood and Susan Swan have lived and where you might once have caught a glimpse of Gwendolyn MacEwen steadying her bike while she fed stray cats in a laneway.

I visited Adele every now and then at her little cottage. She had all but barricaded herself inside a warehouse-worth of cartons and boxes. Artwork made by friends over the years sat propped on top of cardboard boxes full of lifestuff. If death was going to take her, he'd have to be able to find her there among the boxes.

A path that looked as if it were cleared by a machete led past a dining-table to the galley kitchen. Adele cooked soft-boiled eggs and toast, which I recall as being particularly delicious — "A food of the kings," she said. Then we had a bit of Young Writer meets Old Writer, which sounded like this:

"Write to write. Don't worry about getting published. Your reception will be underground at first and then it will surface. You are a writer's writer, in the realm of the philosophical, and that means working at the place where the imagination of the culture expands."

She was not a woman to go into much medical detail, and preferred to talk about writing than health. I never saw her when she did not look as robust as she did when I first met her, but I knew she was weakening because she needed to rest more.

She had set up camp in a bed in a room at the front of her house. A cabinet with glass doors held her mother's dolls. Osker claimed the foot of the bed and a large-screen colour television

occupied a corner.

Over the winter I saw her several times: walking to restaurants and bookstores, at the theatre, at cafés, and sometimes, as on one snowy night, just walking. I saw her one Saturday morning, in the spring of 1992, waiting for a friend at an outdoor café. She invited me to join her for iced tea.

When her friend arrived — an artist named Margaret — Adele presented her with a gift, a number of little paper bags filled with pure powder pigments which Adele had bought on her trip to Italy. Italy. Italy: a place where artists are properly treated! I watched as Margaret slowly opened each of the little bags as if they held gold. The names of colours were pencilled in Italian on the bags — *nero. blu. oro. rosso. bianco. verde* — and inside, dry powder, light and brilliant.

That gesture stuck in my mind as a perfect Adele moment. The pigments represented a kind of pure artistic power, holding the potency of all things in powder form, just add water and stir!

VI
The Hooded Hawk
Anne Michaels

"Every moment is the consequence of every preceding moment, the sum to which our life, at that moment, adds up; therefore we are grounded in the whole cosmos.... I think I drew strength, at this time and for years to come, from my knowledge...that I was where I should be, that I had come into my own; painful to the extreme limit of endurance as that place and state might be."

Kathleen Raine

"The thing about great works is that everything else you've read seems to have been leading up to them, and that they in turn point beyond themselves.... There is something in all that passion, all that intensity, that makes us literally afraid, each book an experience, a quest that takes time to prepare for, with an awareness that the book is waiting as inevitable as the last age that you will reach before death."

Adele Wiseman

History chokes on the little bones
of meaning, the little bones
of love. Early winter, late
afternoon, the room went dark.
We sat a long time
before noticing. You were recounting
a trip to Italy, not the conference, but a woman
in Rome who remembered those who hid
or fled. You stood to turn on a lamp, instead
sat down again. Your voice more distinct
in darkness.

You knew it like a secret:
under the skin, the chalk body
outlined on pavement, the line
you wrote, between "what's permissible" and
"what's possible." History: the silver spoon
in your kitchen drawer,
swastika on its handle. The "tulips and daffodils"
escaping children were told to run to, who
remember instead Westerbork's "bloodhounds and rats."
Your mother's dolls — all the refugee parts
they're made of. History is the love that enters us
through death; its discipline
is grief. The love
that won't coagulate; when blood is broken.
You never forgot the floating ghettos —
S.S. Struma, S.S. St. Louis. Landlocked
in North Winnipeg, listening with your father
to the radio, while the boats were refused
at every port; eleven years old,
you were with them, those who had no place
on earth, while the streetcars squealed to a turn
on North Main, and in the front room
the sewing machines and wooden steaming blocks
thudded all night; with them
listening to your mother tell the story
of their escape across the river —
"we must bring our children to a shore";
with them again in '55, alone on deck
on the *Ivernia*, anxious to begin as a writer;
didn't forget them when we spoke of
exiled Walter Benjamin, who devoured books
"the way a flame 'reads' wood,"
or when later you wrote of your childhood:
"I belonged where I read."

*

The dolls your mother made
were stories. "He's the French type...
dresses just so...he likes to chase after women...."
She holds up an Englishman and in her other hand
his pregnant wife: "Now he's more mature
for his responsibilities." When the stories were sad
she dressed them in finery
so we wouldn't turn away. After a pogrom, when she was young,
your mother rooted out buttons and bits of glass,
"scraps of this and that," and never stopped: wooden spools,
used lightbulbs, leftover leather, bottle tops,
lids of jars, labels, beads,
bone. Her one requirement: that the object
had lost its purpose. So what was broken
transformed to something whole:
a hat, a foot, a hand.
Your mother sewed all night
and fell asleep on the cutting table.

All your writing life, you worked at night.

*

One Thanksgiving it took two
to carry the platter — your idea,
a cauliflower steamed whole,
cerebral and surreal, regal
as the head of a saint. Elevated
to a centrepiece. I understood the symbol:
they harvested cauliflowers
from the fields near Terezin...
At the table, your favourite ghost sat with us,
the poet Heine, who knew home
is in the mouth: not just language but
carp in raisin sauce, lamb
with horseradish and garlic;

even in Paris, surrounded by *cuisine.*

*

To measure one's self against foreignness
is only one kind of measuring.

We sat in your dark apartment and all the years
were with us. This was after another stage of illness.

Of your mother's death
you wrote, "My loss is endless...its only closure
will be my own." This winter afternoon, two years after
your death, sorrow magnifies
through the generations, each human's part
heaped upon the next, in this way our griefs
are joined. For all the talk,
for all the speaking up and
out, the core sample
is silence. We made a pact
of dusk. In your kitchen so many afternoons,
in your last apartment, in this apartment.
This November afternoon.

*

Almost forty, childless,
so much of your life
given to ghosts. You lived with *The Lovebound*
longer than they were stranded on the boat, on the verge
of war. Longer
than the war.
Years later, you pushed the manuscript across the table
without comment. Your daughter almost as old
as the abandoned pages.

In a dream
the hooded hawk is sometimes
love, sometimes
death. Everything stops at the moment
of unmasking.

Colette said: when one we love dies
there's no reason to stop
writing them letters —

Since —
you died,

This year
I have been so opened
by love that presses the place
that won't open —

In the dream you said:
I am being reborn in
the womb of the earth —

You were with them,
those who had no place —

In your dark apartment, early
winter, late
afternoon,

your face had the tenderness
of a hand.

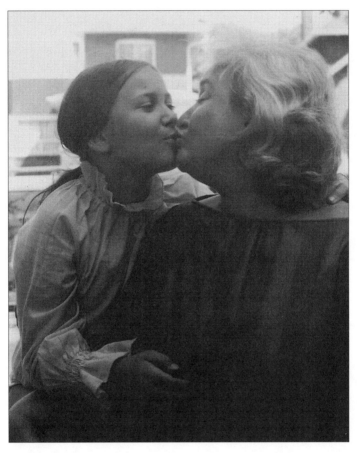

Adele and Tamara.
Photo courtesy of Tamara Stone.

A Memoir of My Mother
Tamara Stone

In her essay entitled "Word Power: Women and Prose in Canada Today" my mother outlined the relatively favourable climate that Canada offers its women writers. She conjured up two hypothetical groups which together were an amalgam of characteristics most typical in the writing community; a baker's dozen each of men and women, for the sake of comparing the forces that shape their lives and careers. The upshot of this pseudoscientific examination was her conclusion that to this day even women who have managed to achieve success in the professional sphere very rarely receive even a measure of the personal and financial support granted to their male peers. In rereading this essay recently I was struck by the difference between my powerful memories surrounding these issues and the more delicate nature of the work itself. My mother was well aware that if she took the findings of her own creative research too seriously, her work could be summarily dismissed for lack of solid scientific proof. In this case her whole argument could be both won: in that this would stand as further evidence for her case; and lost: in that it would simply not be heard. Also, at the point that this essay was written things seemed to be improving. Hadn't she had it pretty good? In her group of hypothetical women she had "even included the one necessary freak, the writer who married late, when already established in her writing career, a husband secure enough to be able to cope, but who nevertheless went through a kind of speeded-up version of the problems and guilts of trying to add the role of perfect housewife-mother to her repertoire. We are of course at the mercy not only of what is expected of us, but of what we have been taught to expect of ourselves."

This freak, of course, was her. So strong was her hope that

for years she stubbornly accepted blame in her own marital relationship for the very same flaws she had exposed in those of her peers. She did take on the role of "perfect housewife-mother" during my childhood, while writing her second novel and working on the side when necessary. Eventually though she was faced with the realization that she'd been mistaken in the evaluation she had made of her own life and that she had more in common than she had hoped with the other women she had created in her essay.

In the few years after this essay was written my mother lost many of her literary women friends to early deaths, while most of her male peers continued to lead healthy and productive lives, enjoying the respect suited to their advancing age. She divorced the man she had optimistically credited with unusual strength enough to love and support her. And despite her literary merit and success she spent several years fighting the most dreadful blatant sexual and age discrimination against her in the academic and literary communities. She was hired as writer-in-residence by a large university. After a great deal of difficulty she succeeded in negotiating terms equivalent to what would have been offered to senior males for the same position. She was a great success and even created a supplementary noncompetitive cross-border student writing exchange which enhanced the reputation of the institution. Nevertheless, over the years she was there the university fulfilled fewer and fewer of its obligations to her. In her final academic year she had neither office nor home. At the age of sixty-two she was shunted with all of her possessions from dormitory to guest suite to condemned bungalow. The president of the university turned a blind eye to her disgraceful treatment though he was appealed to on numerous occasions, both by my mother personally and by others on her behalf. I believe that this ongoing situation was not merely a matter of neglect but a form of punishment for expecting to receive the just treatment that had been promised her. She was shown that there was quite literally no place for her in that world. She admitted that she felt defeated.

My mother died of cancer a year later. Though she never stopped fighting for positive change, she did come to see the irony

of having thought of herself as the lucky exception when in fact she had been subject to some of the worst treatment society had to offer to women. For me these are the memories that surround the issues in my mother's essay. I feel compelled to further her argument armed with the incalculable evidence of her experience. It is my belief that continual systemic lack of support for women, and the associated frustration, not only make it difficult for us to have productive careers, but too often take a grievous toll. It is more than a shame that many of the most brilliant and outspoken women are silenced just when the accumulation of their lifetime's worth of insight could be most valuable. My mother died from fighting. My mother died fighting.

My mother is the most powerful, intelligent and loving individual I have ever known. I was raised in the warm light of her conviction that we were exceptionally lucky, she and I, sharing the drive and the ability to make art. She taught me that this gift brings with it a responsibility to educate the world towards greater and more humane possibilities. At the age of twenty-two I lost the woman who had been my greatest personal and professional support. Strange to say, it was almost a consolation to feel that with that loss I was living through the worst thing that will ever happen to me. I was forced for the first time to test the strength of my own beliefs, and the values she and I had shared that I had to that point taken for granted. Entering the art world myself, I am struck by a double blow to these values. I not only face a society in which the art that I believe is so important and holds such great potential is devalued; I recognize also the same pervasive patterns of sexual inequality, so complex and self-preserving that it is difficult to know where to begin working to change them. I want to continue my mother's work, building on what she learned and what I learned from her, to create a language and a voice to include women in our future history. I want all my children to feel loved and supported in all their ages. My mother felt that the very act of creating thoughtful art made better things possible. Let that be so. But if I can only bring to the lives of my children something of what my mother was able to give to me, that will be enough.

MONKEY BUSINESS: ADELE IN CHINA
Gary Geddes

It's finally stopped snowing outside my window in Montreal and the temperature has dropped to minus 30 degrees. A blue minivan has been trying for ten minutes, without success, to negotiate the hill, its wheels spinning hopelessly on the icy surface beneath a foot of new snow. In fact, the whole of Montreal has ground to a halt. Why go out? There's nowhere to park; snowploughs have cleared a single lane for traffic and dumped the surplus onto the sidewalks, so you have to be a mountain goat or Harry Houdini to survive the perilous slopes and the bone-numbing wind that sweeps across the intersections. This is obviously a time to have second thoughts about the great Canadian experiment, or to take out the travel brochures and old photograph albums in the hope of con-juring up or transplanting yourself to warmer climes. Spread out on my desk are a number of photographs that were taken in July 1981, when I travelled to China as part of the "gang of seven," an official literary exchange whose other members were Adele Wiseman, Alice Munro, Robert Kroetsch, Patrick Lane, Geoff Hancock and Suzanne Paradis. The first thing I notice about these photographs is how lightly dressed and warm we all look, clothes clinging to us in humid airport waiting-rooms, our bodies wilting on the hot tarmac, our foreheads glistening and baked from a re-lentless midday sun beating down on man and monument alike.

Of course, this is not just escapism; I'm far too practical and committed to the work ethic to be just casually browsing through old photographs, even in protest of an encroaching ice-age. I'm hoping these photographs will not only release the subter-ranean warmth of old times, but also bring back memories of my first encounters with Adele Wiseman. I had not met Adele before

the trip. When she showed up at the airport in Vancouver, she was dragging two huge suitcases and a couple of oversized bags made of sturdy, woven plastic. The photographs represent her as short and stocky, with close-cropped curly grey hair held in place by a blue straw fedora. She sports a floppy leather shoulder bag and a pair of glasses that hang on granny-strings over a loose-fitting cotton blouse; below a broad, shapeless skirt she wears bulky Birkenstock sandals and men's socks rolled at the ankle. I remember thinking at the time that she looked more like a bag-lady or country bumpkin than a distinguished Canadian author setting out to carry the word to China.

Adele was not unaware of the eccentric figure she cut; in fact, she was quite capable of an ironic self-portrait: "My stockings sagged. I did not walk in beauty. I was never to be one of those special people, the born elite of the world, with self-cleansing fingernails. Some of us are fated, again and again, to flunk boorishly the proffered moment. We flounder, instead, through a lifetime of staggering and unexpected encounters with the inappropriately exquisite." It's a wonderfully subtle passage which, while making a pretence of self-deprecation, lays waste to the empty, elitist system of values that is concerned with appearances, those mechanics of moral vacuity with their "self-cleansing fingernails." What is graceful and evidently "special" about Adele the writer, of course, is her ear for the fine nuances of language, where the humorous juxtaposition of the low diction of "flunk boorishly" and the high diction of "the proffered moment" serves to critique and explode all class-ridden notions of appearance and style, which become, in their own right, *exquisitely inappropriate*. This quotation comes from *Old Woman at Play*, an important book about the nature of the creative process, which was published two years before the China trip. If I'd read it then, I might have been better prepared for both the surprises in store and the beautiful contradictions Adele embodied.

When I try to locate Adele in the photographs, I notice that she is often formally posed, standing braced against the probing eye of the camera, head thrown back theatrically, feet planted

firmly on the ground, and appearing mockingly senatorial, or she is engaged in some sort of disappearing act. In one shot, she's deking off behind a column to the left on some unknown exploratory mission, one shoulder and a portion of the blue straw hat still visible; in another, she's completely out of focus, as if already beaming off into a separate reality.

Adele quickly became the focus of the China trip, full of curiosity, stories and enthusiasm. Many of the group photos show her deep in conversation, raising a glass of beer, beaming over her immense good fortune, or gloating over finding the largest lychees only to discover from our Chinese hosts that the smallest ones are tastier and have a higher ratio of flesh to stone. It turned out that Adele had done a lot of psychic preparation for a trip which I considered largely accidental, but which to her must have appeared inevitable. Towards the end of *Old Woman at Play*, she remarks that the many languages of China are not an impediment to national understanding or cohesion, since the written language is held in common. She was particularly drawn to stories about the Monkey King, that notorious Chinese trickster figure who shares some characteristics with shape-changing Zeus in Greek legend or Coyote and Raven in the aboriginal myths of North America. I recall her delight on numerous occasions during the trip at seeing this figure represented in painting and sculpture. So it's hardly surprising to find that China figures prominently in Adele's myth of origins:

> Now I can tell the family secret which has, in a sense, governed my life. When my mother was pregnant with me, she went to see a film called *Monkey Talks*, in which Lon Chaney played a man who plays a monkey in a cage in a circus. He is dressed, of course, in a monkey costume. And he falls in love with a girl who scorns him because he looks like a monkey. Who knows, maybe she prefers the bear. Anyway, my mother was disturbed by the film and came away remembering an old superstition that if you become

deeply affected by some being or image during your pregnancy, your child would be born in the image which had disturbed you. For the rest of her pregnancy she worried that I was going to resemble a monkey. First thing she asked the doctor, "Is it normal?" — I think, because she was too embarrassed to ask, "Is it human?" That, in spite of, and perhaps because of the accompanying assurances by herself and sundry witnesses, that I was an unusually beautiful baby, has been the governing anecdote of my existence.

When I first saw Adele start pulling those dolls — the Cossack, the landlord, the crippled child — out of one of her plastic bags (the other turned out to be full of books, not her own but books by her favourite Canadian authors, which she dispersed liberally wherever we went), I thought: Who is this woman who makes up stories about dolls? Why can't she talk about her novels rather than about her mother and all these toys? Now I see those stories and that magical hour of show-and-tell as the fulcrum of our entire exchange. The Chinese writers who sat spellbound through Adele's talk about art and doll-making were neither embarrassed nor baffled by her performance. I'm sure they were relieved and exhilarated to find someone who could cut through the official bullshit and protocol to things that really matter, offering a folksy reminder that only our words and creations might save us all from the curse of stultifying ideologies. I'm also positive I saw the twist of a smile flash across Bi Shouwang's face when Adele held up an oddly matched couple and explained as she does in her book:

> *He's one of those French types you hear about,* mama murmurs, holding up a particularly elegant fellow with a natty tam, an impressively coiffed beard and moustache, slender long arms and legs, impeccable tailoring. *He looks after himself and dresses just-so, and he likes to run after women. His wife,* mama sighs, *she dresses smartly, does her best. What can she do?*

In another photograph, our interpreter, Wang Ronghua, who had to do far too much official smiling and glad-handing, is seen sprawled in an armchair in a memorably drab meeting-room, clutching an armful of Adele's dolls to his chest. Wang had been on the receiving end of the long procession of dolls that made their way around the room. He's wearing an expression of pure delight, one that reaches all the way back to childhood. If you look carefully, you can also see, draped over the grey slipcovered arm of the chair, the prostrate form of the philandering Frenchman, obviously worn out from his amorous adventures in the Middle Kingdom.

Adele believed in the sacredness of story-telling. Upon my return from China, I spent many hours as a guest in her house in Toronto, listening to stories, told first-, second-, or third-hand, shamelessly dredged up and recycled, but always with a slightly different spin. Her description of her childhood reveals how central her relationship with her mother was to her artistic development:

> She kept us on the long leash of an endless rope of language, looping and knotting us as firmly to her as ever she stitched edge to edge in a seam. She lassoed us daily and webbed us and gilded our lives with innumerable threads of prose. Words spun about us; sometimes the very air was afog with words that purled like a fine mist about our ears: stories and persuasions and fantasies and cajolings and adjurations and just plain fast-talking that fogged up your brain with ideas, intoxicated you, led you half-hypnotized where she wanted you to go.

In addition to Adele the conjuror, there was Adele the activist. She did not subscribe to the romantic view of the artist, but believed that what we were all doing was of vital importance and — what's more — perfectly natural. "The artist is not a freak, an oddity, atypical and apart," she insisted. "He is quintessentially

the eyes, ears, voice, the reflection of his culture. Your artist is your culture at the quick." She did not believe in the star system or yearn for individual "success," but considered art a collective force; she thought the desire for fame expressed a dysfunction. That is why she seldom referred to her own writing and spent so much time working on behalf of others — no dogged self-promotion, no jockeying for position. For her, creative activity was a means of growing personally and contributing to the collective maturing of society.

As I was to learn, beauty comes in many disguises. Adele, a teacher at heart, was no rough diamond; she was capable of the most exquisite thinking and writing and story-telling, a veritable dance of eye and heart and intellect, where monkey business, baggy socks and straw hats were transformed in an instant: "the dancer who soars and hangs an extra instant in the air defeats time, transcends possibility, enlarges possibility, challenges the limitations of known dimension." She hated anything that cheapened and dissipated the powerful effects that a writer might achieve. She rejected the prescriptive in art, just as she welcomed the unusual: "The artist is drawn towards the dreaded, fascinating frontiers of the possible. For it is here that he works out the potentiality of his being."

There's a photograph of me, too, holding up one of her mother's clown dolls with broad felt hands and feet, an exuberant ruffed collar, a baggy outfit made from old pyjamas, a shapeless grey wool-sack head topped with a silly squashed hat, a polka-dot nose and two staring button-eyes, below one of which are stylized tears represented by three threads. You can find a full-colour reproduction of this doll in *Old Woman at Play.*

> They say there are no new plots in the world. What is fascinating is to see in what terms every imaginative human being rediscovers and reinterprets the existent realities and shibboleths, what cultural influences are reflected in and reflect for her most validly her own perceptions, what images and metaphors appear

to the artist to be analogous to her own reality. How often, for instance, mama makes clown dolls, "because the children love them"....

—What's that, mama?
—It's a tear.
—Why's he crying?
—Well, you know, that's life. "Laugh, clown, laugh." His heart could be breaking.
—Do you want children to see him like that?
—Children don't cry too? See how nicely he's dressed? They can play with him.

Well, I had a lot to learn about "art as play" and about the sources of genuine beauty from this worker of transformations, who seems now to have been sent not to teach the Chinese about Canadian writing, but to give me some important lessons about how to live my life. Despite appearances, Adele was anything but ordinary, or "normal," though we obviously passed that test the day of her birth; she was phenomenally well read and capable of great intellectual sophistication, yet she was always willing to play the clown or the fool. Like her mother, she used art and laughter as a means of healing, of triumphing over suffering. While she avoided the literary scene, including reviewing and any writing that was merely academic, Adele was a master craftsman who delighted in the infinite variety and challenge of language and, as this anecdote from *Old Woman at Play* delightfully illustrates, in puns and wordplay of every sort:

The language of speech is such a superb medium, the very words we use are so freighted with emotional coloration and meanings, with imagery and symbol, that the process of stringing words together is also a process of suppressing and trimming away unwanted connotations so that we can communicate only what we think we want to communicate. But the inner

needs are "quicker." We think we want to say one thing but the very words we use and the way they suddenly come together out of our own mouths, can subvert our plans. We release all kinds of explosions, echoes, unintended confessions, cries and admissions in even the simplest things we choose to say, the very tones and modulations of the saying. Let me give a small example, familiar in kind to us all. The other day I was explaining to my husband that my sister had a new job in which she had to remove the genitalia of crickets for biochemical analysis. What I actually said, with great relish and enthusiasm, was "You know what she's going to be doing? Cutting the balls off critics!" To which he replied thoughtfully, "If she can find them."

The photographs send me back to Adele's warm and brilliant account of the trip, "How to Go to China (Core Sample from the Continuous Journey)," which appeared first in our collaborative book *Chinada: Memoirs of the Gang of Seven* and was later collected in her own *Memoirs of a Book Molesting Childhood.* Much of the playfulness I want to celebrate can be found in abundance in that essay, in which she describes herself variously as a "farmer," an overly attentive "kid sister" who's glad she didn't bother to read too much about China in advance, since she can just listen to the rest of us spouting what we've learned, and a quite mad Sinophile who has lost her ability to distinguish between the reality and dream.

The blue minivan had abandoned its unsuccessful ascent and taken a more manageable horizontal route through the back alley. The only signs of life in this post-glacial urban wasteland are a grey squirrel, puffed up against the cold and vibrating on the lowest branch of the maple, and a tall man in a parka with the hood up and snapped in front so it resembles the long snout of a bear. Nanook of the North. In a few days I have to head west to Kingston and Toronto. If the roads are clear again, I might drive.

I'm looking forward to doing that, as it will take me past my favourite road sign, announcing two small Ontario villages:

ODESSA–YARKER.

It always seemed such a great name for a literary character — someone with an air of faded elegance, wishing to be seen as exotic, yet somehow inescapably comic. Not surprisingly, Adele, who laid claim to China before we got there and argued so eloquently for the primacy of imagination in our lives, had already nabbed that name for a character in one of her plays.

Arlene Lampert was one of Adele Wiseman's best friends. I talked to her in her home the morning of the first of Toronto's Days of Action, October 25, 1996. She made coffee in a large sunlit kitchen, and we sat in a small, serene front room. Since we had never met before, my questions were tentative, but her answers were generous and full of warmth.

Elizabeth: How long did you know Adele?

Arlene: How long did I know her? *How* did I know her? Well, you know, *how* I knew her is very indicative of the kind of woman Adele was.

I knew her slightly from the early seventies — mainly because she and Jerry, my husband, [Gerald Lampert, author of two novels as well as *The Great Canadian Beer Book* (McClelland and Stewart, 1975), also founder of the summer writing school at the University of Toronto] were in the Writers' Union — that's how they met each other. We went up to her house a couple of times for dinner when she was living in Maple and they came to our house — we used to have huge summer garden parties — and that's pretty well the extent of *how* I knew her, *not* very well.

And then Jerry died suddenly in 1978. By then Adele had moved about four blocks away from me, and Tamara was going to parochial school, Jewish school. Adele had to pass by my house to take her and pick her up, and from just about the day Jerry died, Adele started coming to my house every morning. She came and she'd bring me stuff — she'd cook for me — she'd bring me things every single day.

She was tenacious — she wouldn't let me go. She called me over to eat with them, to have dinner with them. She'd ask, "Are you okay? Come eat with us — come and be with us." She just gathered me up in her arms. It was the most amazing thing — and then Margaret Laurence also did, and they became so important in my life.

Years later, I asked Adele, "What made you do that? You didn't even *know* me — what made you do that?" She said, "I liked you." And she became my sister, closer than a sister.

That's how I knew her — closely — from 1978 on.

Elizabeth: I didn't know Adele well, but that seems very characteristic of her.

Arlene: It was *so* characteristic! Just the way she was so open-hearted, so genuinely involved in other people's lives — it was not a hardship for her to give herself away this way. She wasn't sacrificing anything — but in a way it got very much in the way of her as a writer. She would have written ten times as much had she not been as drawn to people as she was to her work.

I used to yell at her all the time: "Adele, you're letting them take advantage of you! They're taking up all your time! You've got your writing to do!"

But for her that wasn't the case. I was putting my spin on it. It was equally valuable for her to be spending the time with other people's problems, other people's needs, other people's just plain good wishes.

She'd always stop everything dead for somebody else. There were times we were walking out the door to get somewhere — we had to be there at a certain time — and the phone would ring — and I'd just throw up my hands —

Elizabeth: She might not have had such a wonderful sense of character if she hadn't spent so much time with people —

Arlene: Definitely. She also had a wonderful ability to live in the

moment, so that whatever was supposed to be happening even ten minutes up the line would disappear from her the instant she got distracted, usually by someone else. I never heard her once say to anybody, "I've got to run," even if half a dozen people were standing at the door with their coats on.

Elizabeth: I'm really interested in Adele's poetry. Do you know why she suddenly switched to that form?

Arlene: I *don't* know what started her writing poetry. During that time I was living in Spain and California for about four years in a row. I know around '83 or '84 I was up visiting, and there was this huge manuscript of poems. I don't know why all of a sudden everything she wanted to say was starting to pop out in poems, and she didn't have an explanation for it.

I remember I went through it at that time, and took about two dozen of the ones I thought were the most publishable to California with me and sent them out to literary magazines, but nothing ever came of it.

Elizabeth: In some ways Adele's poetry is ahead of its time.

Arlene: It's totally outside of any time. It's not a part of where poetry's going, in a way, and I don't think it ever will be. It just flowed from her head, out her arm and onto the page.

Elizabeth: I think she was ahead of her time in using rhyme.

Arlene: It could very well be that she was ahead of her time. But I don't know why she was feeling out her poetic form — whether it's because she needed to be writing and her time was too taken up for a novel, or whether she just found it easier to get those thoughts out in a more concise way. At the time I know she had gotten herself involved with some other poets and was going to poetry readings endlessly, and so she might have just been absorbing poetry in a way she hadn't before.

Elizabeth: Have you read *The Dowager Empress?* [The long poem Adele was working on when she died.]

Arlene: Oh yes.... Isn't it in the York University Archives? It probably is now. [Tamara had sent fifty boxes of papers to the Archives a few weeks before.] Such a complex piece of writing — and so political and so ambitious — so intricate.

Elizabeth: Is it book-length?

Arlene: Yes, you could say that it is, a book-length poem. She had a lot she wanted to say about politics, about women, about moral issues — and she had a lot of it in that poem.

 Another thing about Adele was, the chaos she was comfortable living in would have driven me mad.... Her house was strewn with papers and bits — flyers that came in the door, little scribbled notes she wrote to Tamara and Dmitry, phone numbers of god knows who, little pieces of real writing, some really interesting pieces of literary stuff — actually, they all got scooped up and tossed into archive boxes.

Elizabeth: They're still there. (Laughter.) What do you like most about Adele's work?

Arlene: I *love* Adele's work. I personally like her writing voice, and then the characters are all so flawed and human and rough around the edges. I also love the language — the old Yiddish way of storytelling. It's fabulous in a true fable sense. Little things become big things just in the telling. There's nothing "high art" in her writing, just telling.

Elizabeth: What's your favourite book of Adele's?

Arlene: Crackpot. I'll tell you a cute story: she once went into a library to find it, and it was filed under "pottery." (Laughter.) I wish I had more to tell you about how special, how really special

she was.

Elizabeth: I hope that will come out in this book. It's quite a mixture of things.

Arlene: It should be a mixture — Adele was herself a mixture. She had a great love for opera, a great love for literature — and a secret sin for the back pages of the newspapers where all the murders and rapes were reported — she was always reading the gory details of the back page of the A section. I said to her once, "How can you read that?" She said, "It's life, Arlene, it's life."

She had a great big house on Rushton Road — have you been by the house?

Elizabeth: Yes. I visited her once.

Arlene: So you saw that she valued everything that was ever given to her. The house was always a complicated mixture of very good stuff and unbelievable junk, and all given equally nice places. Anything anybody ever gave her was always valued; it was always displayed.

But of course all her mother's dolls probably gave her that value for all sorts of things — Have you seen all her mother's dolls? Did you see the doll show?

Elizabeth: I saw a small version when Adele came to Kingston [where Adele displayed and talked about her mother's dolls].

Arlene: The big version [larger and more elaborate, many more dolls and costumes] of the doll show was amazing. Her mother was still alive then — Adele was dressed in one of her mother's concoctions made out of men's ties. Tamara was part of the show too. Adele would bring out a doll — you know how she did — and she talked about the background, a little bit about her mother's life, and little by little the stage filled up while she popped a doll over here, over there —

59

It was at the Bathurst Street Theatre, and they had all kinds of little tables and display stands around her, and then she would call Tamara out, "Tamara, bring me *this* doll." And Tamara, who was just a little girl then, also wearing one of her grandmother's concoctions, would bring out another doll, and another.

At the end Adele was standing with the curtain drawn behind her — she was surrounded by dolls — and she ended the show by saying, "This is my mother's world." And then the curtain went up and there was her mother sitting in a wheelchair with what seemed like a *million* dolls, and you could just feel this great intake of breath from the audience — it was too wonderful — the dolls hung from floor to ceiling.

Elizabeth: At Adele's memorial service, you spoke very movingly about the last days of her life and about her death and the gifts she had given you. You said you kept asking her how she was feeling, and she kept saying, "Sleepy."

Arlene: Yes, oh yes, I remember that so much. I wanted her to talk to me. I wanted her to tell me how dying happens. I wanted her to tell me how to die, and I asked her all the time how she was, how she was feeling — and most of the time she'd say, "I don't know, not too terrible, not too bad." But that wasn't what I wanted. Possibly that's how dying is — you don't feel any big momentous thing, you just feel tired.

And then I was surprised, when we were planning the memorial service — we had decided that we'd each read a little bit and talk about Adele — I was surprised to see, in *Old Woman at Play*, that she'd been asking her mother the same question.

I miss her to this day....

I'll tell you something weird. When she died, Anne Michaels told me at the shiva that during the funeral her watch stopped.

And a year later I was helping Tamara arrange the unveiling [of the gravestone, because Tamara was in Boston] — when we got to the unveiling, *my* watch stopped.

About a month ago, P.K. Page was in town and I was taking her up to the airport, and we were sitting in the bar waiting for her plane. And because I'd been busy with Tamara and sorting through Adele's stuff, I tried to talk to her about Adele — and I looked at my watch to see if it was time for her to get up and go to the plane, and my watch stopped *again* — and I said, "My battery must be out." But by the time I got into the car, it was going again, and it's been going ever since.

Now isn't that too weird?...

What else can I tell you?

When Adele had that brain operation [in 1986], I wanted to fill up her room with brightness. I thought she was so heroic to have had this operation, and really, it was so unbelievable to think that your brain had been taken right out of your head — and had been exposed to light for the first time —

And so I brought her this *huge* amount of bright yellow flowers. I went back in the afternoon — not one there! I said, "Where are the flowers?" She said she gave them all away, to everybody in the hospital. Every room had flowers but hers.

Such a darling! She was such a darling!

Adele at Banff, May, 1991. Adele (in hat) is second row, fourth from left. This picture includes may of the contributors:

FIRST ROW – Tamara Stone, first on right.

SECOND ROW – Caroline Adderson, fourth from right; Stella Body, first on right; Mary Cameron, second from right;

THIRD ROW – Ven Begamudré, second from left; Ingrid MacDonald, third from left; Rachel Wyatt, fourth from right.

FOURTH ROW – Colin Bernhardt, first on left, Don Coles, second from left; Steven Heighton, third from right.

63

Adele and Tamara at Consolation Lakes, spring/summer, 1991.
Photos courtesy of Carol Holmes.

ADELE AT BANFF
I
Don Coles

My friendship with Adele dates back only eight years and is centred in only one of the several stations in her always intense life-journey — the station called Banff, the Fine Arts Centre there — so this little memoir must not be confused with those of some other contributors, several of whom were, I know, much longer-term and more intimate in their relationships with her, a number of whom gave and were given more, most of whom I would think are women. Mine, that is, was a walk-on part, but it mattered to me and will go on doing so.

It began when she came to Banff during the "May Studios," which is a program for writers, a six-week period during which successful applicants live in the Banff colony and write and also work with editors on their manuscripts. Adele came for only a few days, to read from *Crackpot* and also from her *Memoirs of a Book Molesting Childhood*. I was one of several editors in residence and when we all went over to the Rundle Lounge in the Banff Springs Hotel after her reading, I managed a place next to her; we sat for some hours drinking margaritas before a large window looking down into the Bow River valley, even at night one of the privileged views of the world, and we talked. She was, as I remember with some disbelief, quiet-spoken, much more ready to agree than disagree, thoughtful. These are not, as others here may testify, the absolute first qualities that spring to mind when one thinks of Adele: this strong-willed, truculent lady. But it's how she was that night. She was also, though, I noticed, as the evening wore on, possessed of a

few beliefs concerning the writer's role, "values," I will call these, to which she held very, very firmly. They surfaced quietly enough that evening, but there they were; fully in place, it became clear; not negotiable, not to be messed with. I don't think I'll try to elucidate them here, it would be presumptuous or reductive or both. I liked every one of them very much. There seemed to be nothing in them at all that needed, in order for me to feel utterly at home with them, trimming, altering, adding to. I may have thought about halfway towards them on my own before that talk. I knew I was having a good time.

We now fast-forward a couple of years. Bill Mitchell is leaving as head of the Banff writing program; who is to succeed him? Numbers of names are tossed about, all of these are consulted, some of them back off and others eliminate themselves involuntarily. All of these are men, most are establishment figures, they are of a predictable social and religious orientation. But nobody's name is coming out of the hat. At that inaugural search-committee meeting I had suggested, when belatedly and only very mildly pressed, Adele's name. The suggestion had been noted in a kindly tone of voice which made it abundantly, yes abundantly clear that no further enquiry in that direction would be undertaken. This was, it must be said, a nothing if not patriarchal bunch. In saying so I do not mock them: the Centre had been unique on this continent in its generosity to writers, its physical situation, its canny management. You don't maintain a long-running operation of this kind, with its volatile clientele, its inevitable offstage critics, on smoke and mirrors. They'd done well, they'd survived; a worthwhile point to remember right now, with so little to be certain of; with the best lacking the odd thing, the worst full of you know what. But "patriarchal" they surely were.

So two months went by. There was a phone call, did one have any other names?

Well, no, just the same old name.

Thanks. They'd ring back.

I'll not drag this out, there were more calls, clearly lots of reluctance: this woman was not exactly known for her amenability; her track record showed trouble, there was the Writers' Union business, what was that *Crackpot* all about after all, there seemed to be as many enemies as friends, she was, well, she was a woman...obviously it was really, really difficult. Awkward. I'm guessing, but not wildly.

Finally they had to ask her. Well, not quite that, either. They asked if *I* would ask her. Yes, she told me, she probably would take it; but could *they* phone her? If it wasn't asking too much?

And finally they did, and she did, and then the future, all too brief, happened. She ran the program with a passion (an easy-to-pronounce word, that one, and hugely overused, but trust me, this time it's Flaubertian-exact) that lifted and energized everyone who came near her. Obstinate at times and difficult often, but never falling below her own standards, moral and aesthetic, and this is what we'll all, surely, remember after everything else.

If I have ever known an idealist, she was it.

Just one more mostly unrelated thing. The last thing Adele wrote may have been, I'm on the brink of saying "is," the best thing she ever wrote. I mention this not because there is any *sequitur* involved here, only because you may not have read it. It's a longish story, almost a novella, it's entitled "Goon of the Moon and the Expendables," it concerns three children in a sort of hospital/clinic for the study of exotic damage in children and it is variously funny, sad and as luminous as anything you have read all year. It exists at a depth, a deep-down place where the woman who wrote it must, I believe, have spent much more time than anyone who knew her guessed. I don't have many happy thoughts about Adele's last months, and again, there are others in this collection of memoirs

and essays who were more a part of those months than I was, so I'll speak no more of that. But I do have one memory of that time which gives me a pleasure I'll not lose: I had the sense, for once in my life, to write a note at a time that was right, I wrote a note to Adele telling her how much and why I loved that story, and I know she got it and read it because she picked up the phone and read it aloud to somebody the same day she got it, and that somebody told somebody else who, afterwards, told me. Nice of them both to do that.

II
Wingless, Fearless
Caroline Adderson

While in the check-out line at the grocery store I noticed, among the ninety-nine-cent booklets on astrological love signs and how to tone your thighs in fourteen days, one on the ubiquitous subject of angels. On the cover, the standard Renaissance figure, the gossamer and feathers which have always seemed to me inadequate considering the formidable angelic mandate. (Were I charged with illuminating manuscripts or daubing wet-plastered cathedral walls, I'd render my angel stout, too planted to topple, muscling around on the ground.) Skimming the booklet, I thought about Adele, because I'd been asked to write my memories of her and had been preparing myself by remembering. The reading and the remembering merged under the chapter heading "How to Recognize an Angel."

1. They go looking for it.
When I first met Adele in 1987, she had just taken over as head of the May Studios at the Banff Centre. I had applied to the program because I didn't know what else to do with my life. (Eight months before, I'd graduated from university and fallen directly into the arms of a Canada Council Explorations Grant and a boyfriend in New Orleans, but already I was back in Alberta, defeated by love and literature and nearly broke.) About half-way through the program it came out during a dinner conversation that everyone had a scholarship but me. It was my own fault for filling out the application the way I did, *proudly;* back then I really could live a month on six hundred dollars. But to Adele this was patently unfair, so she went looking for it. We could hear administration doors slamming, see her shadow thrown across Tunnel Mountain, fist raised to clobber. Then, two days before the end, I was summoned and informed that I would be receiving, retroactively, a scholarship. By the next year, everyone accepted into the May Studios got one — automatically.

2. Like your mother, they know best.

When I went back to the May Studios in 1991, the custom of a private visit with Adele had been established. We put a piece of writing in her mailbox, then, on the appointed day, climbed up to see her on the seventh floor. My story was about a persecuted family of Ukrainian immigrants, so I was confident she'd like it, but when we met all she gave me in the way of encouragement was a glass of beer and one of those long enigmatic looks. I might have been devastated had I not owned first editions of both her novels signed "...a real writer. Go for it kid!" and "...keep writing. I like it!" Other than that, she never praised my work. She also gave me no indication at all of her personal feelings for me. Although this made me insecure at the time, I see now she had her reasons. I was a bookless writer (as unqualified as one of those Renaissance angels would be wingless) and she, as the head of the writing program, Critical Acceptance personified. Yet I could not win her favour, not by my sentences or my charms. All I could do was write for myself instead. This personal focus eventually grew to be the centredness I needed to write a book. That's what she had in mind all along, of course — that we write books.

3. ...when they are least expected.

When Adele died I was writing a story set in the 1860s, poring over Dickens, trying to get an authentic first-person voice. Everyone I showed it to loved the use of language, but panned the story as a whole and was unable to tell me what was wrong. Then Adele appeared to me in a dream, speaking on the nose, in fact *looking down her nose.* "Doesn't anybody give a damn about plot any more?"

4. Afterward, you are made more generous.

Anyone involved in the creative process understands how much of it is a gift. We labour to ready ourselves, writing reams of shit and nonsense, and just when we are lost to despair, something swoops down. Intuitively we perceive that we have written something right, but we're perhaps unsure if we really wrote it. And we are grateful to have been unburdened of our suffering, to have shivered.

It seems to me that "mature" when applied to "artist" should refer not only to a quota of achievement, but to the ability to recognize a gift, feel grateful for it, then pass it on. I don't believe in supernatural beings, but I do believe in certain people having superior gifts to share. In Adele's case we had her writing, but also her loyalty, her mother-knows-best, her fearless muscling around.

III
Red Hat
Stella Body

It is a stuffy May afternoon. Calgary airport is tinged yellow by grimy overhead light, the habitual languor of luggage. The last bus to Banff has just gone. The terminal is almost deserted. I begin, again, to feel uncertain about coming here, about quitting my job to take a six-week writing program. I've spent most of my savings on the plane trip. Paying for a taxi will take more cash than I can spare.

I'm startled when someone pulls at my elbow. I move away, discomfited. The tugs come stronger and harder. Then my name, pronounced right first time, as it never is. I turn in spite of myself. A short, faintly moustached figure, in grey flannel trousers, a redoubtable red hat. Leprechaun? Shaman? Pushy travelling salesman? How does this man/woman know me?

Very, very well, it seems. The figure not only tells me who I am, but what I am, where I've lived, what matters to me. It matters to her also, she says, by way of reassurance. She speaks for fifteen, maybe twenty minutes. I still have no idea who she is. Then a tall, gentle woman arrives and introduces herself as Rachel Wyatt, the assistant director of the Banff poetry studio. "I see you've met our director, Adele Wiseman."

This breaks, but only for a moment, the spell of my "shaman"-ing. My brain does some quick backtracks, and I realize Adele must have read the poems and seen the required photo I sent in with my application to the studio. But I'm still quizzical. She's talked about things I haven't put into words, haven't ever mentioned to anyone....

A short while later, I find myself in the back of a shared taxi, squeezed against Adele, receiving at short range the bullets of her bright black eyes. "You're a dancer," she's saying. "You write like a dancer, you must allow it to show more when you read. Find a drummer, an accompanist. Jam, work with him."

But you've never heard me read, I want to say. How can

you know this? There's no need to say it, because at the same time I know, immediately, instinctively, it's true. I'd been hesitant to send Banff the dance-derived poems because they were about Africa. I'd worried about voice appropriation. I didn't belong to that country — what right had I to claim them?

They had come to me in an energy of sheer joy, written in sunlight, outside, in the wild. They had come from beyond me, looming huger than I was. They had welled up powerfully as sudden thunderclouds from a crack in the earth, the African earth. Yet I had curbed them with edits, read them timidly.

Now, for the first time, in the taxi, I begin to feel the poems don't belong to me, I am not the one to decide where they'll go. I begin to listen to Adele.

She's talking about my portfolio, but not the same way others have done. My U of T professors have told me to shelve the poems about Africa and nature ("too long, too unwieldy," "no editor will ever publish them"). Instead they coach me to make tiny, gemlike pieces they endlessly polish and repolish. The writers whose groups I've joined in the city haven't been comfortable with them either. They're working on perfecting the witty, slightly bent and streetwise, the kind of thing that makes MuchMusic. But Adele seizes onto what everyone else has dismissed. Seizes on and holds.

"This is the strongest stuff you have," she says, pulling, as if by miracle, copies of "See the Bushman" and "Beat of Life" from somewhere in her clothing. I take the pages, wrinkled, still warm, into my hands. They are covered in tiny hieroglyphics. "You won't be able to read my writing," she says firmly, "but you'll know what I mean."

And I do, somehow. Though, for the rest of the long trip up to Banff, Adele doesn't seem to be talking about my writing. She's telling me to watch the mountains, or rather, to *listen*.

"You can hear them," she says. "You better than most people. It comes from having lived alone, or knowing you're alone even when you're with others. I hear them too, every time I come here, usually when the cab reaches just about this spot. Yes, look at that one over there.... He's just like an elephant, isn't he? Look at

his wrinkled grey skin."

I look for a twinkle in her eye. *Is she for real?* I can almost hear a jibe from the paltry, magic-starved Queen Street crowd I've just fled. But Adele's not looking for a reaction. I'm astonished at how like a child's her face can be: buoyant, upturned, open to the light. Pure bliss. The power of it draws me. I follow her gaze along the high peaks. Gradually I think I begin to see, or hear, what she means.

Once we arrive, there's no more time to talk. I'm exhausted, and fall asleep after quickly unpacking in my room. I don't think about Adele's words again until the next morning. I wake, dress hurriedly and step out into the Banff Centre campus. Suddenly I realize how many choices I have here. It's a dazzling, intense microcosm of life itself. The clear, perfect northern sky, the sun beating a million crystal notes onto the air from the white peaks — all these mirror the brilliance of the people brought together here: artists, writers, musicians; and the urgency of my need to learn from them. I will have a short time here, as I have a short time on this planet — to take from it what I choose, to kindle the quick flame of my essence before I evanesce into nothing.

The insight is painful — a short, too-sharp breath of cold air. Yet a strange calm overtakes my brain's panic. Above me: impossibly smooth, snow-ladled, lifts Mount Rundle. Away from the busy campus, away from the plethora of commentators, editors and potential coaches. I find myself following a path deep into the mountains.

When I lived in the city, I'd take wilderness trips sometimes. My hand would nervously clutch my pen, afraid to let go, afraid to lose even a millisecond's writing time. Now I let my arms swing loose at my sides for hours. My body receives the whole imprint of where I am, the looming blue ink of the mountain's shadow.

I stay in Banff as a member of the poetry studio for six weeks in all. What I feel for, or with, the mountains, what I first began to feel in the car with Adele, returns for long whiles each day. My body comes to learn the rhythm of climbing, the way a

lover learns, and returns, to another's shape in sleep.

Each time I enter them, the mountains imbue me with a profound feeling of belonging, of connection with the earth. They reach through the tense sense-memory of the Toronto office I've just left, where each day my eyes would clamber the length of four small walls, over and over, till my brain tightened and buckled as if to close out the world for ever. Now I come back each day with my lungs opened, my heart glowing, the mountains' space expanding inside me. I write more powerfully than I ever have, far into night's deep space.

Playing through these hours, like a tune heard on the wind, is Adele's presence, as genie, friend, word-wizard. Each time we meet I receive a new infusion of passion. Words whirl from her like tossed firecrackers, words no one else uses: *shibboleth, flapdoodle, prolixity*. She sends me diving for my pen, paging through my dictionary for hours.

I fall into the pattern of climbing in the light, writing after dark, almost immediately. At first I'm worried about the rules of the studio — am I doing what I was brought here to do? In answer to this question Adele simply smiles in silence, turning it back to me. I see at once that the question's already been answered, is answering itself, even as I ask.

Some weeks later I'll learn that there was a problem with my odd schedule, several problems. Adele dealt with them all: quickly and, for me, unobtrusively. To the group instructor who wanted all writers to attend regular classes and crit groups: "This isn't school," she snapped. To the administrative officer who wondered how I managed to get into a security-controlled office with a computer every night: "Keys have a way of walking, isn't it strange?" To the cafeteria manager who bemoaned how writers were taking their meals away rather than having them on the premises: "Food for thought can be eaten anywhere, don't you think?"

As the studio session continues, the moments we spend together each day take on a kind of telegraphic intensity. Adele somehow can read from people's eyes where their thoughts will move, and pursue them there, with a quickness of lightning. Some-

times I appear at her door, sunburned, grimy, in the late afternoon, holding a sheaf of notes. She nods and accepts, needs no explanation. Sometimes she, Rachel and I eat together, long after the other writers have left, canteen loners in a companionable silence.

As my relationship with nature flourishes and my pen's confidence builds, I grow less shy of contact with others. At this point Adele gently shows me what's available: the informal evening readings she opens her own apartment for; the impromptu but startlingly memorable meetings she sets up for writers to meet artists in other fields. I start to attend these. I begin to see that Adele's presence, off-kilter as it always is with convention, even with the ordinary laws of conversation, is as charged with meaning for others in the group as it is for me.

Often I witness someone come into Adele's room, where she's busy answering the throng of young writers around her. She breaks off immediately to meet the arrival with her eyes, a lift of her brow: "And...?" The newcomer launches immediately into deep detail of a work-in-progress, work that Adele always seems to know by heart, instinctively, or the course it might be foundering from.

I also see how Adele introduces people — no names or roles, just an intense, vivid speed-speak of the paths each mind has recently followed. Where they might cross is left to them to find easily, now, as Adele's own eyes telegraph a powerful connecting glance between their own.

But what draws me and, I begin to think, the other students, increasingly to Adele is her fierceness, her mental courage. She's a warrior, no other word meets it; she fights tirelessly in the battle for freedom of the mind. We lie down in the pride of an intellectual lion, not just to lick our wounds but to watch her, learn from her, learn to hunt words. After my time with Adele, I know that whatever academics or conformist trendies I meet back in Toronto, I'll never be bullied again.

By now time is passing really quickly, and our session will be over in two weeks. It will end with public readings, for us to share our progress. These remind me how much my goals have changed since I arrived here. I won't be reading anything from the

manuscript I brought from Toronto, the poems I laboured on so long at U of T. For the radio portion, I've already taped some of the early Africa poems. With the help of the Banff Centre I find some accompanying drums, as the airport "shaman" urged. For the live portion, I want to do something with the very new poems, but I'm not sure what.

That night, I show the group "Apricot," a small poem I've written on campus. It began as an exercise I set myself, to explore the poetic truth of a simple object. Yet one of our writer/mentors, Don Coles, suggests that I pursue it farther, that it would probably yield a longer sequence. Adele immediately suggests that I take the poem to Colin Bernhardt, an actor and voice instructor who's here to assist the writers.

Not for the first time with Adele, I'm confused. A voice coach is fine, to help with an oral reading, but haven't we all just agreed that this poem is unfinished, that it needs more work? And the truth is that, although Adele is fiercely loyal to Colin, I'm a little afraid of him.

I haven't met him yet, but I've heard that, like Adele, he is a person of mercurial intensity. He inspires either instant, fervent admiration or a nervous shying away. In the long term, those who attend sessions with him are tremendously positive about what he helps them achieve. Yet men and women alike emerge from his office hushed, in awe, unable to describe what has affected them so powerfully.

On the evening of my appointment with Colin, it's only my respect for Adele that gives me the strength to steady my nerves and walk my reluctant legs to his office. A tall, dishevelled man lets me in. No furniture, only a few gym mats. When I try to give him the apricot poem, he waves it aside, gesturing towards the open floor. To my surprise, we begin by limbering up as dancers do, stretching slowly and far, waking each particle of the body with the blood's fire.

I soon relax into the smooth rote motions, as the limb-memory of my ballet years takes over. Gradually Colin begins to use the voice, our voices, sometimes I'm not sure whether it's his or

mine. And what he calls up is not the voice alone, it's something more, something that flows like a spirit, both our spirits, moving into one song.

Dreamily I notice the song's words are familiar, *smooth*, *flesh*, *silk*, *centre* — they are from my poem. Now Colin is holding the page I brought. He kneels at my head, reading aloud as I lie on the mat, never losing the chain of rhythm we've made. Slowly, as the mantra builds, I realize I'm answering him with new words, a host of them tumbling from my lips. I'm living in the poem. Held, now, completely, in its world. That world holds far more than I knew. A woman, a man, *murder*.

When I stop and open my eyes, the air is still whirling, orange and red. I realize I have been screaming. It takes a long time for the small grey room to return. I feel fear, fascination, recognition. Wonder at the powers of life and death, woman and man. Even in silence the room throbs, like an empty stage when the players are gone.

I understand what I have to write now. The words don't belong to me, they are an energy that moves through me, the way music expresses itself through a dancer's limbs.

The poem I must write is about apricots, but also about a woman, the Duchess of Malfi. More than three hundred years ago, John Webster wrote a play about her. In the play, her jealous husband uses apricots to test whether she has become pregnant while he was away, then kills her and the unborn child. In the poem I write, Webster is a conspirator in her death:

> Her husband's friend, the playwright
> loops his rope of ink....

There's a knock at the door. Colin looks apologetic. "It's probably for you. I think they just want to make sure you're all right." I vaguely remember seeing a cleaning woman's alarmed face at the window. She's outside in the hall now, with one of the other women writers. I tell them I'm fine, giving them what must seem like an utterly crazy smile. Then I thank Colin, and go away to write. I

don't stop for many hours. The new version of the apricot poem arrives whole, a birthing. On the last night of the writers' program I read it aloud. I am struck by how definite the poem's ending sounds, as though, more than the closure of one piece, I am voicing a finality which we all feel and can no longer avoid:

> She eats the golden, generous flesh
> swallows light, widens, grows
> while her husband
> narrows
> to his sword's tip.

On this, our last night together with Adele, her cancer is a secret we can no longer ignore. One of the youngest women writers sobs almost throughout the evening. Others in the group decide to live together, travel together, keep the studio, her studio, going. We all exchange addresses and make plans to keep in touch.

But Adele's kept the illness hidden so well from us — her quick wits, her determined clarity — that several of us refuse to believe in it. Back in Toronto, we go on calling her, making plans with her, until just before her death. And when she is gone, it's not her fading voice on the phone I remember. It's all of our voices, reading, that last night in Banff. In our words, in her energy that still moves through us, Adele *lives*.

IV
Interview with Steven Heighton and Mary Cameron

Mary Cameron and Steven Heighton were participants in the May Studios at Banff in 1991, the last year Adele Wiseman was physically present as director. I spoke to them on December 19, 1994, about their experience at Banff and their impressions of Adele.

Elizabeth: There are quite a few memories of Adele at Banff in this book, and they're all written for people who know what it's like. So please tell me your first impressions of Banff.

Mary: I got there very early in the morning because I took an overnight bus from Vancouver. I thought that would be a romantic way of travelling — through the mountains, on the bus — but it was tiring. I arrived at six thirty in the morning and apparently there had been a convention of masons the night before and I had to wait for my room — so it was difficult to arrive. I went from lounge to lounge and slept on the sofas, and I didn't know where I was, and everything was more like a hotel than I'd imagined it would be, more impersonal. In that way it was just the opposite of what the May Studios turned out to be, which was incredibly warm and enriching —

Steven: My first feeling was one of surprise at finding myself so free. When I was going to university I worked in Jasper or Banff pretty well every summer, so I was used to going out there and working really hard, in restaurants, mostly, as a waiter or dishwasher or busboy, and doing a bit of hiking on weekends. But when I arrived in Banff in '91, I suddenly found I had all this time free. It was like being in a kind of playground or paradise where you have no need, temporarily no need, to worry about money, and certainly no need to worry about the usual mundane exigencies of life. So I just felt totally liberated.

Elizabeth: What were your first impressions of Adele?

Mary: The first time I saw her was at the meeting we had the day after we arrived, when all the writers gathered. I thought she was an incredibly powerful-looking, stocky, solid woman, somebody who would definitely put up a fight. I thought of Norman Mailer or Irving Layton; physically, she had that fire in her face.

At that meeting I think a lot of us were nervous — I was, anyway — about being there and whether I'd be able to do as much writing as I wanted to, whether I would write at all. One of the first things Adele said to us was that even if we didn't write a word, she knew the experience of being there would be valuable to us as writers. There was no pressure on us to produce. We could just wander, use the library, talk, if we wanted to.

There were twenty of us there, with a wide range of experience and publishing history, and I felt that perhaps some were wiser than others, and I felt uncomfortable about that — but Adele was immediately on equal footing with everybody and made us feel equal. One of the things she said was that writers aren't necessarily wise people, but they are incredibly sensitive — they're aware of what's going on around them, picking things up, reacting like barometers to changes around them. So you didn't feel that you had to be the smartest person in the world — you would rise and fall with the emotional weather. So that was reassuring.

Elizabeth: I spent the whole six weeks worrying about those things.

Mary: It was the exact right thing to say. She seemed to intuit just what we needed. It was a very compassionate thing to say.

Steven: My first impression of Adele was probably different from other people's because I arrived four or five days late and missed that first meeting. I didn't even see Adele for about a week after that. I kept hearing about her, so she became this kind of mythical figure in the course of a single week. She seemed to figure in the minds of most of the other people there for the May Studios as a kind of powerful *materfamilias;* but to me she was mythic and distant.

81

I didn't really meet her on a one-to-one basis until the end, when I talked to her for two or three hours in her apartment.

When I first saw her, my impression was of a gospel singer — a big, strong woman who looked like she could pick up a microphone and belt out a Mahalia Jackson number. She had a kind of intimidating look, as if she wouldn't suffer fools gladly. When I first spoke to her, I remember being nervous of saying something stupid — and undoubtedly I did within a few minutes. I'm a writer because I'm not a good talker, after all; but she didn't say anything to make me feel that. She was tough, but she was never rude. She could be curt without seeming rude, and there aren't many people who can do that. I think it's because you could sense there was real compassion under that tough exterior; and what she said was so helpful.

I sensed right away that she would be really honest with me — and since I've always sought out honesty even though it hurts initially, I knew I wanted to show her some writing. I knew she wouldn't beat around the bush and say, "Oh, this part's good here, but you know, I'm not so sure about this." I knew she'd say exactly what she thought, and sure enough, when I did show her a story I was working on, she invited me up, and we sat there and talked for a few hours. Actually we talked for an hour about the story, and she was direct and unsentimental and very helpful. And then she started telling *me* a story, and she talked for about two hours about being moved around from house to house when she was writer-in-residence at Windsor. It sounded like a crazy situation. I think there was a sense of grievance, but it wasn't the kind of story you get from someone who's simply aggrieved.

Mary: I think it may have been something she was talking about a lot.

Steven: She was certainly hurt about it, no question.

Elizabeth: What story were you working on?

Steven: "An Apparition Play." She was very direct, no nonsense. She just said the first three pages could be done in one — that was about all she said — she liked the rest. She said "You're beating around the bush here, just get right to the point." I thought that sounded so much like what I expected her to say — and then she burst into "Didn't It Rain" — no, just kidding. (Laughter.)

Mary: I never had the feeling from Adele personally that there was any difference between her as a writer and us as writers, I felt that we were all in it together, and that it was as tough for her as it was for us.

Steven: It just occurred to me what she reminded me of. At one group meeting in her apartment near the end, Adele was sitting in her huge chair and Tamara was sitting at her feet, and Adele had both hands on the arms of the chair — she was sitting back with a sort of magisterial expression and saying nothing. It reminded me of the Queen of Lahaina in the film version of Michener's *Hawaii*, which I saw years and years ago. I just remember this wonderful queen saying, "You come, Lahaina," in this powerful resonant voice, and she's so big and happy and confident. I remember thinking she was just like that.

Mary: Like a pugilist but also like a mother who fights for her kids —

Steven: Quiet, but with that look of fierceness —

Mary: Right. But I guess when we were there she was also quite ill, and that's probably why we didn't see a lot of her. She would walk down to the town of Banff a few times with Tamara — but I had the impression that she was keeping to herself a fair amount and was working on her own writing as well.

Elizabeth [Following a discussion of postmodern writing]: Adele fits into the postmodern very well, but she somehow gives the post-

modern life. It's very easy for postmodernism to be all in the head.

Steven: Exactly. I don't care whether writing is modernist, post-modernist or even conservative and old-fashioned as long as it's from the heart and it's passionate and *com*passionate. The world doesn't need more intelligence; it needs more love — or no, it does need more intelligence, but it doesn't need any more *cleverness* — it needs more love.

Elizabeth: Can you make any generalizations about the sort of writers or the sort of writing at Banff in your year?

Steven: I couldn't. It was really varied. That was one of the great things about it. I think they chose writers with a view to variety — I really do — and it showed. So there were no cliquey alliances that formed along stylistic lines — or generic lines — there was too much diversity for that. There were theoretical writers, romantic types, "tough-tender" writers, lazy writers, all-night writers.

Mary: When you were there, Elizabeth, did people talk about the midnight energy coming from Tunnel Mountain?

Elizabeth: The midnight what?

Mary: Midnight energy. I think Adele talked about it too. I don't know if she was into mystical stuff, but people talked about how Banff was a powerful sacred area to travel through. Some people talked about waking up in the middle of the night and feeling strange —

Steven: Really —

Mary: — but it could have been just a generator.

Steven: — and maybe it's a magnetic mountain. Why is it called Tunnel Mountain?

Mary: Well, there's a tunnel.

Elizabeth: They were going to build a railroad tunnel and they didn't finish.

Mary [returning to the midnight energy]: It may be partly because it's very dry —

Steven: Just excitement. I found there was so much stimulation — intoxicating — so many new people — the sense of liberation. And since you've been brought out there as a writer, you feel like a writer, maybe for the first time.

Mary: You don't need as much sleep.

Steven: You don't need much sleep at all. There's a kind of energy and desire to be awake jolting you up.

Mary: And also I found you couldn't help but examine where you were in your life, personally, as well as your work — because all you had to do was think about your work, and doing that you always think about yourself. It becomes a real personal challenge. If you're in any kind of dishonest place, or dishonest relationship, you can't help but be faced with that.

Elizabeth: It keeps you up in the middle of the night.

Mary: Bolt upright! (Laughter.)

Elizabeth: Partly because everyone was so honest at Banff — it really makes the dishonesty you may be dealing with back home more obvious.

Mary: But it's strange that everyone's so honest — they don't have to be.

Steven: I think it's the kind of honesty you get when you hitchhike. You find yourself sealed in fast-moving cars with total strangers — and often you find yourself exchanging all kinds of intimacies and confidences. There's nothing to conceal. You have no vested interest in hiding anything, so you can be totally honest. In a sense, we were locked together in a moving vehicle at the Banff Centre — it's a place outside of time.

Elizabeth: Do you think Adele had anything to do with this honesty?

Steven: I think she probably reinforced the honesty that would have been there anyway — because she seemed to set a high standard of honesty and integrity.

Elizabeth: What was your impression of Adele as a writer — just from seeing her at Banff and hearing her read?

Mary: The reading she gave of the long poem *[The Dowager Empress]* was quite wonderful. I admired that she was doing this eccentric, heroic writing. She didn't appear to care about contemporary conventions of poetry, or about what might be expected of her as head of the writing program. I thought it was spectacular. I remember it as a wonderfully colourful, fantastical long sequence, though I can't remember what it was all about — colourfully plumaged birds —

Steven: That's right —

Mary: Kings and queens, brocade, long Chinese gowns —

Steven: Organdy — lots of organdy — I thought pretty much the same as you — that this was a really eccentric poem, a remarkable show of unselfconsciousness. I'm sure a lot of people in the audience may have been thinking, this is really weird — is this modern poetry? But she obviously didn't care. She would be aware that this

was unconventional, but she was having a great time reading it. I've been self-conscious all my life, so I was really impressed, and envious, and desirous of emulating that confidence — that "take me or leave me" — that's the way to live your life.

Mary: I remember Adele's voice as gentle and warm and with that straightforwardness, with no sense of her being the head of the program.

Steven: Now that I think of it, I can hear it again — not gruff, as I thought at first. A bit nasal — and yes, she could be very gentle.

Mary: She had a hat collection. It was her birthday when we were there, and we wanted to give her a thank-you and birthday present.

Steven: We gave her a hat —

Mary: A couple of us went down to town and bought a purple felt hat with a green band. She loved it, and she wore it — so we must have given it for her birthday. We were there another two weeks.... Do you know when she died?

Elizabeth: June first. We all got back from Banff May 30, and Rachel called her, and she asked how it had been and Rachel said, "Wonderful," and she died the next Monday. It was as if she was waiting to know that it was over and it had gone well.

Mary: When I got back from the session a year earlier, I got a phone call from somebody in Toronto who'd been in the program saying that Adele was really ill and wasn't expected to live much longer — I think a lot of us wrote her at that point.

Steven: She lived a lot longer than they were saying at that time. I got the impression from the letter she wrote me back that she wasn't really all that sick, so I ended up feeling I'd written prematurely. They'd made it sound really dire, as if she had only a few weeks to

live, and she lived for almost a year after that.

Elizabeth: What effect do you think Banff had on you when you look back on it?

Mary: I think it changed me profoundly. It had a very transformative effect on my writing in that up until then I'd been toying with the sound of poetry, and I had gone to Naropa in Colorado where Allen Ginsberg and Anne Waldman teach, where the emphasis is on spontaneity and simplicity, "First thought, best thought" — but at Banff there were so many people who were so serious about their work, as well as having a playful time and being really open and living fully. There was a strong sense that writing *had* to connect with the reader, and elicit emotion. Up to that point, I hadn't really thought of that — I'd been merrily playing an instrument. It made me stop and think about taking responsibility for what I was setting down.

I appreciated the fact that everyone took one another's work seriously — we traded manuscripts and gave each other comments, as well as working with faculty.

And personally, having the space, the quietness, the environment of honesty helped me figure out the things I wanted to change in my life — the places I wanted to go, and leave. It gave me a sense of freedom that I wasn't aware of immediately, as Steve was, but on leaving I knew some things had opened up for me. A lot of us became really close there, and some really good friendships developed.

Steven: I found that the atmosphere of honesty brought my own failings as a writer and as a man into high relief, so that I left there more determined to live honestly...and to write honestly.

Elizabeth: Did you sense any religious or spiritual dimension at Banff?

Steven: I did — because I've always had a kind of spiritual attach-

ment to the mountains since I first saw them when I was about five. Sometimes you see landscapes for the first time, and they strike you as a kind of external reflection of the inner contours of your spirit. I've always felt that the mountains were that for me, so I worked there through college, as I said, in the summers.

Mary: I remember experiencing some strong moments of synchronicity and of being in exactly the right place at the right time — books appearing that were extremely necessary — lines arising — There was a Rilke poem that a group of us discovered that we'll carry with us for the rest of our lives, "The Archaic Torso of Apollo." The last line of that poem is "You must change your life." That was the message of Banff for me, that piercing gaze of art looking back at you.

Steven: The mountains carry the same message.

Mary: Yes. They're just so immensely *there,* without ornament.... On the very last night a few of us ended up on the roof of Lloyd Hall — it was probably the middle of the night or early in the morning — and we looked up and there was an amazing display of Northern Lights. It seemed like the lights were circling all around — we were at the centre-point of this wonderful display. And down below on the walkway was a group of young dancers who had arrived a day or two earlier, and they were all lying down on the pavement and whistling to the stars. We just looked at one another and said, "Of course," because this was yet another amazing soul-opening moment.

There were very few cynics among us, which is probably why some of us were able to feel so open and vulnerable, protected by one another.

There was a contest held every year for the Bliss Carman ring [for the best writer] — and we got together and decided that we didn't want to compete because we felt so close to each other. So they didn't give the award that year.

Steven: I think that's great. I think that was one of the best things we did.... It just occurred to me, Adele was sort of like the mountains — craggy, magisterial, powerful — and something else —

Mary: Igneous —

Steven: Patient. Yes — craggy, magisterial, powerful and patient. I want to say that. Will I be able to look at this interview?

Elizabeth: Oh yes, I'll show it to both of you.

Steven: It's not just a matter of wanting to sound elegant — it's wanting to tell the truth. When I talk, I try to tell the truth, but I don't quite get it right — clear — the way I can in my writing. Some people think you falsify the truth when you rewrite, but I think you're getting closer to what you really want to say, what you don't have the skills to say the first time.

Elizabeth: I think at Banff you were really encouraged to get at the truth and that was part of being a serious writer. There was a sense that there was a truth you could get at — you really wanted to get there, and you would just keep trying, however close or not close you came —

Mary: And a sense that it might take a long time —

Elizabeth: It would take time, but you had it.

Mary: Maybe that's part of what Adele meant that if you didn't write a word the whole time you were there, the experience would still be valuable for you. You'd get that sense of truth. You'd be clarified.

V
Ven Begamudré
Adele Here, Not Here

Hope Park Square, Edinburgh; February 1996
Last August, at the Sage Hill Writing Experience, Elizabeth Greene
asked me to write this brief essay since I had participated twice in
Adele Wiseman's May Studios at Banff. After returning home to
Regina I made a number of false starts but now, even farther from
home, I feel ready. At last. This is not surprising, since the Banff in
Canada was named for the Banff in Scotland, and there are many
other links besides. There is one other reason I feel ready to write
about Adele but it will have to wait. I will admit I cannot claim to
have known her well. I knew her for only five years and yet, as she
was to me then, so she is now. Adele is here, not here.

We first met at a conference in Saskatoon in the spring of
1986. We met for all of thirty seconds.

I was walking past a table when one of our mutual friends
(I am sure it was Lorna Crozier) waved me over. After introducing
us, Lorna told Adele, "His first book's just come out." Of course, I
grinned. I had been grinning all weekend. Adele grinned back. She
looked me in the eye, nodded ever so slightly and said, "Congratu-
lations." I rocked onto my heels and said, "Thanks." Then I was
off, buoyed even more. To think a famous writer would be so pleased
for a perfect stranger, a beginner at that. A grin. A nod. "Con-
gratulations." Sometimes, this is all we need.

Now, ten years later, I find myself in a gabled study in a
Scottish institute; in an eighteenth-century stone house. I have the
luxury of pondering essays by Raymond Carver, interviews with
Flannery O'Connor and poems by Norman MacCaig. This evening
I will attend a seminar by a fellow-in-residence and, afterward, we
will sip sherry. As the poet Jay Meek once wrote, "This is every-
thing we are sailing for." Why, then, am I losing my faith in the
power of words?

In the late 1980s I met Adele for the second time, when
she read at Regina's Dunlop Art Gallery.

She read about dolls, and she perched two or three dolls on the edge of her lectern. We laughed with her when they refused to sit up. What I remember best about this meeting is her shape and size and colour. She was short and stocky, and she wore a bright red pant suit. She reminded me of a billiard ball. Not a flattering comparison, perhaps, and yet, in light of what I later saw at Banff, it feels apt.

Physics tells us that when a moving ball strikes a stationary one, the first ball imparts its energy to the second. But the first billiard ball pays a price, so to speak. It may continue in the same direction, though with reduced energy. Or it may continue in a different direction, also with reduced energy. Simple reasoning tells us that, ignoring the sound and heat generated by the collision, this reduced energy should equal the amount transferred to the second ball — to overcome its inertia and to get it moving. To overcome inertia, most of all. Sometimes the striking ball comes to a dead stop; yet I have never seen a good or, more important, a lucky teacher come to a dead stop. This is where the comparison breaks down, thankfully, because a good teacher absorbs as much energy as she imparts.

Not that Adele really taught. Not that I saw. She made things happen, and she did not so much strike as nudge.

I attended my first May Studio in 1990 but Adele was not in Banff that spring. She was ill, perhaps even undergoing surgery, and we received weekly reports through the co-ordinator, Dawn Lowney. I did not know much about the Banff program, but I did know Adele had begun attracting faculty and participants who, before she had become director, might have been tempted to go elsewhere. I also knew that mutual friends had encouraged her to borrow aspects from other writing programs, like the one at the former Saskatchewan School of the Arts, which lives on in Sage Hill. Yet what struck me most was how, even in Adele's absence, the program was still hers. Unlike the people who knew her better than I did, I did not hang on the weekly reports. Some were worrisome, others reassuring. I am not a man who is easily moved by tragedy, but this was the spring Adele and I truly established the

odd relationship (I cannot presume to call it a friendship) which has survived her. She was here, not here.

The following spring, in 1991, I was back at Banff for what would be my last May Studio. Adele was there as well. With her hands full of administrative battles, she left the teaching to Rachel Wyatt, Don Coles and other faculty, but I believe she met with every participant at least once. I was nervous when she asked me to show her something, but I did give her a short piece I thought might be a poem. We met in her skylit suite, she poured me a glass of wine and we both admired the view. Then she sat, planted her hands on her thighs and said, "Now."

For years I had written poems in secret, usually one a year, and rarely shown them to anyone. The one I did show her was called "When We Are Old" and, despite the *We*, I had never shown it to my wife. It was about the son we had lost, five years before, without even having known him. This happened the very spring my first book came out although, until today, I have never linked the two events. The only image I recall from the poem is of rocking chairs. I am not even sure of this, since I have not looked at the piece since I showed it to Adele. She commented on it not as a poem but as the kind of writing we all do which need never appear in print. Since then I have caught myself writing about our son more often than I ever thought I would. Most of this work will never appear in print, if only because most of what I write never appears in print.

Having said I am not a man who is easily moved by tragedy, and having said I am losing my faith in the power of words, we reach the real reason I may now be able to write about Adele.

This old stone house faces a park called The Meadows. Directly in front of our institute gate are tennis courts. Next to them is an area bounded by a low fence. Often I sit on a bench facing a green sign which reads "Toddlers' Playground," and it gives me a strange comfort to watch the children at play. A few days ago it dawned on me that, sometime this month, our son would have turned nine. This means he would now be far too old for the blue swings and the seesaw and the red slide. There is a strange comfort

in knowing he would no longer want us to keep an eye on him; to ensure he is safe.

The memories we carry linked, like tiny golden chains. I do not think of him every day, or every year at just this time, and yet now, in a Scottish February which has brought us cold winds and blizzards and then warm, sunny, springlike days, he too has become like Adele. He too is here, not here.

VI
Colin Bernhardt

"Adele.... Adele..... Adele would like.... Adele thinks.... Adele says.... Adele wants us to...."

The Writing Programme at Banff belonged heart and soul to Adele while she ran it, even when in the last years Rachel Wyatt stood in for her because she was unable to be with us for much of the time. In her absence we were still always aware of her strong feelings about everything: about the timetable, about the balance of the program, about the needs of this or that writer, about the qualities that a particular teacher brought to us. There was always that crusading energy in her leadership, along with a wonderful tenderness and a real skill for sniffing out talent and bringing it along.

I was lucky enough to be brought into the program early in her regime. I had been teaching voice and speech in Banff's Music Theatre Studio Ensemble, and in the summer Musical Theatre Division. From knowing my work in these programs George Ross, who administered the writing programme at Banff, hatched the idea that the Banff writers — who had to give readings of their work and (like many writers) were not always much good at it — might gain from having a voice teacher. Don't we often talk about writers "finding their voice"? Perhaps I would be able to help writers not only read their works but even find their writing voices. Adele liked the idea, and to my surprise welcomed me into the faculty.

One of the first classes I gave was to Adele herself. And from then on she insisted that every participant experience as many classes as possible. The following summer she asked me to teach Tamara, and we three developed a kind of bonding among us, sharing many meals at Banff Springs and elsewhere. Tamara's acceptance of the classwork was a litmus test for Adele, and for the work we did in the program together.

In her last year Adele accepted my invitation to come to Acadia University in Wolfville, Nova Scotia, to give a reading and

to spend time with our drama students. She was already suffering from her mortal illness, but still determined to conquer it, and still a joyous living force. She read in a ringing tone from *Memoirs of a Book Molesting Childhood and Other Essays* — and those of us who were there can still remember that glorious hour:

> When we were strangers in the land we made our own welcome and warmed ourselves with our own laughter and created our own belonging.... I was a child then.... To us below, identity smelled loud as voices....

Later we presented her with a staged reading of parts of her play *Testimonial Dinner*. She kept us roaring with laughter as she told us about each of the characters, and the people on whom they were based. She was generous and grateful, and warm in her praise of the students and their work. But then, for Adele, generosity was like breathing. Wherever she went, she took with her a shining energy. Her small stature, her hat perched at a determined angle, her courageous steps, her wonderful smile, gave us all a sense that we were warming our hands at a vital fire.

We worked together in Banff one more time the following spring, but after a few days her illness forced her to return to Toronto. We made plans to meet there later in the year and work on her early play, *The Lovebound*. But it was not to be. The manuscript still sits on my shelf. "Do whatever you want with it," she said. And one day I will.

I open our guest-book, and there on the page, in her vigorous hand, I read:

"November '91 Adele Wiseman — lovely — Toronto."

Yes, lovely indeed.

Excerpt from the Margaret Laurence
–Adele Wiseman Correspondence
(letter on *The Lovebound*)
annotated by John Lennox and Ruth Panofsky

Elm Cottage
12 September 1964

Dear Adele:

Where to begin? First, I hope you got my cable okay.[1] I thought that my first reaction to the play simply could not wait for 7 days or however long it takes an airletter. Which may be silly, but that is how I felt. Anyway, I think the play is terrific, Adele, and I also think it is one of those plays which communicate various things to various people — reactions can be, legitimately, as varied as readers, because one tends to take from it the things in it which are closest to oneself.[2] That is true of every work of art, probably. For me, the two things which emerged the most strongly were: the beautiful way in which each character comes across on both levels — i.e. the symbolic and philosophical, plus the human individual flesh-and-blood level; and secondly, the way in which an absolutely straight appraisal of the human condition is possible, without any false idealism or sentimentality, and yet with a final affirmation of man's worth and value.

Previously, before I read the play, I had felt for a long time, as I told you, that it might be a good idea to have it published even if it could not be produced immediately. I now freely admit that I was wrong. I can see now why you have felt, yourself, all along, that the thing *had* to be produced. It does have to be produced. That is its natural medium — the theatre and the human voice, and it demands production. I think it comes across well in reading,

and that it should also be published, but I feel very strongly now that it must be produced. Bob Weaver wrote to me recently and told me (among other things) that he and Esse Ljungh[3] were considering the play for radio and also that he hoped to show it to some theatrical groups in Toronto. I'm very glad, and hope that something may come of it. The only question I have about radio is that I think it would be better for TV, and best for stage, as it was intended. I think something would be lost in a radio production — maybe because I would like to *see* Hitzig and Yesh and Marina, etc. Especially Hitzig, who *must* be seen. He is seen, in fact, in the mind, but one feels that a visual production would present the thing as a total effect.

The humour is good, true, sharp, and points up in some way the pain of the whole. The play is painful to a really terrible degree, by the third act, but the final impression is one of affirmation of the individual's ability to earn his humanity, as well as a recognition of the evil (what else can you call it?) inherent not only in *them* but in *myself*, for what the play really says in the end is that it is never only a question of *them*. At least this is what it says to me.

I found the portrait of Cass a very frightening one, simply because he is capable of such deception and self-deception, and sometimes in dealing with this kind of thing, both in others and in oneself, one gets the feeling that it is very difficult to see him (it; these qualities) in any sort of honesty...that one is in great danger, always, of being taken in. The individual man came across as both dangerous and pathetic (the poetry he attempted; his latching onto "his art," etc.) I also thought it was fantastically good the way you conveyed the insecure man's lust for power, combined with his basic fear of actually seizing power, combined with his violent fantasies, combined with the way in which he hid his *real* cruelties from himself; combined with his sado-masochism, which is always an attribute in some way or other of the authoritarian figure — this was brought out to just the right degree, in the scene in the cabin with Dora, where he begs her to punish him.

Nix I saw as Cass's more clearly dark self — the devil, in

fact, cynical and un-human in an almost bewitched way, and this was one of the things in the play which for me had some echoes of Moby Dick. Other echoes of Melville — the references to Leviathan, I *know* the Biblical background of this, but in this setting it has for me connotations of the white whale as well, and the speech of sudden intense poetry of some of the passengers and crew. I think that these, plus Old Testament references, enrich the whole thing. When I say "echo," I do not mean you are purposely echoing anyone, not Melville or the O.T. — simply that these things, as one's roots, are *there*, and that they strike chords in the reader's mind, and reach deep into hidden places.

The character of Yesh comes across very movingly as himself, and very effectively as a kind of Jesus figure. This aspect is excellently done, because it is never overdrawn, never hammered at — it is suggested simply and with dignity, and left at that.

Abel, who is The Man, comes across with a kind of growing power. At first, he is only himself, a young seaman who is unsure of himself, who isn't the kind of man you would notice much, one way or another. He grows and develops in the reader's mind as he grows within himself and discovers that humanity has to be earned. Both sides of him (both as Abel and as The Man) are shown with honesty — no attempt is made to slur over the dark side or to evade the genuine love of the man through fear of being thought too emotional (this is a great fear of writers now, I think). The thing about Abel is that he actually is capable of destroying the child. In panic, in desperation, in a state of semi-hysteria, he could have thrown the child overboard. He could have done it. He didn't, but that isn't the point. He is shocked, himself, when Marina sees something about him that he doesn't see himself. On the other hand, he is also capable of going with Marina and dying with her because — is there ever any other reason? — he loves her. His dual nature has to be accepted, but he is portrayed as a being who possesses free will. He can choose. He cannot help containing within himself the component parts of good and evil (or whatever words one chooses to describe the creation and the destruction), but he can *help what he does.* He is a broken reed — he isn't a hero; he

could capitulate at any moment. But he can choose love rather than hate. And once in his life, he does. He is tremendously moving as a character simply because his role as everyman is always and at every moment accompanied by the recognition of him, by the reader, as himself, as Abel Green.

Hertzl [*sic*], to me, has some suggestions of Abraham in "The Sacrifice," and possibly this is because (although they are totally different men in so many ways), both contain the strong traditional faith. Herzl and Hitzig, as brothers, seem to me a fascinating presentation of two facets of the Jews...the traditional religious aspect, strong, moving, sometimes oddly archaic and yet with a phenomenal ability to survive; and the contemporary aspect...cynical, ironic, and yet in the end with a compassion hidden under wisecracks and a kind of bitter wisdom.

The character of Hitzig is the major character creation in the play, in my opinion. I think he is marvellously developed — his initial toughness and accompanying innocence, his gradual realization of the situation's reality, his temptation to get himself out and to leave the others, his final affirmation of his belonging with them, whatever happens, and most of all, the depth of the man's love combined with his constant seeing of himself in all his ludicrous aspects and his absolute lack of phoniness and his wry wisdom. His growing love for Dora is beautifully done — this love affair is the reverse of anything romantic, and because of this, it is (to me, anyway) enormously moving in all its odd ways — it is ludicrous, mad, humiliating, exultant, plain and earthbound, two middle-aged people who are both very far from gods, goddesses, heroes, heroines (such as the tales Hitzig spins to Dora) — and yet in some way in the end it becomes Love itself, a mystery like creation. In the end, it is only love (the only direct contact with others, the only means of recognition that Others exist) which binds men to life. "Lovebound," finally, seems to me to convey the sense of the word "bound" in two ways — "bound" in the sense of *moving towards;* and "bound" in the sense of *being anchored by* and even *being tied and confined by.*

The theme of redemption is dealt with in a way which

was to me extremely thought-provoking, and I felt that the juxtaposition of Abel and Yesh, in the end, was very effectively done. Yesh, terribly touching and yet in some way curiously dated, remains (as himself and as Christ) alive among the gentiles. Abel dies among the Jews in order to earn *the man*, the state of being a man. There is in the end no symbolic redemption and no Messiah...only individual men earning their humanity, as Abel earns it, and as Hitzig also earns it. Humanity, like freedom, like salvation, isn't really transferable — either you discover it for yourself or you don't. But the very act of one man's finding it, and earning it — this is, in every way that matters, hope.

I expected the play to be too long, probably because you had been rather downcast about it at one time and had said various people questioned whether it was practical, in a produceable way. I really do not have any qualifications to say even one word about theatre at all, but in the reading of it, it did not strike me as too long. Very little could be cut, it seemed to me, although perhaps something would change to some extent in the production — details, I mean, not anything essential. But nothing is superfluous; everything is there because it is needed and because it has meaning. I do not know what the hell kind of theatre it would make because that isn't my medium. I only know that in the reading it has pace, that it moves in the sense of events and that it moves also in the sense of inner things gradually becoming outer and showing themselves. One criticism of it might possibly be that some parts are too philosophical and even too obscure. I don't think this is so, because it seems to me that contemporary theatre (and novels) must necessarily be trying to do a multitude of different things at the same time and must therefore rely to some extent upon the viewer's or reader's willingness to enter in and try to see and feel what is there — I think that the significant change in English novels within our lifetime has been the growing realization on the part of novelists of the truly ambiguous and complex and uncertain nature of reality, and an attempt to convey this in words while at the same time to convey individual persons in that spontaneous and un-thought-out way — in other words, to be saddled with the

knowledge of what your writing means, and at the same time to be able to forget that sufficiently in order to convey flesh-and-blood in all its surprises. It seems to me that this is what you have tried to grapple with in the play, and I think it has come off. In the places where you have passengers and seamen [——].[4] In the deepest sense, you appear to me [——] about the same things which concern me and no doubt concern every writer, in some way or other — the ways in which people continue to damage one another, and the ways in which sometimes there can be healing; the basic importance of tradition as one's place of belonging in a specific way, and the basic unimportance of creeds and all these differences when one human is face to face in any real way with another. My God, now I am stricken with self doubts and wonder if I have mis-interpreted all this? It doesn't matter, I guess, in one way. This is what I took from it, that's all. This is what it said to me. It will be less than what you intended, probably, and in some ways different — maybe that isn't important. Anyway, it spoke. In the end, what moves me the most is Hitzig seeing that there isn't any easy way out, and he and Dora trying to bargain for the other's life — this is utterly convincing; they don't do it because it is right or because they ought to — only because they cannot bear to see the other person cease to be; but in the end everyone can bear everything because what else is there to do? Only death ends it, but Herzl going back to die, is greater than the Herzl who would have died if the boot had descended before. That is all that matters. It has to matter — this is the essence of our faith, without which "life" ceases to be a different word from "death."

I have become rather emotional, I guess. It is because the play moved me very much. Anyway, write and let me know your reactions to my reactions, etc. Have I seen something of what you were trying to get across, or am I too subjective? I don't know, and in a way I don't care. All this is what it said to me. PLEASE WRITE.

Love,
Margaret

p.s. do you want the copy of the play back or not?

P.S.2. I'm not sure I understand the exact significance of Hitzig's voice at the end — "No whalesblood on the hook?" but it has the evocative power of some poetry — it is eerie and moving, and it carries suggestions of the mystery at the heart of things. This is my first reaction — further thought will probably reveal other things as well in that part.

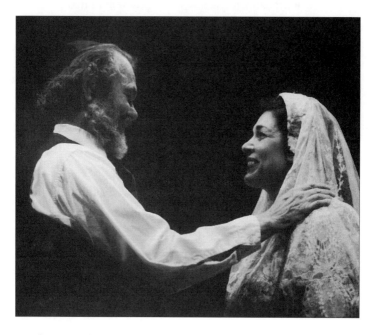

Danile (Les Carlson) and Hoda (Gale Garnett) on her wedding day.
Photo courtesy of Rachel Wyatt.

Adapting *Crackpot* for the Stage
Rachel Wyatt

The scene is the Laurentians. December 1975. Snow falling outside. I was in a hotel room reading a copy of *Crackpot*, a Christmas gift. When I finished the book, I wanted to jump up and shout, THIS is a novel, this is a GREAT novel. I wanted to meet the author and congratulate her.

Toronto. August 1977. At a party in Arlene Lampert's garden. Adele, wanting to talk to me, stuck her foot out as I walked by. I tripped, turned — and apologized. We both laughed. That was how I met the author of *Crackpot*. Our friendship grew through the years and continued in Toronto, at Banff, in restaurants, through postcards and over the phone. And we kept on laughing.

And then came Adele's illnesses, her brave recoveries and her attempts to fight back that last time until her death in June 1992.

I was still in the grip of sorrow later that year when a producer at the CBC, wanting to honour Adele in some way, asked me to adapt *Crackpot* for radio. I was thrilled by the prospect and at the same time daunted. This great novel reduced to an hour of sound and voice! I read and reread the novel and wrote and rewrote, and the radio adaptation was finally produced in Calgary by Martie Fishman and broadcast nationally.

Then Martie Fishman suggested that I adapt it for stage. Stage! All those characters! That thirty-year timespan. I set warily to work. Kim McCaw invited me to the Playwrights Colony at Banff to work on the script. There was no turning back.

It didn't seem difficult. After all, in my reading of the

book the characters had become real, hadn't they? I could see the settings in my mind's eye, couldn't I? With some confidence I sent Martie the first draft of the stage play. We met in Calgary airport when I was on my way to Banff. Over coffee, and without many words from him, I knew I had made the mistake of merely rewriting the radio version with actions. I went back to work, to make it visual, to make it theatrical, to give Hoda and Danile the space to be three-dimensional, to talk and move and EXIST.

Banff. June 1994. Snow is blowing lightly past the window. The actors are reading a new draft of the stage version of *Crackpot*. A great eagle, black and white and powerful, flies by outside.

The reading is taking place in the Lazlo Funtek Building at the Banff Centre, a place Adele loved and where she worked so hard on behalf of writers. And I had been feeling the great weight of trying to do justice to her novel, trying to put her wonderful Hoda on the stage. Somehow that eagle, while it didn't exactly nod as it flew by, gave me a feeling of reassurance. Adele's spirit perhaps?

Victoria. July 1994. A phone call from Bob White at Alberta Theatre Projects in Calgary. He wants to produce *Crackpot* in the playRites Festival in February. Looking over the notes I brought away from Banff, I work through the play again — and again. Trying to get it right. On radio it was easy to follow the line of the book and begin with Hoda at twelve and move along through the years to Hoda at age forty-five. Donna Goodhand, who played Hoda on radio, had a suitably "chunky" voice and was able to age thirty years believably in an hour.

This could be done on stage, has been done. But somehow it seemed wrong for Hoda, this larger-than-life woman, to be seen by the audience first as a child, by either employing a child actor or having the actor be childlike for the first several scenes. Beginning in the middle of the novel and flashing back through

time would present other problems. But writing for stage is all about solving problems. Isn't it?

By draft three, I was getting the structure right but delicately tiptoeing by the birth of the child and the incest scene by having them happen offstage. And then I realized, with some prompting from Martie, that Adele would not have been so pusillanimous. And now the first act ends with Hoda having made that momentous decision to make love to David, her son. What else could she do? That is her question and also mine.

Calgary. November 1994. A very cold, snowy day. I am standing outside the Centre for Performing Arts wishing I had a camera. There on a board in large letters, it says, CRACKPOT. By RW based on the novel by Adele Wiseman. And then I remember that even if I had a camera, there is no way of sending the picture to Adele. Inside, in the Alberta Theatre Projects rehearsal hall, we gather together for a reading of *Crackpot* by the actors who will perform it on stage. There are some familiar faces, some new. Gale Garnett, who is to play Hoda, has a smoky voice, lots of dark hair, and is going to wear a "fat" suit to add weight to her body. Les Carlson, who will play Danile, begins almost at once to move like a blind man.

Over the next two weeks, I sit, listen intently, make changes as the actors move, repeat their lines, directed by Martie Fishman. The actors have suggestions, the dramaturge (Daniel Libman) mutters to me about changes as the scenes move on. We take lines out. We put them back. To denote scene changes and give the actors a sense of where they will be on stage, the stage manager and his assistant move a huge cardboard circle which is a stand-in for the revolve. Blue strips of tape mark Hoda's bedroom. Red is Uncle Nate's living-room. Green marks Yankl's store. I wait to hear whether the intention, the voice, is true to the original, whether it will "work."

Adele was intrigued by theatre. She had written two plays herself. Several years ago, on looking in the mirror one day, she

decided that she looked exactly like Gertrude Stein. She called up and told me I had to write the script and she would play the part of Stein and it would be wonderful. We would get rich or at least famous. The fact that she had never acted on stage in her life was no deterrent to Adele. She called me often with new ideas, sent me books to read, overriding my hesitations with her enthusiasm.

Then I went to England and discovered that someone was already doing exactly what she had in mind and, although the actor didn't look half so much like Gertrude, she was a real actor and the production was enjoying success and was about to move to New York. To my great relief we had been upstaged.

On the makeshift stage of the rehearsal hall, Hoda, a mature woman, is standing in an imaginary spotlight. "Who will tell about my life?" she asks. And then we go back thirty years in time to the moment after Rahel is dead. Rahel, although her presence is there, doesn't appear. The story truly begins when Danile comes back from the hospital and when Uncle Nate comes in to try to send Danile and Hoda to the homes for the aged and for orphans.

Much of the novel has had to be left out. The orphanage scenes are referred to only obliquely. Seraphina doesn't appear at all. But Shem Berl, the eternal soldier, is one of the threads running through the play. He is a vital connection to the old country, to the family's past. Hoda's early fascination with the Prince of Wales — or, as Danile obviously hears it, "of Whales" — is another part of the story which I felt had to stay. After all, does she not see the prince as the abstract father of her child!

At the beginning of Act Two, the Hoda who went to weddings has become the Hoda who doesn't want to hear her daddy's old stories any more and who goes to every funeral. But even in this period of sadness she is a survivor, a fighter. The three women who are my useful Greek chorus, and who also add a lot of the humour to the play, are in mourning clothes. Why does Hoda go to funerals now? She is in mourning for her life, they say. I have tried to take Hoda through those situations that lead the women of the town to see her no longer as a woman no-better-than-she-

ought-to-be but as a woman who did-what-she-had-to-do.

How to end the play? On radio it was easy to bring back the voice-overs, the music, a wise word from Danile, and end it the way the novel ends, in a dream sequence. Putting Hoda and Lazar in bed on stage and surrounding them with voices did not seem like a proper theatrical device. The question is, what are people to take away with them as they leave the theatre? Will Hoda leave her audience with a smile or a tear? A loud guffaw or a heart-catching sob?

Pondering this, on my last afternoon in Banff, June 1994, I went to the library at the Centre and watched the final act of *Der Rosenkavalier* on video. After the sad sacrifice of her love by the *Marschallin*, the lovers have sung of undying passion, the music softens and the little page returns, skips lightly round the stage and picks up the handkerchief dropped by young Sophie. This small action restores perspective, reminds the audience that this is comedy. It gives them a chance to dab their eyes and then begin to applaud.

And now Hoda in her wedding gown, adjusting her veil, turns back to the audience and says defiantly, "So I lived my life a little backwards." The audience, hearing wanna-make-something-of-it? in her tone, dabs its eyes, puts its tissues away, laughs and begins to applaud. That, at least, is the plan.

The rehearsals continue. I have to leave for three weeks to be with the family for Christmas. But I am tied to the play by an umbilical cord like the one Hoda bites to sever herself from her son. Messages, changes, suggestions, come and go by fax.

Santa Barbara. January 10. A deluge. The whole winter's rainfall in twenty-four hours. Floods prevent me from flying back to Calgary. Highway 101 is closed in both directions. The small airport in Santa Barbara is under two feet of water. All day on TV, they show images of rain and flood. Every hour I call the airport bus company, and the answer is always the same. We can't get through. Shall I ever see my play again!

January 11. Very early in the morning. We make a hopeful call. There is a bus leaving but who knows if it will get there? It does get to Los Angeles, but takes five hours instead of the usual two. I hurry from the airport in Calgary to the theatre in time to see a run-through of the second act. There they are, "the Crackpot company." Les Carlson now moving like a truly blind man, Gale Garnett assuming the persona of Hoda along with her "fatsuit." Hardee T. Lineham bringing a touching humanity to his role as Uncle Nate: a man who sees, finally, that Hoda and Danile are his true family. I return home for a few days, pleased that it is going well.

January 21. A beautiful day in Victoria becomes, as I fly over the Rockies once more, a beautiful day in Calgary. At the theatre, final adjustments are being made to give the actors more time for their costume changes. The stage manager says, "We can take twenty seconds off there." Hoda in her wedding gown is saying, "I need more Velcro here." And then they rehearse the curtain call. The curtain call!

Martie Fishman and I go to a nearby bar and nervously have beer and nachos for "dinner." We sidle back to the theatre. Forty minutes before the curtain goes up, the crew is dismantling the apparatus in the stalls, the table and the electronic console that have been there through rehearsals. They screw the seats back in place and remove the cables.

The actors' half-hour begins.

The first people who will ever see Hoda on stage are arriving at the Martha Cohen Theatre. We stand in the foyer, Martie and I — both, as it happens, wearing black — scanning the faces of the ticket buyers until Martie's wife, Heather, tells us that we look like two undertakers and should move in case we drive our potential audience away.

Seven-thirty. In the darkness of the theatre, the music begins. All the characters from Hoda's life gather on stage. They exit. Lights up. The three women are putting the finishing touches to the wedding dress and wondering whether they should inform Lazar

about his bride-to-be's past. Hoda comes forward and says, "Who will dare to tell about my life?"

Monday January 30. Chinook conditions in Calgary. Ten degrees but the Big Sky is filled with cloud. Three days to opening night. Yesterday's preview went smoothly, the best yet. At the end of the performance there were tears, there was long applause and some members of the audience stood in a partial ovation. Or did they have buses to catch?

The actors have taken the play and made it theirs. It is out of my hands. Almost. There are lines that might go better here instead of there. Emphasis that might be different if she did this and he said that. Finally I can only go back to my room and try to get on with other things, and wait and wonder why my stomach feels so full of butterflies, moths, June bugs and other insects.

February 2. Opening night. Martie disappears to watch the play alone. My husband, Alan, and I find we are seated with the critics and as Danile is telling how they came to the new world, even he a blind man, a woman collapses in the next row and is taken out. What kind of an omen is this? (She recovered.)

On stage, enter Polonick, the political conscience of the play. The riot scene begins. The Winnipeg General Strike. Amazing what eight actors and sound and lighting effects can do.

Time for the scene that was most difficult of all to write: How does a woman decide that, rather than tell her son who she is, she must make love to him? The audience gasps when they see that it is David, now a teenager, who has come to Hoda and wants to pay her for sex. She makes her decision. It's over.

At intermission I lurk in the foyer, hoping to hear fine comments about the play, but all I hear is chat about work, the neighbours, children. The people return for Act Two. They have not left, not run from the theatre in horror.

Again the music begins. The women are in place. Another

111

war is about to begin. Soldiers, foreigners, refugees all enter Hoda's orbit. The stage revolves and there is Hoda's room, the delicatessen, the snowy street in Winnipeg. It turns and turns again and there is Danile leading Hoda off to her wedding, telling his old story again, "When they came for me on my wedding day...." In front of us, the critics join in the applause. But do they like it?

We have to wait a whole day for the reviews. And then on Saturday morning there they are. "Crackpot a Crackerjack," says the *Calgary Herald*. "Crackpot as warm as a bagel," says the *Calgary Sun*.

Numbness sets in. For months now I've felt as though I was dragging a heavy cart along a bumpy road. But in my mind a triumphant little voice is saying, "It worked! It worked, Adele!"

Adele As Poet and Inspirer of Poetry
Lenore Langs

Adele Wiseman sitting at a round table in McPherson Lounge, green felt fedora with its pert feather pushed back on her head, Osker the miniature grey schnauzer lying in state at her feet, a circle of students and faculty members clustered about her...and energy crackling like popcorn. That was my introduction to Adele, at the reception to welcome her as writer-in-residence at the University of Windsor.

Some people remember Adele for her award-winning novels; others are familiar with her short stories, essays, children's books or perhaps plays. I came to know her best in her role as poet, and as nurturer of poets. We became good friends, with me her acolyte as she made exciting things happen.

Adele's generous spirit showed itself to me shortly after we met. Office space at the University of Windsor is in short supply and is jealously guarded, and at that time I did my work crammed into a room with several other sessionals. Adele soon invited me to move into her office and share it with her, and so began three years of comradeship and creative work — and pots of tea, bagels and almond chocolate bars.

The creative juices would begin to bubble, and Adele would say, "Let's do something interesting. We could invite writers from other universities to come and read with our students and faculty." I would say, "Maybe we could contact Wayne State and Western and talk about it." And Adele would say, "No, we don't need to do that; let's just send out letters and invite a whole batch of schools to come." So we did, and they did. That's how and why the Wayzgoose reading series was born: from a vision, to bring writers together — writers at all levels, from timid beginners to

professionals, whether students, faculty or members of the wider community. Adele wanted to introduce writers from different locales to one another and to stir up a mix that would promote the exchange of ideas and written work, and she wanted it to be fun. She wanted it to be a safe place for writers to experiment and to try out new work in front of an audience, a chance to test new voices and styles, a venue for reading the pieces that couldn't be read elsewhere. There would be no censorship. There would be no rules.

In the process of looking for a good name for our fledgeling project, we thought up and discarded dozens of unsatisfactory ones. All the usual names for interuniversity events seemed to be traditionally male (tournament, match etc.), and they sounded competitive. We wanted to avoid any connotation of competition. On the other hand, the names for traditionally female events (bee, social etc.) seemed too arch. So Adele asked Jay Ruzesky, who at that time was a graduate student in the creative writing program, if he could ferret out a name from the big Oxford English Dictionary. He started at the back of the book, and "wayzgoose" jumped out from the w's. The original wayzgoose was an annual treat for workmen in early printing offices. It was a festivity that included a dinner and often a trip into the country. "Wayz" or "wase," according to one story, is an English dialect word meaning "a bundle of straw," so a wayzgoose was a stubble goose — one that ate the stubble left behind after the threshing. It may have served as the main dish at the banquet.

This was the word we wanted: a word that embraced writing, eating, celebration; it was perfect.

Adele believed in celebration, believed that it nourished the creative process. So we built celebration into Wayzgoose. During the year, readings were set up to take place at all the campuses in the Wayzgoose network, with different combinations of readers, but we decided to bring everybody to Windsor at the end of the school year, for a day of reading and visiting culminating in a dinner. At this Grand Wayzgoose, we would present the anthology, a compilation of writings by all the persons who had read at any Wayzgoose gathering that year. To make the anthology even more

interesting, we decided it should include original photocopy art as well as text.

Some years we have had a cabaret along with the Grand Wayzgoose; sometimes we have hosted musical groups from other universities. One year there was a wonderful exhibit done by students of the School of Visual Arts at the University of Windsor. I still remember one display by Pina Frabotta, which was a garland of twinkling lights winding down the stairway from the second floor of the Students' Centre. The lights were somehow powered by lemons — thousands of them! That was a feast for many of the senses.

The year after Adele died, we dedicated the end-of-year Grand Wayzgoose to her. M.L. Liebler, a professor at Wayne State University, led the assembled crowd in a tribute. He gave us all brightly coloured, metre-long plastic tubes and, while he read a poem about Adele, we whirled our tubes in unison, creating a music that was weird and wonderful and certainly joyous. I think she would have approved.

Adele felt that artists are the witnesses and interpreters of a civilization, and play a crucial role in the assessment of that civilization. Thus, she felt that artists must speak the truth. She was a passionately principled person, and never compromised her beliefs. She never backed down, or backed away from telling the truth as she saw it, no matter how unpleasant the consequences might be for her.

Writers flocked to her office knowing the door was always open, and she offered encouragement and support, and often food for the body as well as for the mind. She even coaxed a few closet writers into print.

Adele loved words, and polished her writings until every word satisfied her. For this reason, she left behind a large body of unpublished work still waiting for the final polishing. She was diffident about her own poetry, not having the same confidence in her poetic voice that she had in her other work. A few weeks before she died, Tillie Olsen (Nebraska-born poet and short-story writer) visited her, and Adele showed her some poems. Olsen told Adele

that they were very good, and that she should publish them. Adele wrote to tell me this, and was very buoyed up to receive affirmation from someone whose opinion she so valued. Unfortunately, there was to be no time for any more publishing.

Adele's poems have the same strong voice that is evident in her other work. Her imagery is fresh and evocative. She wrote on a variety of themes, ranging from love to politics. The political poems are sharp and witty. The love poems are the sort that will always remain fresh, for they speak across the ages. They are beautiful.

A group of friends met at the Grad House in Windsor in June of 1992 to mourn Adele's death and to celebrate her life. A number of people read poems about Adele or inspired by Adele. Here are a few of them.

Adele's Room
by Lois Smedick

Where is Adele's room?
Who gave every place she dwelt
its special note, like grace.
Doll boxes with a few of the inhabitants
 spilled out
Welter of books slipped free
 from strong, squat hands
Pictures, Icarus hovering,
 wicker carriage that rolled the streets
 of Winnipeg.
All shells of a profligate sea,
 washing fair lands
 through rip, and neap, and flood
Now where?

We pick our way along the edge,
 stoop, try to see the essence

in a single remnant hurled
from endless wealth.
Her room is here.
Still, she encompasses.
Distantly, a chortle,
 sharp raising of the head,
 penetrating, lightly mocking glance:
"You thought I'd stay?
I go to find my birth, my place.
The hollow that I leave is yours."

<div align="center">

dolphin — for adele wiseman
by lenore langs

</div>

she skims the billows
we paddle behind
learning to leap
in her wake

sun glances from sea spray
bursting about her
scattering
rainbows

<div align="center">

Lines: for our writer in residence
by Kate Rogers

</div>

Paid to guide a pencil
she mostly sat in an open doorway
hand extended — an invitation made of skin.
She was waiting for lines — but not her own.
Would scan each visitor for the crease
which folded a forehead,
the horizons of a mouth.

As we remember we want to give tribute
rub each other's hands to bring out lines
like fortune-tellers smack a smooth palm to bring it to life.
"But who can write now," we ask, "when nothing
is certain?"
The roofs above our heads peel away,
shingles flip off like calendar days
in this scalping wind. There is no money
and too much time to notice.

One of us searches the tarot — thinks of branching out
to leaves — how they arrange their shreds on porcelain.
Another took her seamless skin
to a twenty-dollar gypsy:
"Clench your hand," the gypsy said, "to fold pathways
on your palm."

"Make a fist," Adele would say, "it is the same size as your
heart. Etch your skin — then copy the lines."

Adele
by Katherine Quinsey

An incandescent stone
 scintillating
fiery-hearted

 bounding through
 constructed and invisible

 walls

 scattering shards into sparks
 destroying, creating

sparks live at a touch,
 breed life.

The stones pulse blood
 generous and generative,
 nurturing and bringing forth

living heart whose giving
 pierces through all constructed boundaries.

We are her children

 recreated in her blood and flame
 recreated in our own eyes

in our hearts

the stone beats warm
 embedded

a glowing coal
cleansing heart and mind

 into words

that we may speak truth

that we may love truly.

Adele initiated other projects at Windsor besides Wayzgoose. We organized two cabarets, in conjunction with the schools of Dramatic Art and Visual Arts. We hosted a conference on the techniques of writing for children and young people, with top children's writers as speakers and workshop leaders. We planned a series of readings and performances at venues on campus and at

MacKenzie Hall, a local cultural centre. Everything I did with Adele was invigorating and exhilarating. She felt that as writer-in-residence she should be a source of ideas and enthusiasm for other people — and she was. Her energy was catching. Gerald Noonan, a professor of literature at Wilfrid Laurier University, dedicated his poem "Porridge Making" as follows: "in memory of, besides my grandmother, Adele Wiseman, who made probably no porridge but much happen."

Adele did a great deal for the craft of writing and for writers while she was at the University of Windsor but, looking back, I think that her greatest achievement was that she created an environment wherein artists from many different disciplines — music, drama, literature, visual arts — were able to come together to work for the enrichment of all.

Here are four of Adele's own poems, two of them untitled.

[untitled]

In the beginning always innocence
the shock of pleasure
expectations of such joy

The manuals describe
mechanics of a human toy
an intricate device
with what we call
a base emotional
which knows itself alive
and is equipped
with self-perpetuating fluid drive.
Initial spark provides the thrust
with such a kick
that energy translated into lust
makes forward movement
to the next initial spark a must.

This is the cunning of the life force
the survival ploy
which interrupts a tendency
of the machine to stall
after the death
of every fall

Always in the beginning innocence
the shock of pleasure
expectations of such joy

Sound Wisdom Seen

The sound wisdom
Is to know that all love
Comes to naught.

Even that love
Which in marriage
Is most tightly tied
Comes to knot.

The wisdom of love
Is to know
Whether to knot or not.

For the love that is not knot
Is a naughty love

And the love
That is knot
Is a heavy knot

And the knot once tied
Is a hard knot

And the knot untied
Is a fraught naught

And so the sound
Wisdom of love
Is to know knot
Is to know naught
Is to know not.

[untitled]

Someday when science has turned
to what is important at last,
they will find my remains in some tumulus
once all the tumult is past.

They'll see that my bones still glow
and discover
(for bones don't lie)
No half-life of love
and they'll know
that some prehistorical I
still love
some antediluvian you.

They will put me under glass
and an endless line of lovers
will queue to visit the shrine
of the love that does not decline

Or perhaps they'll leave me free
to the touch of lovers seeking
the secret of constancy
And my polished bones will shine
as well as glow

and dream and go on dreaming
that all those hands are your hands
that caress me so
And when they chip off parts
and sell them to desperate lovers
to wear
against despairing hearts,
my fragments of bone will groan gently
and dream
that at last I've come home.

Tree House Song 1

I live in a body tree
a red sap tree a bone white tree
a bifurcated ambulant tree
with branches that move handily
roots tucked up inside of me
a great heart motor driving me
I live in an exploding tree
a mind discharging continuously
I live in a tree of energy
a nerve zap sinew muscle tree
a heart brain flowering showering tree
a flesh rich yellow fat skin tight tree
a thirsty tree a hungry tree
I live open endedly
in a take in and a give out tree

All these trees and more
together separately
live in me

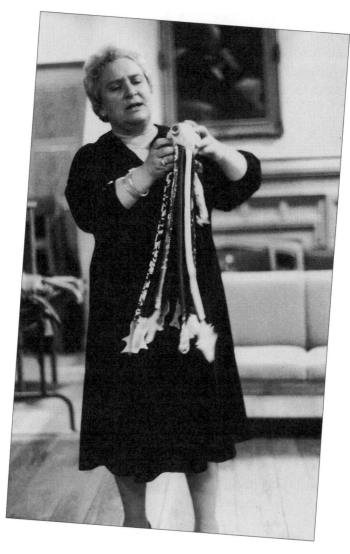

Adele at Ban Righ, April, 1982.
Photo by Sandra Rutenberg.

THE CHARM OF AN UNORTHODOX FEMINISM:
AN INTERVIEW WITH ADELE WISEMAN
Gabriella Morisco

I first met Adele Wiseman in Bologna in April 1989, when she was
invited to the International Conference of Canadian Literature,
Nationes Canada. I was hardly surprised by the frank, bright look
she gave me as soon as we were introduced. It was almost as if I had
always found it reflected very closely in her works. She even looked
familiar, like a tangible reminiscence of Hoda, the unforgettable
protagonist of *Crackpot,* a small, slightly overweight woman with a
beautiful face and black, lively, piercing eyes veiled behind a gentle
smile.

This was how a friendship began that was to last for years,
even when Adele's illness got worse and we could only speak on the
telephone. It was still a priceless and authentic form of communi-
cation between Canada and Italy, and between two women who
were united by the same desire to understand and find in their
literary interests something which might better reveal the mysteri-
ous mechanism of the creativity of human experience.

We spent many hours together discussing art and life, how
to reconcile the two and make them converge in a written work.
The last time we met was in the spring of 1991, when she was in
Venice as a Visiting Poet at Ca' Foscari University, and we decided
to tape our conversation. In the end, much of what we said was the
same as can be found in well-known interviews previously pub-
lished, one example being that of Roslyn Belkin ("The Conscious-
ness of a Jewish Artist: An Interview with Adele Wiseman," *Cana-
dian Fiction,* n.31-32, 1981.) I have therefore tried to leave out
anything that can easily be found elsewhere in order to reveal her
comments and thoughts so far unpublished, which may make her

art more readily understood and interesting.

Adele Wiseman, it is clear, was very willing to collaborate and never refused to reply, even when the questions might somehow have embarrassed her. She spoke in the same honest fashion about herself and her work as she did about that of other writers, whether she knew them personally or not. From this we have an overall picture of an extraordinarily rich personality, of a writer continually engaged in the need to express the profound significance of Jewish *Canadian* culture, of a brave woman who was always coherent with herself and her vision of the world, thanks to, and despite, the different masks adopted in narrative disguise. She often seems to be prophetic in her statements in this interview — as in her last words on life and art, which can be considered a generous testament of hope and encouragement.

Gabriella: I'll start with a question I have been meaning to ask for a long time — that is, since I read just by chance a short story of yours called "The Country of the Hungry Bird." Having already read your two novels, *The Sacrifice* and *Crackpot,* I remember being struck by the completely different tone of the story. Above all, what I could not understand was the type of message the story, which I might call an "apocalyptic fable," wanted to convey. All the inhabitants of a nameless country are bewitched by the song of a beautiful bird that lives off human beings; however, nobody wants to kill it and go without its song, though they are all well aware of the macabre price that has to be paid. On the contrary, many of the people offer themselves up as victims and are proclaimed "Heroes of the Voice." The bird, of course, made me think of the deadly fascination of certain political ideologies or religious fanaticism, the consequences of which may be equally destructive. The story certainly leaves no room for hope and humanity goes on happily and carelessly towards its inevitable downfall. What was the inspiration for so pessimistic an outlook?

Adele: This story has an interesting background. I first submitted it to a literary review many years ago, explaining how I had had the

idea of the bird and its lethal song. The story was rejected. Several years later the same magazine asked me for something to publish, and I sent back the same story without any explanation. Surprisingly enough, it was published immediately.

The first idea was inspired by the figure of a singer, Kirsten Flagstad, a wonderful soprano who was very famous before and after the war. On the record I borrowed from a library, Kirsten sang songs by Gustav Mahler, the "Kindertoten Lieder," very sad songs written by Mahler after the death of his children. As you know, Mahler was a Jewish composer; Kirsten Flagstad was married to Quisling, a Norwegian Nazi leader. This was what I had learnt and never tried to investigate further. During and after the war she continued to be a popular singer — she had an absolutely beautiful voice. She sang about Jewish children and their death and she was married to a Nazi who was out to destroy Jewish children! The thing made me question once again the whole question of art and morality.

The story was my way of recognizing that art is not necessarily moral; if it is going to be moral, it is only because we make it so. But it is possible to produce great art that is not morally or ethically involved. That was the base of that little fable.

Gabriella: What about the people who want to hear that song, even if they know they are going to die if they listen to it? Doesn't this also seem to imply a form of complicity of the victim with his slaughterer?

Adele: Above all I wanted to show that people are willing to do anything in order to gratify their senses. Art can be a drug, a way of poisoning yourself, an instrument which carries poison. A lot of today's literary art can be destructive because it despises many important human values.

Gabriella: The story we have just talked about is, then, similar in its intent to the one which appeared in your book *Memoirs of a Book Molesting Childhood* entitled "The King and the Queen Had

Two Sons"; here, too, you use the form of a fable with an unhappy ending to warn contemporary people of a more than likely technological suicide. Have you published any other stories that I do not know?

Adele: I have one that has been reprinted a number of times, which was written many years ago and most recently reprinted in *More Stories by Canadian Women*. It is called "On Wings of Tongue" and speaks of a little girl I actually knew in my childhood. The family is very like my own and the story is set in a place very like Winnipeg. It is closer to a biographical story than anything else I've ever written. Actually, the character that it deals with is a variation on somebody that I knew and loved when I was a child. It's what I call a wish-fulfilment story.

There is another, somewhat longer story, which you might call a fairy-tale or a fable sequence because it is divided into three chapters. It's called "The King Had Three Crowns," but I haven't published it yet because I'm waiting for my daughter, Tamara, to illustrate it. And I have recently written what I think will be the first in a volume of shorter fiction: it's a long short story, or a short novella, called "Goon of the Moon and the Expendables." Goon is a simple, sort of half-witted boy and has various adventures.

Gabriella: This title reminds me of "Gimpel the Fool," by Isaac Bashevis Singer, which I am sure you have read, he being another Jewish writer.

Adele: Singer is not someone that I've read very much of, but I grew up with some of the earlier masters, like Sholem Aleichem and Peretz. Of course, I read them in Yiddish and there is a certain tone, or approach, that I feel very much at home with, although I don't know that world. I'm not very keen on Singer's world of trolls and superstitions or that kind of magical stuff that reminds me a little of Gogol, perhaps because I was brought up in a more rationalist way.

Gabriella: Yet you prefer in your short stories a kind of fable structure. Why is that?

Adele: Well, I wrote the children's stories because they were easy and it was a way of saying that I didn't want to be bothered any more with a rhetorically developed intellectual frame of ideas. I'd much rather play with it as a story. "Goon of the Moon," for instance, is my version of a science fiction story, but it defines what to me real science-fiction is. It is a story about children so it refers to something inside the story, it refers to the myth of the story. It is easier to use traditional figures in a symbolic context to speak freely about the contemporary world. And the moon is a very strong symbol for these children.

Gabriella: In this story there is a "goon," but all the characters in your novel *Crackpot* are also somehow abnormal: Hoda is obese, her mother a hunchback and her father blind, just like Goon and his little friends. Why do you choose deformed characters?

Adele: Because in general we deny them the right to live alongside us, in the same way as we feel we can, and have the right to, destroy other lives. Ironically, if we consider others "different," we too become "different." Just think of what the Germans did to the Jews. That's why I'm interested in describing people on the edge of society, people who are deformed either physically or psychologically. It is partly an extended metaphor of the Jews. I believe we should all try to open ourselves up to a wider acceptance of humanity.

Gabriella: Thinking of your essay "Memoirs of a Book Molesting Childhood," in which you speak about your literary influences, I was wondering whether you didn't also speak Russian as well as Yiddish in your childhood.

Adele: No, I didn't speak Russian. My parents were from the Ukraine but they kept Ukrainian and Russian for when they didn't want us to understand, so we spoke Yiddish in the house.

Gabriella: Do you in some way feel any links with the Russian cultural background?

Adele: Of course I have read a lot of Russian literature, in English translation, and I must admit that it was the first literature that made me aware of what a writer can do. I am mainly thinking about the works of Tolstoy and Dostoevsky. For example, there's a scene in *Anna Karenina* when the protagonist is about to commit suicide. What Tolstoy does is very interesting psychologically: she's going to throw herself under a train but it is impossible for her as a human being simply to do so, so she has to sidetrack herself. In other words, in order to do the terrible thing she has to become involved with something else that's related to it. So she says to herself: "I will jump when it is exactly in the middle." So no longer is she thinking of jumping; she's really thinking of the moment, and that is what prevents the scene from becoming sentimental but gives it also its terrible power, because of the way the human being can trick himself or herself into doing this terrible thing. And when I read that, I still remember the effect it had.

Gabriella: From the way you describe the scene, I think that right from the start you read from a writer's point of view.

Adele: Yes, I think that was the moment when I understood how much power a writer holds when describing reality. And there's a scene in the first Dostoevsky I ever read, *The Idiot.* What fascinated me was the psychological effect obtained by the description: Prince Mishkin has seizures and Dostoevsky describes very carefully the particular aura of light before he tumbles down the stairs. And then there is a scene at the end when he is in bed with this woman and it's certainly not a sexual scene, but it's something I remember. I read it many years ago when I was about fourteen but I remember the tremendous effect of the story in terms of how colour is achieved, and how stories were set up so that I was trapped completely. I still remember reading *Resurrection,* spending all night reading this little volume and being convinced that Tolstoy was

about to tell me the secrets of the universe. I couldn't wait to find out — all this tremendous suffering — and I remember my terrible disappointment that the secret of the universe turned out to be the Ten Commandments. I still think that ending is a narrative failure, but it's interesting that what you learn there is that something can be tremendously dramatic and moving if it's enacted. If it's listed, as in a recipe, and isn't enacted, then it's a terrific drop. That's why in Milton the character of the Devil is so much more vivid than that of God — because the writer cannot find a convincing way of dramatizing the divine figure.

Gabriella: Talking of how a writer manages to build up his story and involve the reader in it, I found your essay on Henry James highly interesting. I agree with you in your dislike of James' manipulation of certain female characters, seen from a superior point of view . At the same time, I think that he is one of the few writers in English literature who tried to portray honestly the woman of his time, even if basically the point of view remains that of the author — that is, male.

Adele: That's the very problem with James, because James is faithful to James and his own inner reality. He had an agenda in *Portrait of a Lady*, and the agenda was to define what a heroic female character, what tragic female fate, is. There is terrific manipulation, a very clever manipulation, because he very often has female characters criticize the other female characters, so it's always "not him," the author. He had his idea of the highest a woman could reach and he hit upon an ideal of his century — and it's a male ideal in general — that the highest fate for a woman is to pick the hardest path in life, the path which will give her the least personal gratification. And what does a woman sacrifice herself for? What is the highest form of sacrifice for a woman? She sacrifices herself for an institution, for the institution of marriage. And you can see him leading her, Isabel, step by step, because he thinks that for her to choose that unhappiness and uphold the social idea of marriage is the highest form of giving her life. In other words, happiness doesn't count.

Gabriella: So you too are of the opinion that James was basically an antifeminist? *The Bostonians* is in any case a very clear example of this.

Adele: I don't think that Henry James had any intention of defending women. In *Portrait of a Lady* Isabel is the only really acceptable, sympathetic character. But Mrs. Touchett, for example, was a terrible woman. Why was she a terrible woman? Because she wouldn't let her husband have all her finances and she was independent. She insisted on making her own financial arrangements for her fortune, so she was bad, according to James, and according to the old man, her husband. Her friend Henrietta, who was a writer, a newspaper woman, was a figure of fun because she was trying to function as a man in a man's world. There was one softening thing about her: the fact that she was doing it because she had to. She was helping her sister raise her family. It was need, and that was the one nice thing about her.

Gabriella: James certainly finds a moral justification for social transgression in this case.

Adele: And if you consider that James was supposed to be positively disposed towards the women writers of his generation...! And, well, you know who is the ideal woman in that book? It's not Isabel Archer, because Isabel is punished for having the nerve to think that she can be independent in a man's world. The ideal woman is this little wimpy girl, this pathetic little girl who falls in love with this young man. And she's a totally, appallingly, spiritless human being.

Gabriella: We can see this, too, in Hawthorne's novels. Just think of Hilda in *The Marble Faun* and Priscilla in *The Blithedale Romance.* They are both passive, uninteresting female figures who, in the end, turn out to be winners, unlike the two *dark ladies,* who are more fascinating but notoriously more dangerous. Which male writers do you think came closest to giving a faithful and honest

portrait of a woman?

Adele: That's hard to tell. Shakespeare, for example, wrote of all kinds of women who are, within their contexts, at least believable — to some extent, anyway. I don't see it as impossible for a man to write good female characters. I don't see any reason why it should be impossible. I think of Joyce Cary, who is to my mind one of the greatest British writers of this century: he is a creator of characters. *The Horse's Mouth* is wonderful. Actually both Margaret Laurence and I admire him tremendously.

Gabriella: Which female writer, on the other hand, do you think comes closest to an honest portrait of a woman? That is, how do you think a woman should express herself to remain faithful to her female "nature"?

Adele: I think a lot of my contemporaries. I think Margaret Laurence has written extremely well about women; so have Alice Munro and Tillie Olsen. They write pretty naturally about women.

Gabriella: Do you think it's possible to qualify a "female" way of writing as distinct from a "male" one, in style, form and content?

Adele: I think it's basically a matter of context. In a world in which one way of seeing things predominates, there isn't really much chance of dealing with them differently. In other words, you're not free, and that goes for both men and women, to write how you want to, and you are unconsciously driven to write in a perspective imposed on you. I really don't know if there is a "female" and a "male" way of writing, but I'm beginning to think more and more that there are two different types of human beings and that if we could develop all our different potentials there would be a way of expressing ourselves more clearly as men and women.

Gabriella: I think all three women writers you just mentioned were your friends, weren't they? What does it mean to be friends with

another woman writer? Does it mean collaborating in the sense of exchanging views, discussing and reading each other's work?

Adele: Friendship in this case was very important, because it meant that we were not isolated, that we had a context. Margaret Laurence and I could always write to each other and we saw a lot of each other. It came naturally to speak of our vocation. So that was one thing where I felt I was very lucky.

Gabriella: What do two women writers say about their own work? Do they explain that they can't go on with a particular part of the story, or do they simply talk about the plot or characters they are creating?

Adele: No, no. We never discussed our work in such specific terms. We never asked advice of each other. We showed our work when we were reasonably close to completion and we discussed the difficulties we were having. But it was all pretty general; we used to sort of sound off each other. For instance, I wrote the afterword for the new edition of *The Stone Angel* and I simply took quotations from letters she wrote to me while she was writing that book. I traced through what had happened to her, what was going on, simply by quoting chunks of her letters. It was most interesting to see, because something that had happened to her then had happened to me earlier in my work, with my first novel, *The Sacrifice*, when I had shown it to someone who was intrinsically either clumsy or unsympathetic with what they thought I was doing; and this put me off writing, it paralysed me for months. The same thing happened to Margaret when she was writing *The Stone Angel* and it was like a final initiation, a final realization that you have to stand by what your work wants to say, that you cannot try to please others, that you can let them put you off by taking external criticism too seriously, by allowing it to be too destructive. You cannot let others decide the shape of either your ideas or your work. Ultimately, you have to face your own devils and you have to defeat them yourself. And this was something she learned in *The Stone*

Angel, very, very drastically. It was a terrible period for her. It was almost a comic situation, except that it was so appalling.

She had broken up with her husband at that point and she was taking the kids and going to live in England. They stopped off at our place; she was very worried because their marriage was over with and she couldn't afford to pay for a lot of overweight. So she got my mom to help her, and they packed David's running shoes and a whole pile of the kids' toys. I had spent the night reading the manuscript of *The Stone Angel*. She packed the manuscript and she and my mother trotted off and mailed it to England, just like that. And not until she came back to our house did it occur to her that it was the only copy she had. That parcel only arrived three weeks after she got to England, and she was very worried. She wrote to me that she hadn't been able to read it for months, almost a year, because of some devastating criticism. When it arrived, she read it and said: "You know, it's not too bad. I don't think I should change it."

I had warned her about it and she knew that this kind of thing happens. But not until she herself was put through it did she realize. Unfortunately, other people's experience can never teach you anything. I see it all the time, especially now that I'm teaching creative writing at Banff. We never had workshops, thank goodness. But these people have become so dependent on workshops that they come running to you every day practically. And I want to break that dependence up, because if any of them are going to be real writers, they're going to be independent, otherwise you have all the same story; everybody gets ironed into the same thing.

Gabriella: As far as the art of writing is concerned, besides your university studies and the fact that Malcolm Ross was one of your teachers, it seems that your mother was an excellent teacher for you, as we can read in the beautiful book you dedicated to her, *Old Woman at Play*. Here the concept of art, like that of life, is explained in a very original way: you state that art is a paradox, just like the artist who, in order to grow up, has to remain essentially a child; he or she has to maintain that basic innocence which makes

every experience new and unforeseen. Do you think this concept derives from your Jewish culture?

Adele: I couldn't say for sure. For a Jew it's such an everyday experience that you mix things. I mean, you're brought up in a culture that you happen to share with others and yet there's a constant feeling of a more intimate culture. At least it was so when I was growing up. I don't know whether it is so much now with more integrated families. I think there are movements back and forth but I suspect that, at least in part, all this is an attempt to accommodate sometimes contradictory, sometimes antagonistic cultural streams and find some way of using them for a new possible way of existing.

Gabriella: This is also basically a form of paradox: life as a continual attempt to reconcile what is frequently irreconcilable. I think, though, that you gave the best exemplification of art as a paradox in the character of Hoda, the child prostitute in *Crackpot*, with her exuberant way of encompassing and embracing life with all its contradictions. There are at least two moments when Hoda's story reaches a highly dramatic climax, which I should like to discuss with you. One is the night when the girl gives birth to a child and in her innocence is wholly unaware of what is happening to her. The other is when Hoda, as a prostitute, meets her son, who is now grown up and knows nothing about his mother's identity. In the latter case, one of the most famous archetypes in Western culture, the Oedipus complex, is dealt with. But what is new, in my opinion, is that here the myth is experienced from a woman's point of view and, specifically, by a mother. What gives the whole scene a highly emotional effect is experiencing it through the horror of Hoda's looking down, unable to reveal the truth to her son. This new way of facing an ancient, deeply rooted myth is proof of great courage on the part of a woman writer. It is, in my opinion, revolutionary to turn, as you have done, the tragedy of incest, which has branded man from his beginnings (as Freud has said), into what may be, however painful, a constructive, not destructive act,

136

an act of love, that is a profoundly human paradox. I wonder whether you were fully aware when writing the book that you were doing something quite extraordinary, or whether you simply followed the course of the plot, which required something like this at that point.

Adele: Well, I have always felt that the artist who is doing serious work challenges the old rules in order to either remap their course or rediscover their implications and meanings. So the artist goes out to the outer edge and comes to a confrontation between what is socially permissible and what is humanly possible, so I was conscious of what I was doing. One of the things I want to do, and I tried to do this in *The Sacrifice* too, is explore the absolutely best reason for doing the worst thing.

Gabriella: I think you achieved your aim very well in both novels. In *Crackpot* there is something more, and that is the feminist perspective. I am using the term "feminist" in its least stereotyped, most vital sense — that is, as a perspective that tries, from within a different psychological reality, to revise and rename a cultural canon that has become inadequate for our times.

Adele: Hoda's is a kind of sacrifice imposed by maternal love; as a mother she is forced, given the circumstances, to make love, to give her son love; it is a way of making it up to her son for having abandoned him. It is as if she is delivering him a second time, when ironically she is initiating him into his sexual life.

Gabriella: Hoda becomes a mother and a lover in the same moment and for the first time. It is a sort of paradoxical growth of her own femininity. It is a courageous choice on the part of both the protagonist of the story and her author.

Choosing Kabbala and the Bible as a stylistic counterpoint and implicit term of comparison is the other narrative expedient you have used to great effect. Can you explain the reason for these choices?

Adele: As everyone knows, characters like kings and queens are not very common in the Bible, and when they do appear they very clearly break the rules and do terrible things. My favourite characters are the simple folk, members of the people of Israel. As for Hoda's story, I wanted to create something which started out from a mythical basis but with a certain intent to parody and demystify. Something that was the continuation of the story of the Jews but that, instead of taking the whole as a departure point, examined only a few fragments, the broken bits of a vase, at the same time bearing in mind contemporary life in Canada. It was mixing Winnipeg and its "muddy waters" with Hoda to see what would come out. "Muddy waters" is the Indian name for Winnipeg but "muddy waters" is that whole strange cultural mixture that we have in Canada, particularly in Winnipeg, where there are over thirty-one nationalities. Hoda should be the head of a new tribe which includes all the former ones, without considering Jewish or Christian faith, and so on.

Gabriella: Another aspect of Hoda that we haven't mentioned is her obesity: the contradiction between how she looks and what she feels is a problem all women face. For centuries women have been seen and appreciated basically for what they look like and not what they are. Of course, other women writers have dealt with this theme; for example, Margaret Atwood in *The Edible Woman*: the body is seen as a prison the woman is forced to live in. Hoda is another example, with her pure, beautiful soul encaged in this enormous ungraceful body. In one interview, "The Consciousness of a Jewish Artist," you said that Hoda is a sort of extended version of yourself and of how you feel experiences. Could you tell me something more about that?

Adele: Projecting myself into Hoda was a way of examining so many things that I wanted to clarify for myself. I was examining major prostitution; I wasn't thinking of physical prostitution but the fact that we all prostitute ourselves. In order to survive we make brothels of our prisons, when we are not coherent with our own selves.

Gabriella: Hoda is certainly the opposite of all this, because she never cheats herself and only does what she wants to. An example is her joyful laugh when she loses her virginity — an attitude which is totally opposed to the frightened, hypocritical one our Western society has created about female virginity.

Adele: Yes, I tried to give her that objectivity that women tend to have a lot of the time, I mean towards sex. We gradually learn that everything we have been taught is not so, but by the time we have experienced all of this we're past the childbearing age. Now we are learning much more quickly and so we're becoming very danger-ous. One of the interesting things I've learnt with age is that when a woman is fifty and she has raised her family, her energy has be-come her own and she's stronger physically. That's why many of us at that age in the past were burnt as witches — to shut us up.

Gabriella: You wrote *Crackpot* before you were fifty, and the novel can really be an example of the great intellectual freedom you had attained. Is this perhaps due to your own particular experience as an emancipated Canadian woman of the twentieth century?

Adele: I wasn't so young, and I had just had my daughter, Tamara, that year. Certainly I consider myself a privileged woman, in that from childhood I had a lot of freedom. At university I had the chance to study and socialize with a great many colleagues of both sexes on an equal level, and this certainly helped form me as a writer.

Gabriella: Does the scene describing the night when Hoda gives birth correspond to your own experience? Is this why you can ex-press the whole episode with such intensity, especially when you describe the protagonist's labour pains?

Adele: Oh no! I had written that part of the novel at least three years before Tamara was born, and I had Tamara by Caesarean. In that scene I was trying to imagine how the first woman (somebody

had to be the first woman) felt on giving birth. She didn't know anything about what she was doing or what was happening because no other woman could have told her.

Gabriella: That's amazing, and just goes to show once more how a good writer can manage to reach a perfect level of mimetic realism without necessarily speaking about something that has actually been experienced.

Adele: Of course, I used some narrative techniques to make Hoda's experience more credible; for example, she had to be very young and naïve, which is why her mother had to disappear from the scene very early on. Moreover, the detail about her mother's tumour that she thought she might have inherited could have been a logical, though mistaken, explanation for her swollen abdomen. The only thing tied to personal experience is that I also had a tumour when I was younger.

Gabriella: When you finished the book, were you satisfied with what you had managed to achieve?

Adele: No, I wasn't satisfied because, actually, I had written another version of it. Here is an instance of where you get yourself into trouble when you try to impose a structure. I had conceived of the two characters, the mother and the son, as having kind of parallel lives. One of the things that interested me was: how does a person become a strong character and how does a person not become a strong character? In other words, how does a character develop a strong sense of self and how far is this determined by circumstances? So I worked mostly on Hoda's background and her character: her home, the parents' poverty and how, above all, the strength of the family myth had formed the stable basis of her identity. Pipick, on the other hand, had no strong and continuous contact that emphasized who he was and what he was. So he remains a very vacillating character for most of the time we see him.

Gabriella: Pipick's story seems to reflect the alienation of the modern American man. The lack of parents may suggest metaphorically the lack of cultural roots, that is, those that have been lost by the second generation of immigrants. Was this your intention?

Adele: Yes, and I did want to develop it further. I thought that one of the possibilities was that he would come back from the army and there might be some kind of recognition between him and his mother. I tried to write a few scenes about it but I wasn't happy with them. I had shown the typescript to Margaret Atwood, at her request, and she said that there wasn't enough balance between the two main characters. The fact is that the woman is so strong, while interest in Pipick is lost as the novel goes on. I remember that for some time I didn't want to accept this sort of criticism; then one day I was standing by the sink washing the dishes, being annoyed and thinking to myself: "Sure everybody can talk," and so on. And it suddenly occurred to me that there was something I wanted to do, that I wanted to retain the strong focus on Hoda. There's not a strong tradition of what women have to say being preserved. If you look at the Bible, the Talmud or the Torah, you don't see any women in there. Usually, for example, during the Diaspora, men were considered; even in a *shtetl*, where everyone was so poor, man had to preserve, had to write and read because he had to read the Talmud. But only men, because the women worked in the marketplace to keep the family going while the man studied. So that what you have is a blockout, potentially, which is even worse than being blocked out — for women in general — of the culture. So I decided this time to exclude, or at least fade out, the male figure and privilege the female one. That's how I managed to finish the novel, and I'm very grateful to Margaret Atwood for having driven me to change direction and abandon the original project.

Gabriella: Crackpot, in my opinion, certainly deserves to be considered one of the masterpieces of contemporary Canadian, in particular Jewish Canadian, literature. To tell the truth, all your works are a rich testimonial to Jewish culture in Canada, a testimonial

which, besides yourself, includes important writers such as A.M. Klein, Irving Layton, Miriam Waddington, Mordecai Richler, etc. I wonder whether this might not be considered a particularly fruitful period for Jewish Canadian writers, and whether it is destined to disappear along with the inevitable process of cultural assimilation, as is happening in the United States, where the great blossoming of Jewish American fiction and poetry is almost over.

Adele: I can't foresee anything because I think that in lumping us all together you are really grouping a whole variety of writers who are not all saying the same thing, by any means. Part of the renaissance, or whatever, is strictly related to the post-war, to the revelations of the concentration camps, and a kind of recoil which meant that, for a number of years, Gentiles couldn't be comfortably anti-Semitic. Here in Canada there was a strong feeling that the Jews that remained had to be in some sense appeased and assured that not everybody was out to get them, and that they would be free now to flourish. That's a result of the war, and the reason it was a wealthy situation is because so many people, not only Jews, had been knocked off. The country was desolated, millions of people dead; there were plenty of jobs, there was rebuilding, but it was on the corpses of dead societies. All the doors were open because nobody wanted to be called anti-Semitic; most of us are protected from that because most of our Gentile friends don't let us know about the natural kind of conversation that takes place among themselves. I know that because I have been protected from it, but I have heard of it and I know that my friends would never want me to hear what is not even so offensive to them, because it is just part of a cultural speech thing.

Nowadays, many Jewish writers, particularly those that I call "the boys," like Richler, Roth and Cohen, have responded by saying: "Look, look, just don't idealize us. We're just human beings." And they have proceeded to write works which show all the warts.

Gabriella: They are extremely successful writers, however. Don't

you think that their self-humour is basically a form of self-defence?

Adele: Certainly it was a tremendous relief for the Gentile audience to have something said for them that they couldn't say themselves. But I do think that many of these stories reflect a shallow perception of what happened in history and what actually happens between people.

Gabriella: Which writers are you referring to in particular?

Adele: Philip Roth, for one. I'm not saying that they are bad writers, but that there are attitudes and ways of writing, the things they choose to say, that I feel in some senses are playing to the audience. They do not reflect a sufficient evaluation of the Jewish and Jewish American situation.

Gabriella: What do you think of Saul Bellow?

Adele: I like a lot of Bellow's work. What bothers me is that there's a certain intellectual tone that I'd sometimes like to shake him out of.

Gabriella: And Mordecai Richler?

Adele: I think Mordy's an enormously talented and a very nice man. But writing is a craft, it's a manipulation, and you have to know ideally what all the effects are going to be on other people. Although I don't say you have to protect people from defects, you have to bloody well know what it is that you really want. I think one of the things with Mordy is that he sometimes gets carried away with shocking and with his sheer comic effects; and it's not satirical — Mordy is not a satirist because he does not have one point of view from which it grows. There is an almost farcical development of some of the ideas. He's a brilliant writer and wonderfully talented, but I wish that he understood more about some of the things he writes about.

And here is another one of my hobby-horses: when the immigrants came over, they were catapulted into a different world in which a lot of the old values were taken from them, simple things like whether to work or not on Saturday. They no longer had a choice, which forced a lot of the men out of the homes, out of that sort of ghetto. They were allowed now to work and to function outside of the narrowly circumscribed home and community, which meant that they could aspire to all kinds of things that they had not previously thought of aspiring to. One was of making it in a Gentile world, another area was making it with Gentile girls and making it, making it, making it.... In other words, to take on other aspirations, other dreams.

Gabriella: It seems that we can find all of this in the novels both of Richler and of Roth. When they talk of how their protagonists try so desperately to be successful men and lovers, they are simply describing a very real aspect of Jewish American experience, don't you think so?

Adele: Yes, but you see it's an aspect that distorts because they don't seem to recognize how it came about. For example, they attack their mothers when the mothers were the ones who, historically speaking, stayed at home and were desperately trying to hold the old world together. They weren't exposed to it all because they had been brought up without the advantage, usually, of education, etc. They just had the simple faith plus the obvious daily works. To the boys and to the young men, and very often to the husbands, this seemed to be an attempt to keep them strangled, in a stranglehold of old ways, when, at the same time, there was not any kind of concomitant spiritual, religious coping with new problems. All the rabbis could say at that point was: "No, no. You're not supposed to work on Saturdays."

So what you got was on the one hand the social works, the so-called enlightenment, the entry into the political arena, into areas like socialism and so forth, trying to function as a part of the larger world to positive ends. And on the other hand, there was the

promise of the "streets full of gold" and you could make a million bucks. So there was that, and very often what they did depended on the ambience of the area where they landed. For instance, in Toronto, where the Anglo-Saxon wealth of that eastern part concentrated, you found your Jews very often tended to fall into that pattern. In areas like Winnipeg, which were large working-class areas, you have very, very strong communism and socialism.

Gabriella: If you were to compare your work with that of the younger writers you call "the boys," do you think it remains truer to existing Jewish Canadian reality?

Adele: I think that in some senses I have given a more rounded picture. Also I think, though, that I am being sort of unfair because these "boys" tend to be a little naturalistic and I am not. Right from my very first novel, *The Sacrifice*, I have always tried to go beyond simple facts. The reality I am interested in is not the visible social one, but the one that embraces more symbolically the essence of human existence.

Gabriella: It seems to me that in its strong moral commitment your work is similar to that of Bernard Malamud, the Jewish American writer. It is a morality which, anyway, in both of you does not correspond to religious orthodoxy. Which leads me quite logically to a final but crucial question: do you believe in the existence of God?

Adele: No, I don't think so — that is, I'm not religious. In taking Abraham as a model for the character in *The Sacrifice* I was really trying to combine the Greek idea of hubris with Hebrew morality.

The protagonist, Abraham, demands that God should consider him, Abraham, over again, within his own personal, historical context. It is his own need for some kind of personal revelation but it never comes. He doesn't see that what happened with Abraham and Isaac was that God said you are not to sacrifice human beings, and it's what he denied in killing Laiah. Yes, what I

have always tried to include in my stories is essentially the moral inheritance of my people.

As far as religion is concerned, I'm against any kind of orthodoxy like the return of fundamentalism; they're attitudes that refuse to learn from real experience, that reject once again the real world, as orthodox religions have always done.

I do not believe that things are right because God said they are right. That's again paternalistic. You know, I now know five ex-nuns, ex-nuns, women who left the convent and are fierce feminists. They hate the whole set-up because it was another way of being blocked off. It's an example of how religion can falsify and distort reality. As for me, I have always tried to create my own perspective on life and not accept one imposed on me. In art I'm a shaky realist because I incline towards the prophetic. I tend to be temperamental, to be positive in spite of the fact that intellectually I have very clear, unfortunate analytical impulses. So there are the two things that don't always work together.

I think now we must think seriously about our relationship with all the rest of the world, with all the rest of the universe. I think that is an extension of the same problem, the fact that we are unable to see each other as parts of one living phenomenon, one phenomenon of life. You talk about religion, and I tend to shy away from views of religion, but in terms of what we are a part of, we're all part of each other. The air between us joins us, it doesn't separate us. It's part of a continuum. I look upon people and all living things as terminals. A terminal both takes in and transmits. And we are terminals of some great living unity of creation, and each one of us is giving out and taking in, is creating itself and then folds up. It may be some kind of food we're providing for something. Who knows what it is, but it is something.

Photos of Adele by Israel Shenker, 1956.
Photos courtesy of Tamara Stone.

SEVENTY FACES TO A SACRIFICE:
ADELE WISEMAN'S *THE SACRIFICE*
AND JEWISH BIBLICAL INTERPRETATION
Reena Zeidman

Adele Wiseman's 1956 novel, *The Sacrifice*, relies very heavily on biblical characters informed by the Binding of Isaac episode. Briefly, the story-line of Genesis 22:1–19 relates Abraham taking Isaac on a *rite de passage* of sorts to be sacrificed on Mount Moriah. Isaac is saved by an angel's cry, and a ram is sacrificed in his stead. This powerful and enduring narrative has been retold in many different guises, rendered into stirring mosaics and paintings and used as imagery for trials of every sort. Wiseman is following this well-worn path to express the emblematic desiderata of Jewish life in the last century: the transition from old world to new, its emerging new expressions and its call for a restructuring of centuries-old traditions. The *Sacrifice*, on the surface, describes a "biblical" family of Abraham, Isaac and Sarah in the new world of North America (exact location never revealed). But Wiseman does not simply re-write the biblical tale on new soil. In a bold and sophisticated use of the exegetical biblical sources, she manipulates the tradition of *midrash* and appropriates it for a new audience. Her critical approaches to Judaism share much with the literature that was dominant around the State of Israel's birth. However, the method by which she expresses this battle-cry is original even to this group of writers. Zionism may be her final word of "advice" in the novel, but the reasons for this appeal are complex.

The Literature behind the Novel
Wiseman uses extra-biblical traditions with consummate skill. Many critics have not approached the novel with this literature in mind,

and have seen the biblical story as only the wellspring of literary influence. This is a major methodological weakness when analysing any form of literature influenced by Jewish tradition. If we assume our author knowledgeable in Jewish life and tradition, we must also factor in the extraordinarily large corpus of post-biblical literary traditions, known as the "oral law," that accompanies the Bible. It is, after all, impossible, when one is attempting to "rewrite" the Bible, to rely only on the written biblical tradition. The Bible, in its straight, uninterpreted form, omits many characters' motivations, includes contradictory narratives and generally fails to appeal to generations who lack any relationship to animal sacrifice, one of the Bible's main preoccupations. Consequently, the Bible has not remained static, but has developed what could be termed an "additional literary landscape." These exegetical expressions are so dominant that in a sense they obliterate the written Bible and replace the characters with new personae, or at least with additional characteristics that are often far from the literal reading.

Biblical exegetical traditions are commonly called *midrash*, a Hebrew noun that translates roughly as "seeking." The search — and this is perhaps the greatest irony of all — is predicated on the notion that the exegete yearns to define the meaning of a text that acts ostensibly as the final word. After all, the text is said to have been derived from God, substantiated by the oft-cited biblical formula "And God told Moses...." Despite this, the impulse in Judaism to interpret and colour the text is so elemental that people only too often confuse the textual and extra-textual material — *midrash* emerges as one substantial cacophony of traditions. Wiseman is also "guilty" of this, and often introduces into the mouths of her characters, material to an otherwise silent biblical text. For instance, when her Abraham describes the trials of the biblical Abraham in his native land, Ur (modern-day Iraq), the entire episode relating to his monotheistic fervour and the resentment of him by the locals is absent from the Bible:

> But the people demanded that Abraham should be
> punished as an unbeliever who had destroyed their

idols. So his father had him cast into a flaming furnace, and all the people believed that here was the end of this heretic who dared to believe in God.

But Abraham walked through the flaming furnace and was not destroyed. And when the people saw this they knew that the man was a prophet....

We are not provided with any of these details in the Genesis account. All we know is that Abraham had a father (named) and travelled from Ur to Charan and eventually to Palestine:

Terah took his son Abram, his grandson Lot the son of Haran, and his daughter-in-law Sarai, the wife of his son Abram, and they set out together from Ur of the Chaldeans for the land of Canaan; but when they had come as far as Charan, they settled there. (Genesis 11:31)

In this one example, we can appreciate Wiseman's knowledge of many post-biblical literary traditions and her willingness to infuse them into her work.

Abraham, Isaac and the Biblical Akedah

Wiseman's novel shares many similarities with the Genesis account, some pertaining to structure and others to dialogue. The opening of the novel is instructive: "The train was beginning to slow down again, and Abraham noticed lights in the distance." Genesis tells us that after Abraham took Isaac, his donkey, the wood for the offering and "young men" (interpreted as servants), "On the third day, Abraham looked up and saw the place from afar." (22:4) The long train ride is very close to the three-day journey that was undertaken in Isaac's case: "But we have two more days" says Abraham to an enquiring Isaac in the novel. And then Isaac poses another question, in a Beckett-like appeal: "Who awaits us?" This form of questioning is patterned after the biblical account when Abraham

arranges the altar for the sacrifice:

> Then Isaac said to his father Abraham, "Father!"
> And he answered, "Yes, my son."
> And he said, "Here are the firestone and the wood;
> but where is the sheep for the burnt offering?"
> And Abraham said, "God will see to the sheep for
> His burnt offering, my son." (22:7–8)

After Isaac poses his questions, Abraham is engaged in an inner monologue, similar to the Genesis account:

> [Regarding the train tickets] it's senseless trying to
> explain anything to that fellow. Listen to him. Me he
> can't answer a simple question, and now he wakes up
> the whole train and with his shouting up and down.
> Well, I suppose he can't help himself. Would I have
> understood him even if he had understood me?
>
> Strength and humor returned with his decision.
> He moved around and stretched; his blood began to
> circulate again. Like a young man entering deliber-
> ately into an adventure, he felt excited at making a
> positive gesture in the ordering of his fate. (5)

The first section of this excerpt corresponds to Isaac's question and the latter half relates to the "fate" that Abraham voices to Isaac in Genesis.

There are other more subtle signals that Wiseman's story is a retelling or, what I argue, a remoulding of the biblical story. Abraham reflects on his son early in the novel: "The boy was young, the boy was blessed, the boy would grow" (6). These three aspects of the boy correspond, in both tone and tempo, to God's command in Genesis, where Isaac is referred to in three distinct ways:

> Some time afterward, God put Abraham to the test.
> He said to him, "Abraham," and he answered, "Here

I am." And He said, "Take your son, your favored one, Isaac, whom you love, and go to the land of Moriah, and offer him there as a burnt offering on one of the heights that I will point out to you." (22:1–2)

Commentators have treated this three-fold directive to much analysis, in part because of the redundancy of the command in light of the normal biblical economy of language.

Further, the two Isaacs carry weight (literal and metaphorical) on their shoulders: "'I can't let you go on carrying me on your shoulders'" yelled Isaac when he wanted to take a job and quit school (47). Genesis: "Abraham took the wood for the burnt offering and *put it on* his son Isaac" (22:6; emphasis added).

The title of Wiseman's novel plays on the ambiguity of the event. Jewish literary tradition assigns the word *akedah* — literally, "binding" — to refer to the narrative, rather than "sacrifice," which would be rendered *korban* in Hebrew. (The biblical term "olah" used in the Genesis narrative refers to an offering that is totally burned, and not left for consumption by the priests.) The term "sacrifice" signifies more of a personal activity. For this reason the Hebrew term used most likely refers to the binding of Isaac on the altar. Wiseman is aware of this ambiguity and uses it consciously in her novel; she never specifically refers to the person who is performing the sacrifice or to its victim. Isaac may be the obvious choice of subject because of his heroic act (where he saves the Torah), but Abraham also sacrifices someone in a way that I suggest is meant to redeem him. Consequently, the title connotes the complexity that accompanies the Jew in the modern world: in what ways is it necessary to sacrifice, and what is the aim of the act?

Isaac
Wiseman's Isaac shares affinities with the biblical personality, in being a son to Abraham and Sarah and eventually outliving his two siblings, but his character is drawn principally from midrashic literature. In Isaac's most dramatic act in the novel he sacrifices

himself in a noble attempt to save the Torah from burning in a synagogue fire (194-5). The most startling aspect of this act is that Isaac operates without the encouragement of Abraham or any other character. Wiseman develops an Isaac who differs from the biblical figure, but who owes much to his midrashic character, although this bond too is severed.

In Genesis we find that Isaac is almost sacrificed, saved by the sudden appearance of a ram. After "God's angel" stopped Abraham from the deed, we read, "When Abraham looked up, his eye fell upon a ram, caught in the thicket by its horns. So Abraham went and took the ram and offered it up as a burnt offering in place of his son" (Genesis 22:13–14). However, in a number of the approaches to this verse Isaac actually dies on the altar, is burned and is resurrected, for ever marred by the experience. Even though this interpretation seems like an extreme position, there is textual evidence to suggest it. Genesis notes that Abraham returns alone to the base of the mountain: "Abraham returned to his young men, and together they set out and went to Beer-sheba. Abraham remained in Beer-sheba" (22:19). Where was Isaac, ask the commentators? They posit that Isaac must have died and been resurrected at a later date. One comment in the Babylonian Talmud notes that he died leaving his ashes as a mark for those constructing the Second Temple:

> When the generation that returned from the Babylonian Exile began to build the Second Temple, how did they know what to do with the altar... R. Isaac Napha said: They beheld Isaac's ashes, that these lay on the spot."

The assumption encoded in the talmudic response relies on Isaac's death through fire and his revival. One such medieval tradition makes this explicit:

> When Father Isaac was bound on the altar and reduced to ashes and his sacrificial dust was cast on

Mount Moriah, the Holy blessed be He, immediately brought upon dew and revived him.

Redemption, in general, is achieved through Isaac's near-fatal experience:

> Whenever the children of Isaac *sin* and as a result come into distress, let there be recalled to their credit the *Akedah* of Isaac and let it be regarded by Thee as though his ashes were heaped up on top of the altar, and do Thou forgive them and redeem them from their distress.

This approach was popularized in the Mahzor (High Holiday Prayer Book):

> O, do Thou regard the ashes of Father Isaac heaped up on top of the altar, and deal with Thy children in accordance with the...Attribute [of Mercy].

Wiseman, to be sure, employs these well-known traditions, and has Isaac die indirectly by fire. However, the new synagogue in her narrative is not built on the site where Isaac saved the Torah scroll, but rather is situated in "the heights," a richer section of town. In my schema, Wiseman is suggesting that the new world shares little with the Jewish world of old. Life does not take on symmetrical significance with God as the obvious director. In Abraham and Isaac's new world there is no justice, and figures are lacking the strength to save the old site. Quite simply, redemption fails to operate in the traditional manner advanced by our texts. Even Isaac recognizes the ironic note in his act when he suggests that the saved scroll is none other than the very one donated by a thief! Consequently, Isaac's act restores the tainted Torah scroll, a sorry end to an unparalleled act analysed critically by Isaac himself:

> And they [the new builders] will examine it [the

Torah] and want to know its history. And someone will say, "Yes, it was donated by one of the first Jews of the city, Schwarzgeist." And someone else will say, "Schwarzgeist — aha, he must have been a fine man if God saw fit that his Torah should be saved." And so the name of this other sterling citizen, and both these names will be preserved in the annals of time. Old men will bless us. (215-16)

Modern Jewish history, in Wiseman's eyes, shares very little with its midrashic predecessor, even if the circumstances portray a world where everything is in place. The tragedy in Wiseman's story is that all appears ripe for redemption through ashes, but none is forthcoming.

Isaac's solitary act demonstrates another element of the sad state of affairs in which Wiseman judges this world. She has Isaac acting in a blind fashion, reacting to some primal instinct. His comments bear this out: "Did I ever realize the danger of the moment...I have committed an act of faith" (212). He acts without reflection, in a way that is distinct from the biblical Isaac but bears many similarities to the actions of the biblical Abraham. It is Abraham who follows God's orders in the Genesis account, not Isaac, the latter introducing the obvious missing element for an animal sacrifice: "Here are the firestone and the wood; but where is the sheep for the burnt offering?" (22:7). Further, the biblical Isaac requires deception to continue on the divinely commanded journey. Not so in Wiseman. This character reversal demonstrates how the author manipulates the sources at hand. In her recasting of the events, she blurs the biblical Abraham and Isaac. Isaac is more like Abraham than Abraham is — a recognition which, I suggest, marks the tone of the entire book: the lines of the old world are submerged within the new. The children reject the tradition of another time, not in any rebellious, conscious manner, but as a matter of course. Isaac, for instance, chooses his own bride, Ruth — a departure from tradition not lost on the ever-critical Ploplers: "It's funny how the boys choose girls nowadays.... Some-

times I think they go to too many parties and get their heads turned so they hardly know what they're choosing" (94). Abraham, rather than agreeing with this viewpoint, defends Isaac's choice: "'My son' — Abraham's voice was firm with only a slight edge — 'knows what he's choosing'" (94).

The most significant manner in which Wiseman brings out Isaac's Abraham-like qualities is by relying on the midrashic Isaac who is drawn as an adult. Despite the lack of biblical evidence in this regard (many traditions age him to thirty-seven), the midrashic Isaac, displaying marked rational behaviour at the darkest hour, encourages Abraham in his trying task. He has been transformed into a new, more powerful person, one so aware of his own weaknesses that in one tradition he encourages Abraham to bind his cords of death tightly on the altar itself, lest he flinch involuntarily and blemish the sacrifice, thus disqualifying himself for God:

> When Abraham was about to begin the sacrifice, Isaac said, "Father, bind my hands and my feet, for the urge to live is so willful that when I see the knife coming at me, I may flinch involuntarily and thus disqualify myself as an offering. So I beg you, bind me in such a way that no blemish will befall me."

Wiseman's Isaac is also drawn as an independent figure in yet another rather subtle development in the novel. In one section, Abraham recites to Isaac the biblical story of the Akedah, whereupon Isaac concludes, "the three of them [were] bound together in their awful moment" (179). "Bound" is an allusion to the binding in the Genesis account: "They arrived at the place of which God had told him. Abraham built an altar there; he laid out the wood; he bound his son Isaac; he laid him on the altar, on top of the wood" (22:9). The physical act of binding is reinterpreted on an emotional level. The "binding" becomes a haunting allusion to the unity between father and son, a point noted by many biblical Jewish commentators. The biblical account says, "Abraham took the wood for the burnt offering and put it on his son Isaac. He himself

took the firestone and the knife; and the two walked off together"
(22:6), and later "And Abraham said, 'God will see to the sheep for
His burnt offering, my son.' And the two of them walked on to-
gether" (22:8). This repetition of the word "together" provokes a
midrashic response that captures the poetry of the union:

> [Despite the pain of ultimate death] "they went both
> of them together" (22:8) — one to bind, the other to
> be bound; one to slaughter, the other to be slaugh-
> tered.

Another section also addresses this poignant moment:

> "And they came to the place" (22:9) — both carrying
> stones [for the altar], both carrying the fire, both car-
> rying the wood. For all that, Abraham acted like one
> making wedding preparations for his son, and Isaac
> like one making a wedding bower for himself.

The novel omits this midrashic element in the climactic scene of
Isaac's life; Wiseman's Isaac carries out his act independently, free
from his father's will. This refashioning of his midrashic character
suggests the weakness and failure of modern Jewish life. Human
relations in the new family unit and within the larger Jewish world
are devoid of unity. Jewish life is left without its literary and moral
markers — a new sort of relationship must be forged between all
forces of society, but Wiseman's characters lack the fortitude and
knowledge to respond.

Abraham

The figure of Abraham owes much to the biblical persona, but his
final act, his "sacrifice," is a grotesque and significant departure
from the biblical unit and its exegetical tradition. In this way,
Wiseman once again takes a character who is known to act in a
certain way based on all biblical traditions, and develops him into
such a dramatically distinct character that broad irony and pathos

are the only responses evoked.

In an act that appears to parallel that of Wiseman's Isaac, Abraham also "sacrifices." In the biblical account, he refrains (with the aid of the heavenly agent) from the horrible act. Wiseman not only has her Abraham murder, but has him kill an innocent victim, Laiah — a woman who is eager to marry him.

Abraham's murder is full of ironic incident. Is it possible to draw an Abraham, based on the Bible and its subsequent traditions, who really has the potential to kill someone? Wiseman knows only too well that Abraham is personified as a character who eases human suffering and pain at every opportunity. On one of many occasions, we find him treating three "men," who eventually disclose Sarah's impending pregnancy, exceptionally well (Genesis 18:1-8). This episode sees our protagonist resting by the oaks of Mamre — a rest well deserved, according to *midrash* — after his circumcision late in life. Despite his discomfort, we find him reacting to the visitors in a flurry of activity, granting them every possible element of comfort: cleanliness, food, security. Another biblical story finds a bargaining Abraham attempting to save the morally bankrupt towns of Sodom and Gomorrah (Genesis 18:20–33).

The novel sees Abraham not only murder Laiah, but do so at the very moment when she is admiring his beard, a symbol of the old country. Abraham's eerie cry, "Live!... Live!... Live!" pierces the death scene (304). This mantra might be a cry for Laiah to live, but it also suggests a plea in which Abraham's own life is being summoned; that is, a cry for his own spiritual and emotional regeneration as he is ironically taking another life, slitting a woman's throat, in a way all too reminiscent of the potential human sacrifice of the biblical account. Abraham also intones part of a prayer, which suggests that this act could be used to lead him back to God, or at least back to some form of stability:

> Looking at her then, he was lifted out of time and place. Lifetimes swept by, and he stood dreaming on a platform, apart, gazing at her with fear growing in his heart, and somewhere his Master, waiting. As in a

dream, the knife was in his hand, the prayer was on
his lips. Praying over her, at some neutral point in
time, he saw her as though for the first time, and yet
as though he had always seen her thus, saw her as
something holy as she lay back, a willing burden, to
offer, to receive, as once another.... From inside him
a tenderness swelled toward her, and for a moment
he forgot his fear and felt as though he were almost
on the point of some wonderful revelation.

"...Eloheinu Meloch Hoaul'om...." (303)

This somewhat repetitive passage makes it very clear that Abraham
is recovering his self-worth, his sense of place in the world and
possibly within the divine realm. The latter element is revealed by
the Hebrew blessing voiced by Abraham: "[Blessed are You...] our
God, King of the universe...." Even more haunting is Laiah's ob-
liviousness of the manic mood of her imagined lover, and she "hears
with amazement the Hebrew words. Even over this [ostensible
imminent sexual relations] he has to make a blessing. Her lips
twitched to a smile" (303). It is at this moment that Abraham ex-
periences some form of revelation:

Even as his arm leaped, as though expressing its own
exasperation, its own ambition, its own despair, the
Word leaped too, illuminating her living face, caress-
ing the wonder of the pulse in her throat.... (304)

"The Word" may refer to the opening lines of the Book of John,
but since Wiseman, in my mind, does not draw on any other Chris-
tian symbols, it is unnecessary to identify this passage with New
Testament imagery. More consistent is that the "Word" refers to
the Ten Commandments, rendered in literal Hebrew as the "Ten
Words." Wiseman is proposing, by this suggestive play on "the
word," that Abraham tries to pattern his life on the command-
ments, or by extension on the entire Bible, a force of stability and
faith. But Abraham misses the point; he is too literal-minded and

fails to realize that this form of faith is an unmitigated failure in the new world. It is no longer possible, according to Wiseman, to rely on the word, or any part of it. Abraham fails to recognize that one can not substitute one victim for another, as his biblical namesake does. After Isaac "sacrifices" himself, all biblical models are inoperative. Once again, suggests Wiseman, re-evaluation is the necessary tool that will save the older generation.

Sarah
Sarah shares many similarities with her biblical namesake. The book opens with Abraham commenting on his wife's beauty: "The first time I saw her she awakened desire in me." Compare to Genesis 12:11: "I know what a beautiful woman you are."

The character is not one of the more appealing or more developed figures in the novel. But Wiseman, in her own understated way, infuses Sarah's character with elements found only in the interpretive tradition. We notice from the outset that Wiseman's Sarah is portrayed as emotionally paralysed, silent, almost dead. She even lacks the ability to speak. She performs very poorly in English classes, as if she isn't there: "Sarah had sat shyly, and blushingly couldn't answer the questions that were put to her by the young teacher" (24). Sarah's silence again: "When she cried it was no longer as though she cried with tears. The ocean had drained away, and she cried now with only the pebbles on the beach" (27). In part, this Sarah is created from the emotional aftershocks of her two sons' brutal death in a pogrom in Eastern Europe. Abraham remarks on this several times: "'We thought that my wife had died right then'" (58). And later he refers to her lifelessness during Isaac's illness: "My wife could not bear much more. The boy's illness had sucked what was left of her spirit from her" (72).

Significant for us is not that Sarah is so lacking in human spirit, but that it is Isaac who has developed a tight and impenetrable bond with his mother. He comments on her characteristic silence at many points in the novel. At one juncture, the young Isaac remarks: "His father's deep, open-mouthed breathing continued to purr and chortle from the bed, and his mother lay silent, curled

up under the bedclothes" (9). Moreover, it is Isaac who senses his mother's imminent death. In a very dramatic scene, as Isaac is running to catch a streetcar on his way to tutor a student, the strength of this union is revealed:

> For a long time Isaac remained there against the tree, so that in the end he knew that it was too late to visit his pupil. By the time he had started on his way home, placing one foot uncertainly in front of the other, he knew too, without even thinking about it, that his mother was going to die. (142)

This relationship owes a great deal to the rich midrashic tradition on the Sarah–Isaac union during the Akedah. Although Sarah is absent from the biblical narrative, the exegetical tradition introduces her into events at three critical moments: as Abraham and Isaac set out on the journey, at the moment of near death and at the homecoming. Many of these traditions focus on the loving and sensitive relationship that exists between mother and son. In one fascinating section, Satan, a dramatic, sly character, attempts to draw Isaac away from the divine plan by using Sarah as bait:

> Satan left Abraham, and disguising himself as a young man, stood at Isaac's right and said, "Where are you going?"
> Isaac: "To study Torah."
> Satan: "While still alive or after your death?"
> Isaac: "Is there a man who can study after his death?"
> Satan: "O hapless son of a hapless mother! How many fasts did your mother fast, how many prayers did she utter until at last you were born!"

Sarah and Isaac's souls are so united that Sarah midrashically accompanies Isaac into his near death. At the very moment, between life and death, we read:

[At the time Isaac was bound], Satan went to Sarah, appearing to her in the form of Isaac. When Sarah saw him, she asked, "My son, what did your father do to you?" He replied, "My father took me, led me up hills and down into valleys, until finally he brought me up to the summit of a high and towering mountain, where he built an altar, set out the firewood, bound me upon the altar, and grasped a knife to cut my throat. Had not the Holy One said to him, 'Lay not thy hand upon the lad,' I would have been slaughtered." Even before Satan finished his tale, Sarah's soul left her.

It is Isaac who places his death in the context of his mother's imminent loss:

"Father, hurry, do the will of your Maker, burn me into a fine ash, then take the ash to my mother and leave it with her, and whenever she looks at it she will say, 'This is my son, whom his father has slaughtered....'"

At another juncture:

Then Isaac said to Abraham, "Father, don't tell Mother about this while she is standing over a pit or on a rooftop, for she might throw herself down and be killed."

It is evident that Wiseman relies on these colourful midrashic traditions to detach the seemingly one-dimensional characters from their biblical roots and have them rely on other wellsprings of influence, to reflect the non-biblical, or rather the non-traditional, elements in the modern life of the Jew.

Conclusion

The Sacrifice advances a critical vision of modern Jewish life. Wiseman's characters fulfil only a fraction of their biblical or even midrashic namesakes' potential. Isaac dies without any hint of resurrection and Abraham sacrifices the "wrong" character. Nothing is clear any more; all lines of communication and received tradition are lost or broken, or require reinterpretation. This is Wiseman's way of responding, through parable, to the problems of Jews in modernity. She forces us to pose the question: Can we only relive the episodes from the Bible, or from the post-biblical tradition, like a pedlar cyclically repeating ritual from year to year? Is there nothing else? Wiseman recognizes this agonizing difficulty so entrenched in an ancient religion.

The novelist, however, does not respond solely through layers of ambiguity and irony, but actually concludes the novel with an answer of her own, one that is perhaps more "traditional" in certain families of socialist-zionist leanings. She ends with Isaac's son assuming the mantle of responsibility. Wiseman chooses to grant a *Moses* the new world rather than a *Jacob*. The latter, in Jewish exegetical tradition, represents docility and adherence to constant Torah study, a man who "dwelled in tents" (Genesis 25:27). Moses, conversely, represents a character who acts and finally saves Israel from slavery in Egypt. Wiseman's Moses likewise demonstrates these qualities. He is distinguished by his visit to his grandfather Abraham in the institution on Yom Kippur, the Day of Atonement, a day when many Jews devote themselves to prayer, fasting and abstention from work. Moses, in a powerful break from these religious rituals, actually takes it upon himself to visit his grandfather, thus directly rejecting tradition in its accepted expression. He represents the new child, full of compassion as distinct from religious zeal and other remnants of tradition. He will not be able to experience revelation in the older ways, but draws on one that rests on human interaction and reflection. So we read the narrator's version of Moses after his visit with Abraham:

Nothing had happened, really. [Moses] had not

wrenched from the past a confession or a cry for forgiveness; he had not won an exoneration or wreaked some petty revenge. He did not even know concretely, in any way that he could explain to himself as yet, any more than he had known. And yet he knew that he was a different person from the boy who had gone up the hill. (345)

Moses' visit triggers his thoughts on love: "He wondered if he would have the nerve to say right out, 'I love him [Abraham]' — just like that" (346). Moses is not the only new type of Jew. Those wealthier children, always eyed with suspicion by the less privileged classes, also demonstrate the new liberal approach to life. Moses recognizes this in his remarks about the wealthier Aaron: "He seemed — pretty nice, for a heights kid. It almost seemed as though he had been trying to make friends" (340).

Zionism is a force dominant in the new generation, and operates as a replacement for traditional values. Moses meets Aaron, grandson of Chaim Knopp (Abraham's best friend), who is planning to fight in the newly formed Israeli army. Zionism's sense of hope emerges in Aaron's conversation with Moses: "'We'll start a new country.... Start new, build new, clean, get rid of all the dirt'" (339). The rebirth harmonizes perfectly with the young generation. Wiseman's vision of hope for her generation is clearly one of the Moses variety: compassionate, non-religious and thoughtful, with a sense of Zionism as an entrée into a new world. Wiseman's approach resonates with the archetypal post-Zionist thought in and around the State of Israel's birth. The Diaspora is viewed as a stage of Jewish history that requires obliteration. Yitzhak Baer sums up this sentiment in *Galut* [The Exile]:

All modern interpretations of the *Galut* fail to do justice to the enormous tragedy of the *Galut* situation and to the religious power of the old ideas that centred around it. No man of the present day, of no matter what religious orientation, dares claim that he

is equipped to carry the burden of the centuries as did his forefathers, or that the modern world still presents the internal and external conditions necessary to realize a Jewish destiny in the older sense.

The *Galut* has returned to its starting point. It remains what it always was: political servitude, which must be abolished completely.

Perhaps Wiseman's vision is naïve for the 1990s, but it is perfectly consistent with the hopes of many in the expectant times of the 1950s.

CRACKPOT: A LURIANIC MYTH
Kenneth Sherman

*Into how many pieces does one break
and still bother to count the pieces?*

Crackpot — an intriguing title. Hoda, the novel's central character, is physically a cracked pot, a prostitute or, as she comically calls herself, a "Sexual Worker." Then there is her blind father, Danile, who is also referred to as a "crackpot." He is a Shlemiel figure. Hoda says: "There was something in Daddy that acquiesced in not knowing." His innocence and naïveté make him something of a fool, yet that same childlike quality provides him with a clear perception of thoughts and issues. He is unable or unwilling to see much of the hard-core reality around him, yet his cronies point out: "There was something of holiness about him...his questions were not the questions of a fool."

Aside from puns and character implications, "crackpot" refers directly to the novel's epigraph:

> He stored the Divine Light in a Vessel, but the Vessel, unable to contain Holy Radiance, burst, and its shards, permeated with sparks of the Divine, scattered through the Universe.

This is from Ari's Kabbalistic legend of creation. Ari was Ashkenazi Reb Isaac, also known as Isaac Luria (1534–1572), a Jewish mystic born in Jerusalem who developed a significant strain of Kabbalistic theosophy. Wiseman is not employing some esoteric bit of religious occult. In his study *Major Trends in Jewish Mysticism*, the Kabbalistic scholar Gershom Scholem points out

167

that the Lurianic myth is a form of mysticism "which has exerted by far the greatest influence in Jewish history and which for centuries stood out in the popular mind as bearer of the final and deepest truth in Jewish thought." As evidence of this, the name of one of its major components, *Tikkun*, is now the name of a leading intellectual magazine in the U.S.

I do not wish to suggest that one can place the system of Lurianic myth over *Crackpot* and come out with a perfect fit. A novel has to have some edges hanging out, some mysterious inner pockets that the reader can delve into. But an understanding of the Lurianic myth will help us to better understand the novel's major progression.

The Lurianic Kabbalah constituted a direct response to the Jews' expulsion from Spain, and bears a relevance in our time to the questions raised by the Holocaust. Luria's Kabbalistic work contains a creation myth which is divided into three major experiences: *Tsimtsum* — the self-limitation or exile of God; *Shevirah* — the breaking of the vessels; *Tikkun* — the harmonious correction and mending of the flaw.

Tsimtsum, the first experience, is like a self-exile which God himself undergoes. He who once filled the universe retreats from part of that universe. The reasons for this are complex and varied. One of the more obvious reasons, which Scholem explains in his book *On the Kabbalah and its Symbolism*, is that the limitation creates a "pneumatic, primordial space...and makes possible the existence of something other than God and His pure essence."

From this exiled position, the *Shekhinah* (God's visage; His radiance) sends forth its ray of light into the primordial space where creation takes place. One form creation takes is *Adam Kadmon*, or Primordial Man, whose eyes refract the lights of creation emanating from the *Shekhinah*. This holy radiance is to be refracted into vessels consisting of lower mixtures of light. Upon impact, however, these vessels are shattered. Scholem states, "This is the decisive crisis of all divine created being, the 'breaking of the vessels'"; after this event, the heaviest sparks and portions of the broken vessel fall to lead an existence of their own as daemonic

powers.

The result is devastating: a myth of alienation and redemption is created. Scholem states, "After this crisis nothing remains as it was. Everything is somewhere else. But a being not in its proper place is in exile. Thus, all being is in need of redemption."

Everything is flawed, like the female hunchback and the blind man who create Hoda, like the bodies of the men who come to her for comfort:

> Sometimes they were indeed horrible deformities of the human vessel...often they were such little things, such minor cracks and chips and variations in the human design...in the minutest flaw men divined perfection withheld, and saw themselves cast down.

Hoda herself knows that she is a cracked vessel. Though she is called a "sturdy little vessel" early in the novel, she is destined to break, for her father has "stolen the brightness from the sun," the *Shekhinah*'s radiance, which is rumoured to have caused his blindness. This brightness, or "sweetness," accounts for Hoda's love, compassion, joy and sensitivity, by which she attempts to spread good will and comfort throughout the miserable, dark world about her. But these qualities, mixed with her own imperfections (for instance, her early ignorance of how babies are made), result in a painful series of events which at times bring her to the brink of madness.

Early in the novel, Danile, who is referred to as a "leaky vessel," reveals to Hoda his own perception of the Lurianic universe:

> I don't know; it's hard to figure it all out. There seems to be something not quite altogether between time and place and feelings and events. The pieces don't match up; they won't hold still, the right time, the right place in life, the right feeling, the right length and strength for each...there are just too many pieces,

each reaching for the others, and each being swept along in a different direction.

It takes Hoda some time to accept this vision. Essentially she is an optimist, a reveller, a girl who celebrates everyone's wedding and weeps at everyone's funeral. Her concerns are universal. It is rumoured she even visits the Gentile cemetery. She says she feels like "a direct tap to the source of boundless good will, just waiting to be turned on." Given Hoda's future occupation, the "turned on" may be too heavy a pun; yet it must be kept in mind that Hoda makes no moral distinction between sexual and spiritual good will. And upon the character of her school teacher, Miss Boltholmsup, guardian of WASP squeamishness, prejudice, and puritanism, Hoda streams forth like a ray of light, revealing the neurotic, paranoid mind that has been given authority over a classroom of children.

No moral consideration of her activities breaks in on Hoda until after she unexpectedly gives birth to a son. The scene is the most vivid in the novel and we are invited to make a connection with the "breaking of the vessel," through the process of birth. Again, creation is imperfect. Reacting spontaneously, Hoda bites the umbilical cord; she ties an unprofessional knot that leaves her son "flawed" and accounts for his name, *Pipick*, Yiddish for navel.

From this point on, Hoda must contend with her guilt (she anonymously leaves the child on the steps of an orphanage), a guilt which drives her at times to think of herself "running, sucked by invisible forces through the dark streets."

In Luria's Kabbalistic thinking there is the implication that the exile of the *Shekhinah* may be a symbol for our own guilt. It is therefore fitting that Hoda is now able to catch glimpses of a Lurianic universe. Listening to a story of sexual depravity concerning the director of the orphanage, Hoda thinks of her own life:

...something came to life in her, shards of an irrevocable Hoda, buried all those years in her own flesh, searing through her to a lost wholeness.

She now has "the suspicion that in fact some situations are irremediable," and when the guilt over her orphaned son reaches its zenith, we are told:

> She, who had experienced at times an electrifying sense of the unity of beings, now felt the jagged chill of dislocation, of separation even of herself from herself.

Here we have the keynote to the Lurianic experience — the exile of the self from the self.

In an attempt to alleviate this guilt, Hoda sends anonymous donations to the orphanage for her son, whom she calls "the Prince." Aside from Pipick, he is also called David, which, like "the Prince," has associations with royalty. In the Lurianic myth, the Prince is a Messianic figure. Nor is this Hoda's first prince. Earlier in the novel she indulges in adolescent fantasies of involvement with the Prince of Wales. She leaves a mysterious note with her newborn son concerning this fantasy, which leads to the baby's royal nickname. The connection here, between Hoda's romantic delusion and her belief in the future success of her offspring, may suggest that her Messianic dream is adolescent in nature.

Luria is very clear on this: *Tikkun*, or redemption from the tragedy of the shattered vessel, requires every Jew to participate in good deeds and prayer. As Scholem states, "In the Lurianic myth the Messiah becomes a symbol...the coming of the Messiah means no more than a signature under a document that we ourselves write." Like much of Jewish theology, the Lurianic Kabbalah is essentially existential in nature, emphasizing action over dreams.

Not until Hoda gives up her dreams about both princes is she ready for redemption. She decides it would be detrimental to try to make contact with her now wandering son; we are told, "Hoda no longer nursed futile dreams."

Hoda is not the only Messianic believer. Her son seems able to bring out the dreams of the entire community:

The congregation was much impressed by the piety and sense of responsibility of the foundling son, and dredged up instances from the Holy Works of like special cases who had been mysteriously introduced among the people, to perform eventually feats especially assigned from heaven.

Hoda's son is seen as a "champion, destined to engage and vanquish this new fiend of Europe, this German Hitler." It is also expected that the Prince will eventually be cast out by his own community and made an exile, which is exactly what happens later in the novel when a powerful member of the community, in need of a scapegoat, generates false rumours about David. For Luria tells us that even if the Messiah were to come, we would act like those at Sinai, worshipping the golden calf and casting God's gift aside.

A further aspect of the Lurianic myth which bears relevance to the novel concerns the *Shekhinah* (thought of as feminine) being torn from the Godhead, *Ze'ir* (which is masculine). To make herself whole, Hoda must find a man; a marriage of masculine and feminine must take place. She meets a displaced person named Lazar who has lost his wife and children in the Holocaust. Like Lazarus, he has risen from the dead:

> ...he was plucked alive from all that dead flesh; out of all that pile of bodies he alone dragged himself free and crawled away from the charred pit.

Hoda originally rejects Lazar because he offers her a "new life," and she is done with such hopes and dreams:

> You know what happened to the last guy went around offering new lives? They nailed him up!

But Lazar proves to be strong and sensitive, and Hoda is moved when given a glimpse of his tragic past, which Lazar believes lives eternally in the present; he asks, "How can you remember what can never become the past?" Hoda identifies with Lazar's suffering and yet realizes the enormity of it in comparison to hers. She is shamed and at the same time conquered. In the end, she extends herself towards Lazar, thus existentially returning the feminine to the masculine.

In her final vision, which concludes the novel, Hoda appears to come to terms with her life. We are told, "She occupies her past; she inhabits her life." Her vision takes place in a dream; whether that disrupts the strength of the vision is a matter for speculation. All one can say is that Hoda sees herself participating in a scene of reunification, drawing "a magic circle" around a class of children, telling them that soon "they would all be stirring the muddy waters in the brimming pot together."

The broken vessel has been mended, and a vision of universal interaction, physical as well as spiritual, is promised.

THAT THIRD BIG FICTION
Seymour Mayne

In memory of Adele Wiseman

That third big fiction
 gnawed,
held you like a crab
 in the pincer
 grip of its claw
and then worked its way
 deeper
finding a route to
 nurture
in the very veins
 of your blood.

Pacified from time
 to time
it retracted and you
 burst forth
with generous help,
 but when stillness
spread like a quiet pool,
there it upreared
 itself again,
and you could not
 keep it in check
with poetry or prose,
with warm hospitality
 to friends.

It got bolder at the end,
 leapt out,
held down your strength
 thwarting the unborn words
and then caught you double
 with a knockout
to your caring head,
leaving pages and pages
 orphaned and uncollected.

THE FISSURE QUEEN:
ISSUES OF GENDER AND POST-COLONIALISM
IN *CRACKPOT*
Michael Greenstein

What would happen if one woman told the truth
about her life? The world would split open.

—Muriel Rukeyser, "Kathe Köllwitz"

Both feminism and postmodernism, according to Patricia Waugh,
"celebrate liminality, the disruption of boundaries, the confound-
ing of traditional markers of 'difference'; the undermining of the
authorial security of the 'egotistical sublime'" (4). In this align-
ment of feminism and postmodernism, Waugh goes on to say, the
goal is not to isolate the individual ego but "to discover a collective
concept of subjectivity which foregrounds the construction of iden-
tity *in relationship*" (10). While Adele Wiseman's *Crackpot* certainly
fulfils these criteria, it also belongs within a post-colonial tradition
where, in the words of Wilson Harris, the reader has "to perceive
realism and fantasy as a threshold into *evolution and alchemy*. That
threshold is a component of the 'mental bridge' within and across
cultures" (Harris 69-70). When Linda Hutcheon demonstrates how
post-colonialism destabilizes the fixity of borders and centres, we
may immediately recognize the common terrain shared by femi-
nism, postmodernism and post-colonialism. Magic realism in post-
colonial fiction initiates a kind of double vision or "metaphysical
clash" within the colonial culture, a binary opposition within lan-
guage that has its roots in the process of either transporting a lan-
guage to a new land or imposing a foreign language on an indig-
enous population (Slemon 12). Like its protagonist, Hoda, who is
able to embrace so many bodies, *Crackpot* contains multiple varieties

177

of feminism and post-colonialism.

Hoda's development from childhood through adolescence and womanhood places *Crackpot* somewhere between the female picaresque and *Bildungsroman* traditions. Hoda's coming of age certainly accords with Annis Pratt's description of archetypal freaks: "These enclosure images, associated with the eighteenth- and nineteenth-century gothic novel, surface in contemporary characterizations of young heroes, 'growing up grotesque'" (31). Backed into a corner and under the bed, Hoda bursts forth from images of enclosure as she becomes an expert at shattering all confusing boundaries. As an adult, Hoda corporates her childhood vision by succumbing to an incestuous relationship with her son. "The heroine's developmental course is more conflicted, less direct; separation tugs against the longing for fusion and the heroine encounters the conviction that identity resides in intimate relationships, especially those of early childhood" (Abel 11). Hoda's breaking the most intimate of taboos is never erotic, for the sheer comedy of the situation neutralizes the sexuality: Pipick's grotesque umbilical cord displaces his penis as a prominent marker, insisting on original fusion rather than sexual dominance, even as Hoda's layers of fat insulate against pornographic impulses. Wiseman's use of *erlebte Rede* or *style indirect libre* allows the reader to enter Hoda's mind but distances the reader from her body, so that anatomical sharing supersedes the sexual act. In *Crackpot*, since sex is only one of the many forms of bonding, it never controls the narrative at the expense of other themes and images.

As Wiseman shuttles between realistic and fantastic modes, she simultaneously distances and involves the reader with regard to Hoda's life. If in traditional comedy we tend to look down at the comic hero, in *Crackpot*, where directions are constantly reversed, no sooner do we assume a superior position to Hoda than we are immediately drawn into the speaking mirror of the heroine's anatomy. The reader celebrates Hoda's sexuality alongside her. The fairy-tales embedded in *Crackpot* are, in Ellen Cronan Rose's words, "embryonic tales of *Bildung*, related to 'primitive *rites de passage* and initiation rituals,' what can a woman learn about her own

socialization if she rewrites a fairy tale 'so as to clarify its meaning?'" (Rose 211). In Hoda's rite of passage, Wiseman rewrites not only fairy-tales, but also Canadian Jewish reality, the coming of age of Canadian Jewish history. Just as Wiseman uses these feminist strategies to subvert patriarchal structures of orthodox Judaism, so she affirms post-colonial strategies to criticize traditional hierarchies in Canadian society.

Current theorizing about post-colonial writing focuses on the roles of magic realism, allegory, irony, myth and parody in transformations of history from the metropolitan version of High Modernism to the re-visionings of postmodernism. All of these elements are present in *Crackpot* to a greater or lesser extent. Consider, for example, the transformation of the motto for Winnipeg's City Hall — Commerce, Prudence, Industry — which extols the authoritarian, patriarchal virtues of capitalism and colonialism. Hoda challenges that motto from her unique perspective, which combines linguistic overkill, grotesque vision, socialistic levelling, the deconstruction of male authority, and post-colonial strategies. In "other" words, Hoda's excessive orality overwhelms the master narrative etched on the big fancy shield in the centre of the building, over the front doors. Her series of *petits récits* and her linguistic play transform those old proclaimed truths of Commerce, Prudence and Industry into something else — the essential comedy at the root of humanity, as perceived from the wholeness of androgynous vision.

Wiseman leads up to her exposé of City Hall by reminding us that Hoda visits the Public Health Department for urine analysis and breaks down the barriers between private and public. Hoda uses any orifice to lay bare artifice: "The sentences she puzzled together lost some of their youthful clarity and certainty, and gained a little more of the disturbing resonance of ambiguity, took on, in fact, something of a rudely philosophical cast" (211). Like Wiseman, Hoda artistically strings phrases together and strives for the ambiguity which disturbs her immediate audience and resonates along colonial corridors. In her long discursive monologues she tries "to hunt down and capture the truth towards which her

unwinding words seemed to beckon, perennially teasing her to the perennially incomplete revelation of words and yet more words" (211). This proliferation of words and the repetition of "perennially" indicate a shift towards post-colonial assumptions. As a model citizen holding her sample, Hoda wants to displace the sheaf of wheat and the buffalo with a picture of herself in her bare skin holding the bottle in her lap. Her iconoclasm levels an already flat prairie.

After recounting "the fairy-tale part" (213) of Hymie's bootlegging story, she arrives at its moral:

> So don't ever be ashamed of your city motto, is all I can say. You take those three words, plus a little bit of this and a little bit of that, and you can end up where you won't ever have to worry about commerce, prudence and industry again, because when you're up there that high, anything you do or don't do is all right by everyone all over. (213)

With the simplest language Hoda's pastiche or *bricolage* unsettles categories and assumptions; her own mottoes supplant the established ones: "maybe they should change our motto up there altogether. Instead of those three words and those pictures, they should have a picture of a big, naked arse, and underneath it just two words, 'RISK IT!'" (303). Wiseman and her protagonist risk their prose so that the two schoolteachers who listen to these words soon discover that at times "one's own dear familiar country can suddenly seem so foreign" (303). In this revision the foreigner moves to the centre while the more established citizens are shunted to the margins during the comic transformations and defamiliarizations. Hoda extends her anti-colonial harangue from City Hall to Manitoba's Parliament Buildings.

> Maybe Hymie was a bootlegger, but those hadn't been Jews who'd stolen all those millions that were supposed to go into building the Parliament Buildings

downtown when she was a kid; they were big-shot gentiles, practising their own variety of commerce, prudence and industry. Let anyone make a crack and Hoda knew what to come back with all.... (214)

Within post-colonial and feminist contexts, Wiseman's novel demonstrates how to make cracks and comebacks in Canadian history.

Just as Hoda exposes her body, so this prose-titute lays bare the very foundations of language.

> What if she sometimes got off the subject? It could be just as important to give people the feeling of how you felt, and get the feeling of how they felt, as it was to stand up there telling them how they ought to think. If some of those big-talking comrades would stop talking and listen sometimes and try to understand how their audience really felt, they wouldn't always be so sure of themselves. (214)

The prostitute's feelings and richness of language tumble the politician's certainties; Hoda's twofold vision contests the official version of history and political doublespeak.

The final metamorphosis of City Hall's motto occurs in the novel's concluding pages, where Hoda combines reality and fantasy on the verge of falling asleep. She changes the three words into "condoms," "prurience" and "incestry," (300) in her transformation of a Protestant work ethic into the prostitute's ethnic hedonism. If the shift from commerce to condoms is a move from the public sphere to the private, it is also a feminist strategy for containing male dominance. Not only does the condom protect, it also functions metonymically as the container of both phallus and semen, thereby forestalling procreation. The condom joins with several other significant containers in *Crackpot*. While condoms may serve as markers of prudence, in Hoda's ironic distortion they lead to prurience, the opposite of prudence. In its evocation of the roots and heritage of ancestry, "incestry" highlights the taboo of

internal relations between generations. If the talmudic logician debates the 'prose' and cons of condoms inhibiting incest, the comedian merely shrugs off any causal connection.

Hoda's womanhandling of Winnipeg's motto is a paradigm of feminist and post-colonial deconstruction of patriarchal and colonial habits of mind. But the novel's final dreamlike sequence goes even further in its recapitulation of earlier thematics. In bed with Lazar, a survivor of the Holocaust, Hoda resurrects his life and hers as the "answer" comes to her suddenly on the back of "the sleep bearing steed" (426). Her brilliant solution is a wall-to-wall mattress, more down-to-earth than a magic carpet but as encompassing as the flat prairie outside. Through her lifelong metonymic attachment to mattresses, Hoda extends her horizons, knowing that she must repeat her formula to remember it, in a novel filled with memories and repetitions.

Having dismembered the structure of City Hall, Hoda goes to work on the orphanage in her dream. "She was astonished to see inside of the orphanage for the first and last time as it was pulled apart like a movie set" (300). In a world of repetition the distinction between first and last time may become blurred, much as the relationship between insides and outsides pulls apart in the novel. The cinematic simile recalls earlier passages about movies which create a surrealistic effect on the borderline between reality and fantasy. Indeed, the novel's conclusion blurs identities of fathers, sons and lovers as Lazar, Danile, Daddy, David, Pipick and Danny are drawn into Hoda's magic circle of curtsied feminism and post-colonialism. What is also magical about Wiseman's narrative circle is that it is broken, cracked like the pots, resisting closure. "Soon, she promised extravagantly, in the ardour of her vision, they would all be stirring the muddy waters in the brimming pot together" (300). Her encompassing vision is ardent because feminist and post-colonial: she stirs Winnipeg's muddy waters, disturbing the metonymy of sediment and liquid, pot and contents. *Crackpot* is a vessel whose muddy waters of meaning seep out through a "backwards" reading, as David instructs his class in the penultimate paragraph of the novel.

Having examined the final paragraphs of *Crackpot*, the reader may proceed, Hoda-like, backwards, in Wiseman's re-visioning of Canadian Jewish history. To follow Hoda's and Wiseman's backward direction is to follow Harold Bloom's rhetorical strategy of metalepsis, or a jumping over of middle terms in a reversed sequence of tropes. Metalepsis is a kind of reversal, crossing over or return to lost origins; within a Jewish and post-colonial context, Wiseman skips over the intervening centuries of Christian domination to earlier lost Jewish origins. That is, where Christianity sees the Old Testament as mere figuration of the New Testament, the modern Jewish writer takes a backward leap over the New Testament to return to original sources in a metaleptic move that parallels, in some ways, the recuperative methods of feminism and post-colonialism. The novel's Kabbalistic epigraph about creation challenges not only Christian and colonial versions of history, but normative Judaism itself. "He stored the Divine Light in a Vessel, but the Vessel, unable to contain the Holy Radiance, burst, and its shards, permeated with sparks of the Divine, scattered through the Universe" ([5]). Is the vessel the female container of creation and experience for the male God? Creativity will always exceed any attempts to limit its meaning; hence the diasporic shattering of interpretation. Just as Wallace Stevens's jar in Tennessee reverses Keats's Grecian urn, so Wiseman's *Crackpot* reverses time and space through the bursting of boundaries between inner and outer. Cracked pot, shattered vessel and invaginated condom disrupt ordinary metonymies by inserting metaphor into the shards and crevices of creation.

If the epigraph yields mythic and iconoclastic readings, the opening genealogy personalizes the process of transformation: "Out of Shem Berl and Golda came Rahel. Out of Malka and Benyamin came Danile. Out of Danile and Rahel came Hoda. Out of Hoda, Pipick came, Pipick born in secrecy and mystery and terror, for what did Hoda know?" (7). The repeated "out of" hints at lineage, transformations, *creatio ex nihilo* and the metonymy of interior/exterior — picked up at the end of the first paragraph, "Things can't go in and out of the same little mouth simultaneously" (7).

From Shem Berl, a tinker or mender of pots whose name means "name" (as in the name of God) and evokes "barrel" (another container), Wiseman moves to the question of Hoda's knowledge, her initiation into tribal rites. Hoda's epistemology and her "magically endless supply of food" (7) at the outset turn into her "magic circle around them, showing all she knew" (300) at the end.

In *Crackpot's* world of synecdoche, parts, pieces and shards accentuate the fragmented immigrant experience from hemisphere to hemisphere. Danile introduces a line of thought that Hoda will pick up:

> There seems to be something not quite altogether between time and place and feeling and events. The pieces don't match up, they won't hold still, the right time, the right place in life, the right feeling, the right length and strength for each. (21)

To accentuate these unmatched pieces, Wiseman hyphenates her descriptive qualifiers: "ever-so-slightly hump-backed" (7), "feet-on-the-ground, world-on-your-shoulder" (24). If Rahel's and Hoda's hyphenated bodies are grotesque, so too is their house, particularly the tumbledown porch, that marginal segment of the domestic environment: "the tree roots had grown under the verandah and were year by year heaving it more eccentrically askew. The whole verandah was like a wooden wave, in the process of a long, slow-motion undulation" (25). On the sea of the prairies, the oxymoronic wooden wave seems particularly appropriate, preparing for the "ruler of waves" (31) in Hoda's education and fantasies. From the perspective of *Crackpot,* whatever is eccentrically askew approaches the truth.

Hoda's post-colonial apprenticeship continues at school, where teachers have "unloving voices that told proudly how westerners had beaten down the wild Indians and crushed the treacherous half-breeds and made the great new continent a place fit to live in" (31). Wiseman's irony emerges through the contrast

between Hoda's loving voice and her teachers' unloving voices, the contrast between innocent half-breeds and the treachery of breeding, and the highly suspect notion of a fit place. Indeed, in *Crackpot*'s post-colonial context the misfits are the heroes. Patriotic (matriotic?) Hoda sings "God Save Our Gracious King" better than anybody else in class because she secretly loves the Prince of Wales, who could make her a princess. As a saviour of mankind, the heroine ironically achieves royal and divine status while her name ("thanks" in Hebrew) comments on gratefulness and grace. After school she ascends a Canadian snow castle and shouts, "I'M THE QUEEN OF THE CASTLE!" (35) in the fast-fading glamour of her reign. Regal fantasy combines with fairy-tale to revise colonial structures in her comparison to

> the Frog Princess and Beauty and the Beast and the Ugly Duckling and Cinderella too. All kinds of girls who thought they were the fairest of them all would get a surprise some day when the young prince who was ripening in his long-chinned, pale-eyed, nondescript, special kind of noble beauty would come from over the seas and not even notice them at all. (36)

Wiseman replaces one notion of nobility with another as she aligns Hoda's rite of passage with the prince's.

Similarly, Hoda teaches her teachers in an allegorical reflection of how the more "primitive" culture may instruct the more "civilized" in a post-colonial attack on imperial designs, as the earthy child of the graveyard inverts stable hierarchies.

> Hoda had discovered that "duty" and "honour of your country" were the things you said that made you feel patriotic and just like everybody else in English. In Yiddish the words that felt right when you talked of wars and soldiers were, "When will they stop killing each other like wild animals and come home and look after their families?" (34)

The chiasmus of the second sentence undercuts Victorian imperialism with Jewish humanism, and the reader suspects that the multiply displaced outsider — female, child, Jew, immigrant, Canadian, grotesque — moves inside with her words of wisdom. As "*mamma-loshn*" (78) or mother-tongue, Yiddish provides the right feeling, insisting on family nurturing instead of colonial militancy; its curious syntax corrects the Queen's English.

Mixing pavement fact and ethereal fantasy in Chagallian manner, the girl from the colony-ghetto marries the representative of Empire, putting an end to power through the acceptance of difference and otherness:

> Most of the time he got both his mother the Queen
> and his father the King to realize that she was best for
> him and was so nice the people wouldn't want to make
> civil war anymore when they got to know her, and
> she got Daddy to realize that she would be like Queen
> Esther and save the Jews her whole life long. (126)

The closest this revisionist comes to her dream, however, is the incident during the general strike at City Hall when she rescues her Yiddish teacher, Mr. Polonick, from the charging mounted policeman, at once a representative of royal power and a throwback to the Cossacks. This natural revolutionary is equally naïve in her sexual life, and soon unknowingly gives birth to a son whom she abandons at the Jewish orphanage with a note:

> In her note, Hoda had pieced together, out of the
> confused shards of dream and desire and the longings
> of her shattered childhood, the following: TAKE
> GOOD CARE. A PRINCE IN DISGUISE CAN MAKE
> A PIECE OF PRINCE, TO SAVE THE JEWS. HE'S
> PAID FOR. (154)

Through imagination, linguistic play and messianic irony her bastard Canadian citizen will be eligible for the throne of peace.

186

Wiseman names him David Ben Zion formally, but he acquires the nickname Pipick because of his navel, a curious, knotted little tail (with a self-reflexive pun on the tale of *Crackpot*). From the opening genealogical line, naming plays a crucial role in the novel, empowering the immigrant who has to learn a new language in a virtually nameless city from a family without a family name. When the church ladies come to visit Hoda's father at home, she describes her mother's death to them — the tumour, pustulant liver, gangrenous gall-bladder, suppurating spleen.

> The information was impressively mystifying to the ladies, since Hoda didn't know the English words for many of the hidden parts of the body she was naming, so she named them in Yiddish, the very foreignness of which gave the whole rendition, to the ladies, a medically authentic, if ominous sound. Hoda was not, in fact, quite sure of what some of the names referred to anyway, although when she got to the story of the disintegrating spleen she had an inspiration and this time succeeded in dragging them over to the pot on the stove to show them what she meant.... (64)

Just as she upsets these evangelicals with her sinking and floating signifiers, so she disrupts her teacher's sense of propriety at school as Wiseman combines Isaac Bashevis Singer's grotesque with Sholom Aleichem's humour to depict her protagonist's education, reversing roles of student and teacher (named Miss Bottoms-up):

> Suddenly she knew exactly where Hoda was leading, saw in disgusting detail the whole obscene picture, the wretched couple of cripples copulating in the graveyard while the bearded, black-robed, fierce-eyed rabbi stood over them, uttering God knows what blasphemies and unholy incantations.... (97)

Even as the immigrant pupils correct their teacher's substitution of program for pogrom when she asks them to put the plagues behind and sing "The Maple Leaf Forever," so Wiseman teaches us how to reread, rename, and re-vision in her old-new bilingual curriculum.

Linguistic confusion reigns at home, where Hoda's blind father repeats, "*chazri*," an injunction for her to study which sounds too close to the word for "pig," (120), so that her clandestine sexual escapades at the back of the house form part of her hedonistic education in comic humanism. The harlot-tutor turns metafictional:

> What gave you that uneasy feeling that your tongue was turning around and without even knowing it was making a joke on itself? Word to word, sentence to sentence, whether you knew them to be false or felt them to be true, spun out across an abyss, with you swinging helplessly from them, blindly spinning and patching and criss-crossing the net.... (175)

From her dialogic interconnectedness Hoda, the deconstructress, knows how to reverse narratives and criss-cross history through a series of metaleptic moves:

> She had a crazy fantasy that kept tempting her. Suppose she were to re-enact all her movements of that long-ago night? Only backwards.... She might be able, that way, somehow to erase her earlier path, negating what had been, nullifying the past.... Or would it be like in the movies, all neatly packaged up and ready to play itself again, after the projectionist has, just for fun, shown you the film running backwards while rewinding it. (219-21)

With her retrograde step and jagged chill of dislocation, crackpot Hoda displaces history and geography lessons.

Hoda and Pipick undergo rites of passage which under-

score the evolution of Canadian Jewish society. To examine their ritual processes in the light of Victor Turner's anthropological framework is to shed additional light on post-colonial critiques of dominant cultures. Turner traces the individual's development through three stages: preliminary, liminary, and post-liminary. Of these three the intermediate liminary, threshold or transitional stage is the most important, for the liminoid is freed from society's laws and structures to enter *communitas* — a state analogous to Buber's "I-Thou" relationship. "Liminal entities are neither here nor there; they are betwixt and between the positions assigned and arrayed by law, custom, convention, and ceremonial" (Turner, 95). As outcast and orphan, Hoda and Pipick celebrate liminal ambiguity. In *Crackpot* Wiseman follows the development of Hoda and her son as they re-enter society in a post-liminary state; in so doing, they elevate themselves and Canadian Jewish culture to post-colonial status. Pipick's comically abbreviated sexual initiation mocks the taboo of incest: "he'd barely crossed the threshold when he tripped his load" (330). To trip their burdens of history, Hoda and Pipick cross feminist and colonial thresholds; in a godless universe these leaky vessels of liminality nevertheless retain a spark of the divine. Thanks to Hoda, the *ma-kés* (curses, plagues) are transformed into "mocky." In *Crackpot*'s transformational regionalism Wiseman foreshortens history and foregrounds those gaps, absences and silences produced by the colonial encounter and reflected in the text's disjunctive language of narration. When Hoda looks back at Lot's wife, she is saved from the petrifying biblical example by her own comic ability to look forward and dissolve flesh into the free flow of experiential *communitas*.

To the objectifying male gaze Wiseman opposes Hoda's resounding subversive voice. Hoda chews her food and her discourse in rambling dialogues and *petits récits* that celebrate humanity. *Crackpot* is offered as a kaddish (prayer for the dead) from one woman to another, praising God's name through the shards and sparks of Hoda's direct embrace, which restores wholeness and plasticity to the Vessel.

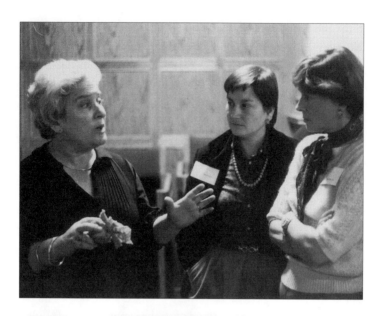

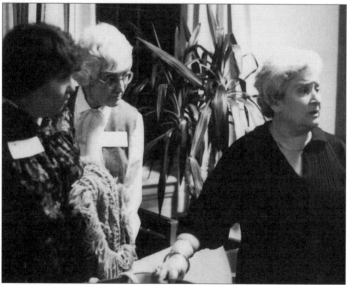

Adele at the Ban Righ Foundation Council Meeting, April, 1982, with
Janet Troughton and Beryl Bailey (above), and with Elaine Berman and
Bette Solomon (top).
Photos by Sandra Rutenberg.

190

Adele Wiseman's Poetry and the Genesis of "Goon of the Moon and the Expendables"

Elizabeth Greene

The imaginative work of Adele Wiseman's last decade remains largely unpublished and inaccessible. Her brilliant last story, "Goon of the Moon and the Expendables," published in *The Malahat Review* just before her death, received great praise from those who read it, including Don Coles and Joyce Marshall, but has not before now been available in book form. Adele's lyric poetry, written between 1981 and 1986, is stored in three boxes in the York University Archives, the few printed samples give little idea of its range or of the sheer delight in language that informs it. *The Dowager Empress*, the long poem she was writing at the end of her life, is unpublished and only reached the Archives in the fall of 1996. Thus, a complete critical assessment of Adele's literary achievement is not yet possible.

I hope to begin rounding out the Adele Wiseman critical canon by considering the way "Goon of the Moon and the Expendables" grows out of the poetry and extends the themes of Adele's earlier work. The poetry files and the drafts of "Goon of the Moon" also provide rare insight into the way Adele gathered phrases, images, bits and ideas and fused them with an alchemist's skill, transforming the ordinary into the unforgettable.

No reader of *Old Woman at Play* would be surprised that Adele Wiseman was as fascinated by verbal bits and fragments as her mother was by buttons and bits of glass. The drafts of her poems, and the idea notes for "Goon of the Moon and the Expendables," indicate that she started from a line, an image, an incident, and would polish each part before joining it to another. Only in

later stages did she work the parts into a whole, at least in the longer pieces.

The poetry files in the archives date from 1981 through 1986 and attest to years of serious poetic apprenticeship. Especially in the beginning, Adele reworked drafts and fragments and eventually consolidated them into finished poems, almost none of which were published in her lifetime. (When she did finally send her poems out, under the pseudonym S. Wa, they were returned with form rejection slips.) The poetic drafts are interleaved with scraps that Adele wanted to keep: bits of paper with words or lines on them which sometimes appear in finished poems and sometimes don't; one or two streetcar transfers; at least one napkin. Some of these jottings are unpoetic: planning menus, guest lists, probably for Christmas. One has a poetic image never developed: "The tree/asqueak/with birds." Many others are idea notes for finished poems or show Adele working with parts of poems that were later worked into longer, more complex wholes.

The poetry begins with a series of love poems, some wry:

Loved one
You said you would call
again
Should I hold my breath
again?

Here, and throughout the poetry, there is a very clear speaker's "I/ eye" which is more personal even than the speaker in the creative non-fiction. Love is a theme throughout the poetry — one wonderful sonnet ends "Though you deny us harmony of hearts/I'll bless you in the singing of my parts" and another poem contains the memorable line "Loneliness begins and ends with you."

There is also a series of myth poems, on the subjects of Pygmalion and Galatea, Icarus, Cassandra, and creation and destruction. There are some poems on motherhood and for Tamara, and a few of Tamara's drawings grace the manuscripts. Adele has also recorded her daughter's reactions to the poems on a few of the

192

manuscripts. There are nature poems, including backyard sunsets and tree poems, poems written from news clippings, poems about the workings of the mind ("On the cutting room floor of consciousness/All fragments lie") and, as one would expect, poems about being Jewish. One fragment, later integrated into "Canjew," insists on the necessity of bearing witness:

> We who belong nowhere
> whose testimony is the irrelevant truth
> whose fragile power lies in consciousness acute
> in conscience absolute
> Foresee with blind insistence
> with implacable hindsight
> Eyes are our memory
> Memory our eyes.

The poem brings together several of Adele's major themes: displacement/dislocation, so central to the experience of her characters and to the twentieth-century generally; the importance of consciousness, vision, memory and testimony. The phrase "the irrelevant truth" also characterizes her work, with its perspective that shifts easily between the moment, history and eternity. Truth is not always "relevant" but it is essential. Our quantitative age may not be looking for anything deeper than relevance, but art insists on something more enduring.

The poetry files also contain many palindromes, suggesting Adele's fascination with the shape of words, the relationship between forwards and backwards (Hoda, remember, went backwards into occupying her past, inhabiting her life). There are also several shape poems. Most of the poetry is rhymed. Most of the poems have also been through at least ten drafts, although in many drafts only a few words or line endings are changed. Reading through Adele's unpublished papers, both poems and drafts of fiction, gives the sense that she was constantly gathering words and material for her work. Her mind seems to have been a cauldron of ideas, perceptions, images, phrases, out of which the writing came.

In the file for March 1985–February 1986, she wrote on a small, square, white piece of paper, about telephone-memo size, "The expendables had adventures." This is the fourth of a cluster of "idea" notes that contain the beginning of "Goon of the Moon and the Expendables." Many of the notes crackle with the excitement of inspiration: "Take out the R. Take out the D. What have you got? GOON!" Other idea notes show as well that Goon is the nickname for Gordon, the sunniest-tempered and most agile of the four characters, but also the one with the shortest memory. Most of the notes are in the voice of Josh, the central character and the narrator through the draft dated June 1986: "No matter what instructions I gave my body, it would spring. Only grasshoppers are more predictable. I'm trapped inside a bunch of scrambled grasshoppers." In another note, Josh says of Gordon, "Except for the fact that he was real it was almost like I'd made him up." Judging from these notes, the inspiration for the story came through the voice of Josh; Josh presented himself to Adele as a character with a dysfunctional body and a free-ranging, creative mind. At the start of the story, his "true science fictions," as he calls them, look from the outside like "fantasies" to Lucinda. Lucinda, clear-sighted and political as she is, understands life and power, freedom and rights, but doesn't really comprehend how serious Josh's "science fictions" are, how they give importance and heroism to characters who might otherwise be dismissed as "abject." In this Josh can be compared to Danile, the storyteller of *Crackpot*. Where Danile, the visionary, is blind, Josh, the spinner of words, the poet, has a speech impediment so severe that Gordon and sometimes Lucinda often have to translate for him. As Josh grows, his art grows closer to life. His final dream is not of "adventures" but of a life of great beauty. The "true science fictions" colour the story, but by the end Josh has left them behind for the difficulties, the adventures, of his adult life. "Goon of the Moon and the Expendables" is the story of Josh growing up and, as his vision changes, so his art changes — unlike Danile, whose stories stay the same, the same treasures, over a lifetime.

From the early moments of inspiration, the story is about

the contrast between inner and outer, about the power of the imagination to transfigure the "abject." In this story the abject is the undesirable body, spastic, immobilized, unappealing, the "I" but "not-I." While media culture conditions us to believe that imperfect bodies have no right to desire, Adele allows her characters not just desire but also sexuality and love. She makes the distinction between exploring and enjoying sexuality, as Josh, Gordon and Lucinda all do, and experiencing love and friendship. She doesn't spare us the characters' outsides. Josh drools and lurches; Gordon's eyes are skewed rather than level; Lucinda is "potato shaped" although with silvery curls and a "fresh laugh"; Miss Nomer, the nurse, has "big, wet, buggy eyes" and Josh thinks she shaves. Still, beneath the surface tensions of the story, all four characters are bound together by caring. (The Dylan Thomas epigraph, "They sang in their chains like the sea," reminds us of the tidal pull of the moon on the seemingly unfettered sea and echoes the medieval-Renaissance image of the great chain of love that binds the world. C.S. Lewis, in *The Discarded Image*, suggests that this chain is held together with magnetic links, with "kindely enclyning" or gravitational attraction.) By contrast, the well-coiffed, perfumed, well-dressed volunteers, Gordon's "wish-mommies" (before Josh assures him that his true mother is the moon), are timid and ultimately incapable of giving or receiving love. The volunteers are attractive, even seductive, on the outside, but their hearts are closed. They mean well but they are constricted by convention and reason. The moon is not their mother, so far as we know, nor do they sing in their chains like the sea. They represent anyone cut off from elemental forces, the pull of the moon, the flow of the sea. They are Adele's version of e.e. cummings' "most-people" and appear — always briefly, in different forms — elsewhere in her work.

What is it to be human? Can you be human when your body, or your intelligence, gives you only half a life? Josh, with his stories of aliens and a special band of expendables sent on secret missions, at times feels as if he belongs to a different race. One of the notes, in the voice of the nurse, Miss Nomer (whose name is one small instance of Adele's delight in wordplay in this story),

shows the limits of Josh's "science fictions": "I don't think, she remarked sharply, that you *would* be mistaken for anything but human." (The italics are Adele's.)

One of Josh's threshold tests in the story is to embrace his humanity and follow his soul's growth in spite of his athatoid body and slurred speech. The story insists that true humanity is in the soul, rather than in the able or disabled body; that the ultimate worth of a person is inner rather than outer.

Adele explored, even pushed at the margins, through her entire literary career, always positioning herself as a Jewish writer and choosing Jewish central characters. In depicting Abraham, a murderer, in *The Sacrifice*, she took a risk; but the risks in her second novel, *Crackpot*, were far greater. Rahel, Hoda's mother, has a "slight" hump; Danile, Hoda's father, is blind, in the best tradition of sighted blind men and wise fools; Hoda herself is sufficiently overweight that no one notices when she gets pregnant and then has a baby. Even her son, David, as he grows up, is embarrassed about his body because of the amateurish knots Hoda made in tying his umbilical cord. In "Goon of the Moon" Adele goes still further. The names of Joshua and Naomi, Joshua's little sister, suggest that this story too is about a Jewish central character, although ethnicity is not foregrounded. Josh describes himself as a "well-hung athatoid CP" whose speech is understandable only if you "slow down your ears." In the tape Adele made of the beginning of the story, Josh is unintelligible (to this listener anyway) without the written text. It is ironic but fitting that the artist figure, who loves words and who is the imaginative centre of the story, has such difficulty conveying his ideas, and often needs Gordon or Lucinda to translate for him. Gordon, the Goon, has an enlarged, hydrocephalic head (with a shunt to drain it) and an asymmetrical face with one eye higher than the other. He is also short as a child, even as a teenager. His walking and talking are fluent, his temper is sunny but his intelligence is slow. Lucinda, with her "summarizing intelligence" and her decided politics, has the frailest body and can be disempowered simply by being taken out of her wheelchair and put on her back. Even Miss Nomer, the Dragon, feels "alien," al-

though Goon defends her from the first:
> She's not ugly, said Goon defending her, just scaly.
> "Flaky," I could always outword him.

Master of words, Josh is only partly right about the Dragon. She is flaky, but as the story proceeds Gordon is proved right too: Miss Nomer is "one of them," as Josh finally recognizes at the end.

Judging from the notes, the story began with Josh and the Goon, who are, in some ways, complementary. Josh is intelligent and imaginative; Gordon walks and talks with agility. A note suggests that in the first plan of the story Gordon was to die rather than fade off into the limbo of perpetual dependence. We never get quite as close to the two women characters, Miss Nomer and Lucinda. We do learn that Miss Nomer has fled from life in taking this job in the hospital, that in allowing herself to love one child "secretly, richly, extravagantly," she has returned to life and her humanity. It is quite clear that this love is not sexual: "Though no one could accuse Miss Nomer of being anything but a thorough-going professional..." — if it were, the story would be very different, and Josh would not recognize the Dragon as a fellow alien at the end. Lucinda, the first of the characters to grab our attention in the finished story, was the last of the four to emerge. She doesn't appear in the idea notes and only wheels onto the page in the first extended draft, in March 1986. Lucinda "stuffs her feelings away" (as Miss Nomer does too) but she is the only character whose mother is frequently present, so she has a continuing, strong emotional life, and her affection, more than any other single thing in the story, impels Josh's growth from adolescent to adult.

In her 1991 interview (see "The Charm of a 'Non-Orthodox' Feminism"), Gabriella Morisco asked Adele why she chose "deformed" characters. Adele replied: "Because in general we deny them the right to live alongside us, in the same way as we feel we can, and have the right to, destroy other lives. Ironically, if we consider others 'different', we, too, become 'different'. Just think of

what the Germans did to the Jews. That's why I'm interested in describing people on the edge of society, people who are deformed physically or psychologically. It is partly an extended metaphor of the Jews. I believe we should all try to open ourselves up to a wider acceptance of humanity." As usual, she is the best critic of her own work. Her exploration of the margins, which places her in tune with the writing of her age and yet pushes harder at the edges than most other writing, begins with her sense of difference as a Jewish Canadian woman writer, but ends with a radical vision of characters whose inner worth contrasts strikingly with their external appearance. In this end of the millennium, when governments are making things increasingly difficult for the poor, the sick, the disabled, the elderly, Adele's impassioned defence of the "expendables" is especially timely. Here, as elsewhere in her writing, she explores one of the central questions of our age: are people disposable? Who has the right to judge?

In the midst of the notes for "Goon of the Moon" is a smaller set for the puppet opera *Someday Sam*, which Adele was also working on in the early eighties. These notes point out themes common to the opera, the story and the poetry. The voice here is Sam's, but there are similarities to Josh's voice — and to Adele's in the poetry:

> for somebody to love me too
> for somebody to hug me too
> Oh I could love you half to death
> if you were alive. You could hug me too. That's
> what I want
> it's all I want.

> almost as though someone could love me
> if I hold still enough
> if I don't breathe
> at all
> If I don't show how much I need it

a thing is beloved for what it is, no
matter how ugly, no
matter how small

Someday Sam shares with "Goon of the Moon" the insistence that a person (or thing) must be loved for its essential qualities. Lovability embraces difference or exceptionality. In *Someday Sam*, the main character is a child of parents too busy working for "someday" to pay attention to him "now." Thinking that his parents would love him if he were a doll, Sam tries to become one, much to his parents' horror. Sam's return from dollhood to boyhood underlines one of Adele's central themes: no one should have to change dramatically in order to be loved. Love is not a reward for those who reshape themselves in conformity with an ideal or stereotype but is a right, necessary as air or food for children, or for anyone who has a feeling heart. The theme of lovability links the puppet opera with the story and the poetry, suggesting that all began in the same imaginative space. Some of the poems, like the story and puppet opera, explore, gently but decisively, the theme of uncaring as the beginning of evil. One wistful short poem called "Your silence" runs:

The silence of God simply makes me
doubt His existence
Your silence makes me doubt my own.

Silence, uncaring, is erasure, and it is only a step from this silence in the poem to the nameless librarians and teachers in "Memoirs of a Book Molesting Childhood," and another step to the frightened, destructive Miss Boltholmsup of *Crackpot* and the slightly sadistic Gorp of "Goon of the Moon."

For Josh, the threat to love is not uncaring, but jealousy. One of the last notes, in his voice, signals this subtheme: "Even science fiction creatures can be jealous of each other."

Jealousy is a quality Josh dislikes but has to acknowledge

in himself. As Gordon begins to scurry around town and wears a "new ease that sat surprisingly on him, almost a sophistication," Josh blurts out his envy and feels better for admitting it. About the same time, as Lucinda is winning top marks in her high school class and also making friends, Josh is "dismayed to feel jealousy in his heart, not only jealousy because she was paying so much attention to them, but baser jealousy, because they were also paying attention to her." When he confesses these feelings, she counters, "'I'm jealous of you too. You're going to live to get out of here.'" Characteristically, Lucinda has the last word. Any life, compared with others, may seem lacking. But as Lucinda tersely predicts her own too early death and Josh's hard-earned independence, she lifts the story to a different level. In her awareness of her weakness, she reminds us of the absolute beyond the striving, the successes and failures of individual lives — and of the short-sightedness of jealousy, which sees the peak moments but not the whole pattern, which longs for other peoples' arrivals but not their struggles. And in those few words, Lucinda reminds us of the finality and levelling of death.

Death was part of the story from the first, as the epigraph from Dylan Thomas suggests. One of Adele's idea notes for "Goon of the Moon" reads, "My whole family came to his funeral." Originally Gordon was to die, but Lucinda's death, glimpsed but not understood by Gordon, is more chilling. There is no funeral, only Lucinda's body carried out of the hospital by orderlies, with her mother, "a small stooped woman," walking behind. Lucinda, like Hoda in *Crackpot*, embodies political activism and civil disobedience; and her death is reminiscent of political deaths in totalitarian states: a body spirited away in the middle of the night, one faithful mourner, official silence. Josh, the dreamer and story-teller, is left behind to grieve, almost to the point of madness, until Miss Nomer, the Dragon, brings him back to the routine of everyday life. Lucinda's death occurs about four-fifths of the way through the story. After her death, she becomes a spirit guide to Josh, who often talks to her and calls her "angel." Her name, full of light, takes on an added, transcendent symbolism. Her death is a crisis for

Josh, who, after being pulled from his tidal wave of grief by Miss Nomer, takes his life into his own hands. By the end of the story, he has moved into his own apartment and fulfilled Lucinda's dream of meeting for coffee at Yonge and Bloor, although his companion is not Lucinda but the Dragon. Lucinda's death, like her love, is beyond the reach of Josh's art. It is a dark curtain that hangs behind the comedy, a reminder of finality, even as the story turns back towards life.

"Goon of the Moon and the Expendables" goes farthest into the territory of the margins that Adele claimed for her own. The characters are "aliens" (as Josh describes them). By choice or biological destiny, they live on the edge, in a regimented environment. Their struggles for rights and freedoms are emblematic of the struggles of other marginalized groups — and so seem familiar as we read about them. Like almost all of Adele's work, "Goon of the Moon" is political, but it makes citizens of unlikely characters, Josh and Lucinda. Gordon's struggle for freedom takes a less reasoned path — he simply runs away. Adele's notes make it clear that he was an escape artist as Josh was a science-fiction artist and Lucinda an activist. Here, as in most of Adele's work, the margins contain heroism, love, caring, things the mainstream has lost. Adele is in tune with her age in exploring the margins and marginalized people; in reclaiming the heroic and feeling from an earlier age of irony. She is radical in that she chooses characters the reader might turn from in chance encounters on the street. In a period when many writers' values are rooted in appearances, Adele bases her writing on values that endure. Each of her works pushes successively deeper into the country of edges in that quest.

"Goon of the Moon and the Expendables" is also Adele's most radical exploration of art and the artist. Here too she continues to push at the margins. Josh may seem an even more unlikely artist than Hoda, artist of love, or Chaika Waisman, maker of dolls — not just because of his physical limitations, but because of the contrast between his appearance and the gaiety, the wit, the learning of his mind. His delight in wordplay informs the story, and links it with Adele's five years of steady work on her poetry, her

experimentation with forms, sounds and rhymes that preceded the first draft of the story. A note with the heading "scifi lingo" is the sort of play with words that Josh and his creator both delighted in:

outer space
inner space
scrambled inner space

feel space
now space
new space
here space
head space

Some of these appear in the story — "aliens from inner-space," "gordon's makespace," "exterworld." They are a further link to Dylan Thomas, coiner of words and trampolinist of rhyme, whose influence is evident through most of the poetry.

Josh is the one who gives the story its comic and heroic twist, through his jokes and through his imaginative transforma-tion of life in the hospital into science-fiction missions and adven-tures. Typical of the artist in Wiseman's work, he recognizes the significance of small actions, but the actions here are even smaller than in the earlier works; the discovery of meaning in them is cor-respondingly stunning. Josh has read enough to compare Gordon's being left in the garbage as a baby with Oedipus' being exposed at birth. Josh is the one who gives Gordon the moon for a mother (and so places the story firmly in mythic tradition). Josh also praises the Goon's rescue of worms when it rains, his putting them back in the ground when they try to emerge because "worms are the nails of the grass." Yet — also typical of the artist in Adele's work — he is inseparable from his material. Gordon not only translates Josh's "true science fictions," he also inspires them. At the end of the story, Josh says ruefully to the Dragon, "'And I used to think...I was giving him a life.'" This is partly true, even with the limita-tions of Gordon's memory, but the Goon has also given Josh his

art. And it is Josh spinning out stories to comfort Gordon that gives Miss Nomer the glimpse of his "entrapped unblemished soul."

Standing behind Josh, Adele the writer shapes the story with her own transforming sensibility. The narrator shows us how heroically Lucinda fights for her life, battling both bureaucracy and illness with every breath. The narrator also casts Josh as a heroic figure, partly through the feelings of Miss Nomer, partly through admiration for his skill with language and story, for his care of the Goon and his love of Lucinda. Whether or not the author too needs translation leads into the larger question of the nature of criticism.

During the last spurt of work on the story, in October 1987, Adele decided to shift to a third-person narrator. This change allowed her to enter the heads of all her characters. It also created, in the narrator, a fifth important character and a point of view that allowed a slightly more distanced perspective on events, a shaping consciousness distinct from Josh's. It allowed for greater development of Lucinda and Miss Nomer and so for a better balance between the male and female aspects of the story. By the end of October 1987, the story was almost in final form. As with *Crackpot*, the ending came last. According to Constance Rooke, once the story was accepted for *The Malahat Review*, Adele made a number of small, perfect changes that brought it to its impressive final form. One of these, not prefigured in the notes or the earlier drafts, is the interchange between Josh and Miss Nomer as they eat dinner together in a restaurant at Yonge and Bloor. Josh acknowledges Miss Nomer as a "good friend"; she primly spins out her theory of dragon robotics (this was in the drafts); he sees how much she has cared for him; and through her memories, he becomes able to "occupy his past," to feel nostalgia for the science fiction that gave shape to Josh's childhood. Josh says of Gordon, "I thought I was giving him a life," but Miss Nomer remembers more deeply, remembers the gallant, unblemished soul who overcame his own sorrow and loneliness to comfort his friend with stories. This short scene is filled

with multiple recognitions (Josh of Miss Nomer as good friend, as "one of us all along"; Josh of himself, "what an awful little prick I must have seemed to you sometimes!"; the reader of Miss Nomer as not only "one of us" but also someone who has allowed herself to love, "secretly, extravagantly, richly," as someone who has cared for Josh and guided him to adulthood).

In those instants, too, the reader recognizes that Miss Nomer has shot into the emotional centre of the story and that Josh, in trying to give Gordon a life, has also given one to the Dragon. In Adele's work generally, male and female complement each other. In this story, each of the four main characters, two male, two female, is an essential part of the whole vision. But it takes both Josh the artist and the shaping narrator behind him to discover the meaning and the beauty in such unlikely material.

Adele says in "Lucky Mom" (*Memoirs of a Book Molesting Childhood*) that her two central subjects are sex and suffering. These are certainly important in "Goon of the Moon." All of the characters suffer from being "alien" — Adele's most dramatic statement of the theme of difference that characterizes her work. Josh, besides being an artist, is also an adolescent, and his sexual explorations are essential to the story. The incident where Josh and the Goon "save the sardine, spit out the whale" is obviously one of many. Josh's encounter with the volunteer in the staff washroom is deeply comic and satisfying. The love between Josh and Lucinda is deeply touching, a blend of physical, emotional and, in the end, spiritual intimacy. Beyond sex and suffering, Adele celebrates art and love. Because her materials in "Goon of the Moon" are so unlikely, her success is stunning. But the story succeeds not just because of the vision that transfigures the material but also because of the skill with language that five years of poetic apprenticeship had honed to dazzling, because the story, like a good poem, knits together so many different strands.

Adele wrote in "Instructions from Poems in Progress":

Always obey dissatisfaction
The greatest uncertainty

is not in the setting out
but in the moment before completion.
The moment of most intense dissatisfaction
precedes the miraculous synthesis.

Tom Marshall said of "Goon of the Moon and the Expendables":
"Adele's story is extraordinary — with the cumulative power of her
best writing." In venturing to the extreme margins, Adele found
the transforming love and imagination central to literary tradition.
Also at the margins is Josh's dream "of a life of great beauty," a
dream which more mainstream characters are often too busy to
glimpse, let alone pursue. In "Goon of the Moon and the Expenda-
bles" (as in *Crackpot*) Adele explored not only some of the "central
unacceptable things" (as Ted Hughes says an artist must), but also
some of the central transcendent things, and we can see that, though
the inspiration was intriguing, the story grew as it proceeded to the
final "miraculous synthesis."

GOON OF THE MOON AND THE EXPENDABLES
Adele Wiseman

Though we sang in our chains like the sea.
—Dylan Thomas, "Fern Hill"

Of the three of them, Lucinda with the long curls and the look of a surprised angel had shown, even as a child, the keenest overall intelligence, a summarizing, woman's intelligence, quick and whole. "When the potato shape, with little shoots for its arms and legs, comes into fashion," she wrote when most at her age were still mouthing flashcards, "I will be Queen of the Ball." It upset her teacher, who marked her down as a potential troublemaker, which indeed she became.

Joshua was at once the most intellectual and the most imaginative. Between his intellect and his imagination there were, however, large gaps, in which he often floundered, mired in temper or tears.

Gordon, untroubled by reflection, scampered through his days. Spared the rigours of excessive comprehension, he loved most, at that time, to have snippets of his life story told to him as it unfolded, largely in Josh's imagination. Josh's stories seemed to clear, momentarily, the hazy mirror of his self. He listened with admiring astonishment and believed every word, even those he didn't understand, as they rolled into his ears and disappeared. His was the happiest temperament. He was as well the most mobile of what Joshua called the 'aliens from inner space.'

"So that's how it happened," he explained to Gordon. "Each of us here got trapped in a flesh warp at some time during

the trip. Damaged machines, that's how they spotted us. There's millions of us out there, Goonie boy, got through clean, just waiting for the signal to strike. And more coming all the time. Every time they bring one in here you can bet it's a casualty from another mass landing, another innergalactic fuckup. Of course, security does a memory wipe; it would be too dangerous otherwise, with us at their mercy."

"But we remember, eh Josh?"

"The special few are always on action alert."

"They're gonna rescue us, eh Josh?"

"When the backward locals are mature enough to handle our advanced technology."

"Soon," said Gordie confidently.

"Only don't tell Lucinda," Josh cautioned.

"Surprise her, eh?" Gordie chuckled. Fragile, indomitable Lucinda, raging her way through a cliff-hanging adolescence: "We have real problems and we have to fight them in the real world, now, every day, if we ever want to be treated like human beings, not...not mistakes."

"Power," argued Josh. "They have the power, and the only way to fight them is never to be where they think you are."

"So you'd rather be nowhere than fight them." Josh couldn't help noticing how pale she was, gasping a little now but continuing impatiently. "We have to try to get the others to back us, not just fill them with fantasies."

"Not fantasies. True science fiction."

"True human beings! With rights, and maybe even something to contribute."

"Oh sure, allow me to contribute my great gift of oratory, my golden tongue, my silver spittle. Suddenly, they'll all hold still and listen. All the walls will come tumbling down. 'You talk like bugle boy Joshua' will become a compliment. The spastic stagger will be the dance of the age. I'll be the hero of the new order, Apotheosis of the Expendable, ta ra ra!"

But he sat in council with her and backed her, and even found himself getting sucked in and baying passionately for re-

forms he was convinced they hadn't a hope of winning.

"We're going to get out of here, Josh." That 'we' and the intensity of her conviction both thrilled and frightened him. "We'll meet and have coffee together on Bloor and Yonge."

"It's a date. I'm the guy the cop just arrested for drunken walking."

"I'm running him down now. HEADLINES: 'POLICE OFFICER RUN DOWN IN SIDEWALK MOTOR ACCIDENT. DRUNK AND WHEELCHAIR ESCAPE FROM SCENE.' She had the freshest laugh, like cool water running through him.

They had both had a crush on Lucinda since they were little. Josh in those days was still stunned from having been declared alien and sent away to live with other strangers. Gordon was so confused he didn't even know who he was or where they'd found him. It was Lucinda who noticed that Gordie, in those early days, before all his adjustments, couldn't bear loud noises. He was clutching his ears frantically one time when he felt something soft and warm on his face. Lucinda had rolled over to him and was stroking gently with her pudgy hand. From then on he would grow a sheepish, diagonal grin on his face if you so much as mentioned her name. And Josh, more cunning, used to mention it often, especially at night in bed, to tease the Goon, who never quite caught on that Josh teased him as an excuse to say her name and to think about her out loud.

"Goonie Goonie, Lucinda Lucinda, kissy kissy, smooch smooch smooch!" Only it wasn't Goonie Josh saw leaning over her, hoping he wouldn't poke her eye out as he reached to caress her hair, praying he wasn't drooling on her lovely head, taking aim for her lips, and Lucinda helping, reaching up, guiding his face with her hands....

"Aw Josh!"

"Goonie loves Lucinda, touchy touchy!" Lucinda, tiny and compacted, Lucinda whose hair curled crisply silvery like her name.

"Aw Josh," Goonie didn't know how to defend himself. "Aw Josh, she's a girl."

"You love her you love her, smooch smooch smooch!"

Lucinda never tried to forestall Josh when he talked. She waited and listened, which is more than could be said for his own earth father, who always guessed at what he was going to say and got it out first, and was so pleased with himself because they were getting on with the conversation, and there was nothing Josh could tell him. A year or so older, she already knew the ropes when he made his stunned appearance. Even back then Lucinda had ideas and opinions. As soon as she could she cornered him and told him what was what and who was who in this place.

A little younger than Joshua, Gordon, as he had been named at some point when he was being passed from hand to unwilling hand during the first few years of his existence, was close enough in age to be paired off with him in a cell on the second floor with the other males. The little foundling had cried a lot at first, a flat, continuous, monotonous inhuman sound that communicated a misery from somewhere out beyond the merely human. It made their keepers nervous. But the dragon noticed that letting Josh talk to him kept him quiet, and she let Josh go on talking sometimes way after lights out. Joshua understood that maybe the kid needed a howly doggy sound to fall asleep to, like he himself had needed his own earth mother's murmur in prehistoric days. For a long time the dragon was the only one who realized that Gordon could actually understand what Josh was saying. For that matter most of them had a hard time accepting that he was ever actually saying anything, or that it could be worth waiting that long for him to get it out. It was just lucky that while Josh was a quick thinker and a slow talker, Gordie was a slow listener and a quick talker.

"What's Josh saying?" They'd turn to Goonie, right in front of Josh.

"Thank her for dipping her boobs in my soup. Tell her next time to take her blouse off first."

"He wants more soup, please." Gordie's grin reached up sideways running parallel from his dropped left eye to his raised right. Once they'd got over their initial recoil at the sight of him, the sweet-smelling volunteers he was so fond of couldn't help

succumbing, at least at first, to a kind of every-moment-aborning charm. He would lurk in the main corridor waiting for an opportunity to sidle over to a new lady. A volunteer would feel something rubbing up against her, and she would look down and there he was with his asymmetrical eyes closed and his skew mouth beaming and his nose all flared out. She would stiffen up at first, but she was a volunteer after all, and when he continued to nuzzle she would bring herself to put her hand down, tentatively, to pat lightly, with fingertips, the large, fair, misshapen head, at first as though she expected it to release an oily or gelatinous substance, and then, when it didn't, with guilty largesse. And Gordie, murmuring "mommy," would be hers.

Unfortunately he was a take-advantager, a not-leave-well-enough-aloner, a take-me-homer, a why-notter, a not-take-no-for-an-answerer. Though there was no nastiness in Gordie, and in his pursuit of the glamorous mommies there was only an unquenchable and always baffled hopefulness, his keepers and the volunteers sometimes perceived, in his behaviour, signs of low cunning and an alien insensitivity to their better feelings. He was incapable of even hearing reasonable explanations and promises of "another time, darling," and in the early years was not above making a scene.

When he, for instance, tried to assert the magical power of wishful thinking, and announced to a 'mommy' that she was going to take him home in her car, now, and she murmured, a little embarrassed, some formula about another time, he was likely to burst into a heartbroken "But you promised you take me home. You promised I be your Goonie." Clinging and hollering, weeping real salt tears on her nice clothes, he got her charitable feelings all mixed up and dirtied, when really she had made no such promise.

During the years when he attached himself to every likely looking woman who came into the place, for he was not mono-mamous, inevitable rejection taught him only to be more persistent. Sometimes it worked, at least partially, and Gordie got taken to the plaza for an ice cream cone, or even to a real home, where he saw wonders he afterwards couldn't even describe to Josh, other than in little dislocated spasms about cookies and milk, nice dogs,

big TV, floors covered soft...soft all over. So Josh, who knew well enough, filled it all in for him.

As often as not, though, big Gorp would come along and rescue the volunteer. "Rules," he told her grateful ears, "special permissions required; after all it's a responsibility in case of" and so on. "Besides, it's bad for them. This one's a runner as it is. Turns them into little beggars if they know they can get away with it." And he would pick up the weakly flailing little adventurer and rolling his eyes and shrugging a complicity of understanding with the beleaguered volunteer, would haul Gordie off, giggling and squirming in his captor's arms, for Gorp, to show the volunteer that it was all good fun and there were no hard feelings, was tickling mercilessly.

Out of sight of the stranger, however, Gordie quickly went limp and quiet, but did not escape the bone-crunching squeeze before Gorp put him down. Gorp knew well enough not to shake him. His punishments were nicely calibrated. Still, when Gordie had managed to get his breath going, and scuttled off a ways to a good headstart, he called back sassily, "GORP! GORP!" It was not, of course, the keeper's real name.

"Whad you call me? I'll break your legs!" Gorp lunged forward.

"Ha ha GORP GORP!"

What was a run-around doing in this place anyway? "Ya don't belong here! I'll send ya to the loony bin!"

"Ha ha ha MISTER GORP!" Gordon had reached the stairs.

"I'll send ya to the pickle house! I'll send ya out of here on a stretcher, covered over!" That got him. Gorp watched the tail end of Gordie disappear. Lousy little leftovers. Threaten them, punish them, take away their privileges, bunch of nothings and you still couldn't teach them respect.

"He said on a stretcher," Gordon told Joshua anxiously.

"Yah, well, so what?" Josh cooled it.

"Like we saw. You know."

"What does he know? Gorp wouldn't know snot from toe cheese if he was tasting it. 'Yummy yummy, what is it mummy?'

212

MIS-TER GORP! Oh you beauty Goonie. I wish I'd been there to see his face. He wants us to call him Mis-ter, doesn't he? You gave him half of what he wanted, so what's he complaining about? Half of what I want is a lot more than I ever get."

"But...covered over, Joshy." For once Goonie couldn't be sidetracked.

Sometimes, when Gordie couldn't sleep at night, Josh would waken and see him outlined bare-arsed against the window. The dragon never could get him to keep his pyjamas on. To Josh it was a sign that the kid was getting ideas about running away again. But occasionally on his night watches Goonie saw things, and his voice would come hissing, penetrating Josh's dream. "Josh, Josh, come see! Quick!"

Josh made it just in time to see the ambulance, its lights out, dead white under shadows in the driveway, backed up to the door overlooked by their room. He caught the faint purring of its idling motor, saw the covered stretcher disappearing into the back, saw with aftersight the little figure outlined by the sheet, as the van doors closed. They watched it, ghostly, drive away.

Gordie, without making any apparent connections, seemed to develop an instinct for when it was going to happen again. Josh, thinking back, remembered a difference in the air when someone was taken very ill, a kind of disembodied nervousness. And someone who had been sick was always missing afterwards.

"He said he would put me on a stretcher." Goonie's voice was beginning to quaver. In a minute he would be bawling. "I don't want to be covered over, Joshy."

"You won't be covered over. I said you won't be covered over," Josh bayed.

Mouth open, Gordon waited. "Listen, Goonie, have you forgotten who your sky mother is? Do you think she'd let just any arsehole like Gorp send you on a mission? Have you forgotten who you are? Have you? Have you?"

"No," said Gordon uncertainly. "Tell me, Joshy."

"Don't you remember you're not just any garbage-can baby? Are you not aware that you were a nine-days' wonder? That they

didn't think you'd survive? That they coddled you and shunted you and gave you the best medical attention that they have on this primitive exterplanet? Do you think they did all that only to allow a neanderthal throwback like Gorp to cover you on a stretcher? Not on your bloody likelies. Do you remember I told you there's a reason why we're here?"

"Yes, what?"

"We're a sacred company with a holy mission." Josh drew himself up, puffed out his chest, bawled out in a hoarse whisper, "EX-PEN-DA-BLE! EX-PEN-DA-BLE!"

"EX-PEN-DA-BLE! EX-PEN-DA-BLE!" Gordon was finished long before Josh, and he got a couple of extra expendables in, so it sounded like a round, which pleased him, and he began to chuckle.

"What does it mean, Joshy?"

"It means that they will have to do without us here when we're called away for our important secret mission. That's why we're covered, when they rescue us at night, because we're in hiding, on our way back to headquarters. And it's so hush hush all Gorp knows is the outside parts. He doesn't really know what's going on inside. And he mustn't know. But we salute EX-PEN-DA-BLE! EX-PEN-DA-BLE! THE SA-CRED COMPANEEEEE!"

"Will I have to go on a mission, Joshy?" Goonie was still uneasy.

"Not for a long time. You have to be ready for it. And the moon has to be ready, because it will be the most important mission. Your mommy has to call you, remember? 'Goonie, where's my little Moongoon?'"

Goonie laughed. "I saw her first, Josh."

On that night, Josh had been jerked awake into a room filled with bluey light. Goonie was bare naked at the window, his hands up on the pane and his nose pressed against it, so for an instant Josh thought maybe he was sleepwalking, like he'd read about, trying to push through the glass. But he turned and called, "Josh, Josh! She's coming in! Hurry!"

Josh worked his way over. Goonie was crooning. "What a

beauty, hey Joshy? What a beauty! Big, eh? Bi-i-ig. She woke me up. She's coming in for a landing, Joshy. She's coming here!"

She sure was a beauty. A long arm's reach away, coming up over the horizon beyond the scrub field, looking right at them, checking everything over with her creamy flashlight, bathing them in her soft blue glow, the biggest moon he'd ever seen. "Waaaaa-a-o-o-o-o-ohhhwwwww!"

"I saw her first. She woke me up. What a beauty, what a beauty, eh? She woke me up first." Goonie was crowing, proud as though he owned the moon. "She's coming in, isn't she Josh? She's gonna land."

He plastered his face against the window again, his big, fair, misshapen head glowing spooky like everything else in the reflection of reflection. She sure was big, and she wasn't even a full moon yet. One side was kind of stove in. Josh was suddenly inspired. "Hey, Gordie, she looks just like you. Close up she really looks like you. Maybe she's looking for you. Maybe she's your mommy, come in close to find you. See how she's looking so worried? 'Where's my Gordie? Where's my little Gordie, my Goonie I lost? Where's my little Goon of the Moon? Where's my little garbage-can baby? I just dropped him for a minute and stopped to scratch my itch and they found him and said, "This is a special baby. This is a great gift of moon kind to mankind." And they took him away. I want my baaaaby! I want my Goooooooonie!'"

By this time Josh had forgotten about the dragon at her station and was baying away, "Goooooooonie!"

Goonie squinted up, trying to read him, his cockeyed face wavery, ready to laugh, ready to screw itself up if Josh was teasing.

"It's good, Gordie, it's good news. The moon is the boss of the night. Now she's found you she'll come to see you're tucked in every night. She gets lonely. She wants to see her baby close up. Let her look at you now. See Moon, he's all right, a perfect Goonie all over. He's a good little Moongoon. Turn around and show your mommy. Bend over. See, isn't he cute? Mr. Toronto. Someday she'll have a special job for you. Goon of the Moon to the rescue!"

You couldn't help loving the little twerp, turning around

and bending over on command to moon the moon. Even Lucinda, who didn't like Josh when he was mean, laughed a little when he described the moon shining on that little white arse, and Goonie's anxious expression as he craned around to see if the moon approved of his bottom.

"See, she's smiling a little. She's saying, 'Oh, not bad. He's my little beauty all right.' See how her mouth goes 'Oh!'"

Gordon laughed. He liked happy things. He liked happy things about himself.

"Kiss your mommy goodbye for now. Quick. Dragoon. DDDUUUURRRRAAAAGGGGGOOOOOOOOOOOOON!"

Goonie chuckled. He loved things to be tied together, good sounds, good things. He pressed his face against the window, smacked it passionately, and was under the covers in a flash.

Joshua was still manoeuvring into bed when the dragon appeared. She had moved slowly and trod the corridor heavily to warn of her approach. She was not one who liked to catch them out. She glanced around now, her big, wet, buggy eyes lingering at the window (or did Josh imagine it?) and on Goonie's bed, where he lay all hidden, curled up in a tense, conspiratorial ball.

"I won't have any more noise now from either of you," she said quietly. "You'll be tired in the morning." This was for Josh, he knew, but he only grunted as she straightened his covers. There was too much he didn't understand about the dragon. He had this project to think seriously about the dragon sometime and get to the bottom of what bothered him. Why was she so nice? Of course he knew she loved Gordie. Once, when the little Goon was sick, and she was holding him, and he called her "mommy" she turned her face up with such a funny look on it, Josh laughed before he could stop himself. She didn't look at him that time but he knew she must have heard his stupid giggle. And he felt so mean he had to tell Lucinda as soon as he saw her. Lucinda didn't spare him either. Often, when she was sick, she wished they had someone half as nice on her floor, and if they gave Miss Nomer a hard time and made her quit then the dumb boys would find out what it was like to get sick with some of the others on duty at night.

But you really had to be pretty sick to pick such an ugly one for a mother. Of course Goonie had never had a real earth mother. When Josh teased him about it afterwards, "She's not ugly," Goonie insisted with unwonted stubbornness, "just scaly."

"Flaky. She comes off on you, leaves little bits, ugh. And her chin's purple."

The Goon just looked at him pleadingly, his eyes getting swimmy.

"Well, red and blue anyway."

"You like her too, Josh."

"Ugh! Aargghhh! Yuk!"

"She tucks you in."

"That's her job! Aw run away, you can't take a joke. Go on, pissoff, I'm tired of talking to you. Get out of my room and shut the door."

"We're not allowed to shut the door."

"Oh is that so? Well I'm allowed to do whatever I want to do, and I'll shut the door myself, right after you leave."

"Where am I going, Joshy?"

"How should I know? Away. Bye bye. Just go out the door and I'll shut it and you knock and I'll say 'Who is it?' And you'll say, 'It's me, Goonie, can I come in?' and I'll say, 'Of course, you dodo, it's your own room, come on in and make yourself at home.'"

Gordon went out into the corridor. Josh slammed the door behind him. Gordon knocked. Josh shouted, "Who is it?"

"It's me, Goonie, can I come in?"

"Of course, you dodo, it's your own room. Come on in and make yourself at home."

When Gordie had turned the knob and entered, beaming, Josh shouted at him, "And don't try to tell me I'm not allowed to shut the door!"

Docile though Goonie was, and placatory when Josh was in a temper, Josh was always careful to draw him back in after he had spurned him in one of his rages. There had been one wretchedly terrifying night when they were children, when Gordon had disappeared after Josh had yelled at him. Unable to tell anyone,

convinced that the dragon was hanging about outside the door because she had guessed he had made Gordon run away, he had lain awake listening to the accusing patter of the rain on the window and scoured by wretched fantasies.

In a half-dream, sometime before dawn, he saw the dragon carry in little Gordon, freshly bathed and wrapped in a towel, watched her put his pyjamas on, and heard her shush him before she withdrew. He listened to his roommate squirming between his sheets as she shucked his pyjamas. Deeply contented, Joshua was drifting off to sleep when he collided with Gordie's loud whisper.

"Sleep tight Joshy! Sleep tight Joshy!" Gordie repeated hopefully.

"Sleep tight. Did you go far?"

"All the way and back."

"Do anything?"

"Sure saved a lot of worms."

"The whole driveway? Both sides?"

"Raining."

"Brave guy!"

"Yah?" Chuckle.

"Yah, all night in the rain, Goonie on guard to save the foolish worms if they try to leave their wormholes. Up and down the driveway, Goonie on patrol. There'll be no dead worms drying on this driveway tomorrow, not if our hero can help it. Action alert! Here comes a silly worm, poking out of its hole.

"'Oh, it's raining. Think I'll go on a trip.' Wiggle wiggle wiggle.

"Here's Goonie to the rescue. 'No, no! You'll dry for this!' Swiftly Goonie tweaks the worm's end with his iddy finger. Zoop! The worm zoops back into its hole. And here's another, and another, zip! sip! slurp! sucked like spaghetti back into their holes. All the way up the driveway, all the way down the other side, crouching, galloping like a rabbit, the brave knight of the worms, sip sip, zip zip, slurp slurp slurp, zoop zoop zoop zoop zoop! Noble Gordon! Does he care if it's raining? Does he care if it's cold? He's got a job to do, the most important job of the rain. Do you know why it's

the most important job of the rain?"

"Yes. Why, Joshy?"

"Because the worms are the nails of the grass. Wet noodle nails." Josh couldn't help laughing. Goonie laughed too, extravagantly. "No. It's true. They hold the grass down. If the worms leave their holes in the grass the whole grass carpet will tilt off and fly away in the wind, and there won't be any more grass, just mud. And when it rains you'll sink right down in the mud when you try to walk, down down down, and unless you hit a big rock you could just disappear."

"Goonie?"

"No. Goonie saved the worms and the grass. Nobody will sink down now."

"Naughty."

"Who says?"

"Dragon."

"Oh yes, naughty naughty, bathy bathy, huggy huggy, nighty nighty, wicked wicked Gordon."

*

"You can't take your eyes off him," staff used to tell each other, when he was still practically a baby. Look away for two seconds and he'd disappear into the bush off the grounds. Once, they found him across the highway and up the hill in the shopping centre. How he'd got across without getting run over they talked about among themselves for days. Josh figured he might just have managed to cross with the light. It always amazed him how earthlings who could talk so easily talked so much crap. Lucinda said it really offended them that there was someone here who wasn't reliably helpless. But she went a little too far for Josh when she declared that Gordon was the only free spirit in the place.

"If he's so free why doesn't he stay away then?" Josh challenged.

"He will, when he's ready. He has choice," Lucinda affirmed. "We have to have choice."

"He has legs, too," said Josh, "and nothing to lose." He didn't even want to imagine what his earth parents would do, and even worse, say, if he tried to escape.

"You're jealous," Lucinda retorted, unfairly accurate, and added, "So am I."

"Though he's sure good for morale," Josh conceded, mollified.

One time when they brought Gordon back they tried to punish him for running away by making him sleep by himself in a kind of little closet off the corridor, and they took all his clothes to make sure he wouldn't somehow escape, because they never could figure out how the little Houdini did it in the first place, and how he got so far when he did. Shut up there in the closet in the dark without even a window, Goonie got really spooked and he started to howl and bang on the door. They probably thought if they paid no attention he'd stop. But he didn't stop. He begged and he banged and he bawled and he howled and after a while it just seemed to get away from him, and it wasn't Goonie begging and kicking, it didn't even sound like him anymore, but something else was keening through him, something awful and scary and desolate, something more real than you could bear. It got to Josh. It got to all of them. Josh was so upset he fell out of bed again, trying to get up in a hurry. He was all bruised afterwards, but he got to the corridor, and there was the dragon, shooing him back, and by this time Josh was yammering and wailing himself, and pushing to pass her, though she was trying to say something and he could see she was upset too. A bunch of staff were clustered around the closet, looking worried. If Gordon had a really big fit, not just one of his little fadeouts, then what? And all the wards by now were filled with whimpering and hollering. So finally they had to unlock the door on Goonie.

The minute the door opened he went streaking out past them, all in the buff, and he went racing down the hall, keening and wailing, bare-arsed, dipper dancing, into the dorms and over the beds and around, clanging gurneys and zooming wheelchairs at them when they came after him. Then down the stairs and yip

yipping and girls screaming "Go Goonie!" and cribs shaking and banging and even the sickest scratching at their sheets.

Back upstairs zoomed Goonie, in the door, dived into his bed, under the covers, rolled himself up in the bedding and was still. Nor would he budge when they had come panting into the room after him and stood scolding over him, telling each other how wicked Gordon was ashamed to show his face and how disappointed everybody was in such a bad Gordon. They wanted the satisfaction of at least making him bawl and say he was sorry, but Goonie just played dead, though knowing him, Josh wasn't sure how long he could hold out. So Josh, climbing back into bed, called out "Go Goonie, go!" And the dragon, standing near him but not making the mistake of trying to help, said, "That'll do Josh," and "Hadn't we better see to the others?" So after a few little promises about what was going to happen tomorrow if there was so much as another sound from this room, the white smocks went out to calm the others and put the excitement that was still humming up the whole place to sleep.

At last when everything was quiet and the lights were out and even the dragon seemed to have stopped patrolling around, here's Goonie tugging at Josh's blanket. "Josh, hey Josh, what happened? What did Goonie do?"

<p style="text-align:center">*</p>

Lucinda had spent her short lifetime practicing how to hide her vulnerable feelings, smuggling them secretly, like harbouring outlaws, lest they be discovered and used against her in her public campaigns. She submitted, cold-eyed, to indignities, masked her pleasures lest they be observed and snatched from her. Even as late as that brief, final period, when, largely through Lucinda's and her mother's persistence, she and Josh and one or two others had won the right to attend a city high school, her keepers still, when she exasperated them, got the last word by simply picking her up and setting her down on her back on her cot, where she remained as stranded as though she were in the middle of an ocean. According

to the Gorpish kind of the earthling world, "the wheelchair is not a right but a privilege."

"Thief!"

"I'm no thief. It's our property we let you use, when you behave."

"Whose property? Bully!" Lucinda had mastered, surprisingly well at her age, in spite of the indignity of her helplessness, the nuances of contempt.

To show her how far her smarts would get her, when she had displeased them, her keepers simply put her schoolbooks up on a shelf she couldn't reach. She would spend the evening before a test trying to persuade the marginally more mobile on her ward to help her, and couldn't even bring herself to blame them for being too afraid to lose their too little by antagonizing their keepers. Once, though, she confessed to Josh that sometimes she didn't give a damn anymore, about anything or anyone in this whole lousy holding tank.

"But you go out on a limb," he reminded her, "even for the shits."

"That's about our rights," she replied, "not what's inside." It was as close as Lucinda could come to saying out loud that she was afraid she had lost what she had kept hidden so long inside, and that she might never know again what her own feelings were unless she got out of this place.

Josh, unbidden, suddenly had a scary feeling about her, a feeling of her separateness, her unfathomed inner shape, her destiny. He couldn't bear it. He reached out clumsily. The bad feeling was instantly forgotten in the warm, living feel of her under his hand. He let his hand remain on her shoulder as she paid no attention, calculating how long he dared, before she would shrug him off, trying to gauge what would be better, to see how long she'd let it stay, or to remove it before she noticed, so he could put it there another time, since she hadn't forbidden it this time yet. It could become the natural thing he did every time they met, simply casually manoeuvre his hand onto her shoulder, and feel her soft flesh and the bone underneath. And from there....

Only it was the wrong hand on the wrong shoulder, his left hand facing her somehow silly on her left shoulder as if he were about to pass her, but just standing there, awkwardly, while she talked, without looking at him. She must think him an idiot, but she was too nice to say anything. Josh jerked his arm back, narrowly missed her jaw, and hung there before her, hot in his entire body, an elastic of spittle lengthening out of the corner of his slack mouth.

"It boggles the imagination," Lucinda was saying, "that they once actually called a place like this 'The House of Happiness.' It's enough to make you wonder about the true story of the place they called 'Paradise,' whether it was really an expulsion, or an escape." She glanced at Josh, indicated, matter-of-factly, that he was drooling, and continued, while Josh, released from his embarrassment, half turned away to tend to himself.

"They didn't publish the book about the daily humiliations of Paradise, about the Angels of the Lord who nightly wheel you naked in the commode chair to the embarrassment of your public bath, side by side but trying not to look at the other females, or the angels who scold you for wanting at least the privacy of your body, such as it is, and nightly thunder, 'That door is to remain open!'"

Lucinda was more sensitive, maybe, than Josh and Goonie about baths, but then she was more helpless. Only she never acted more helpless. "If you want rights you have to act as though you have them. Why should your late night passes be suspended for a month because I came in five minutes late last night? Why should we all be grounded because Gordie's taken off again?"

She argued fiercely, not only for the physical, but for all the privacies which they were routinely denied, and even sometimes denied each other. She had had nothing against Josh having got to read, for instance, with Gordie's help, his own records in the files; that she considered a right. But she lectured him for having read Gordon's, though he explained the Goon had asked him to read them to him. He didn't understand a lot of it, but he'd sure been thrilled to see the two old newspaper clippings about how

he'd been found in the garbage.

There had been no garbage-can goodies for Josh in his own case history. He'd known most of that stuff before, even the scientific names, but the files nothingified him, stripped him from himself. He wouldn't have minded so much maybe if he'd read in his files something like "This guy even needs help to beat his own meat." But he wasn't even that real; his file turned him into an abstraction, not even an abstraction with a nice-looking left profile that hinted at what might have been, or an almost girlishly peachy complexion, except for where the trace of manly fuzz had begun to feather his chin, just an abstraction on which the promise of an exceptional intelligence had (was he exaggerating to imply regrettably?) well, presumably anyway, been wasted.

Gordie was so excited by his file that when, in completing the daring, daylight operation with the slick precision and faultless timing of which no earthling keeper could have imagined them capable, they had returned the files, closed the office door behind them, and were about to scuttle out of the danger zone, the Goon spotted two perfect female earthlings, before Josh could stop him, he had tacked in their direction and bubbled impulsively over to inform them, in his winsome but garbled way, that he was the famous garbage-can baby in the newspapers, who had been found with cephalus, just like his mommy who had only put him down to scratch her itch.

Josh, in his hurry to get away from where the Goon was setting off a venereal panic among the innocents, flung himself precipitately along the corridor, lost his balance and fell. The pretty skirts came running down the hall with their flashing legs and kneeled down and worried over him while he swore and slobbered and kicked at Goonie, who had come running to help too, to get him to shut his face. Then of course Gorp burst out of the staff john where he hid to have his smokes and came striding over. Seeing him, Goonie took off. Gorp hauled the mortified Josh onto his pigeon toes and did some chest beating and gave his Tarzan yell for the pretty ladies, or so Josh told it afterwards, when he had got away with a stern manly warning for being out of bounds.

Lucinda had a few things to say about all that out-of-bounds crap. Nothing got by her without being questioned. Even Gordon didn't get away with too much when Lucinda was around. Josh tried to excuse the Goon by explaining to her that he himself at least had a memory of being often held, in what he called the prehistoric days. Not so Gordie. He was a compulsively touchy touchy little fellow, touch starved, Josh explained wisely. Touch touch with his swift little hands and the girls laughing. "Goonie! You're just awful!"

"What did I do? What did I do?" Beaming, really wanting to be told. An instant later, paws flashing, "Did I do this, this, this?" And Gordie is off, escaping, his weird cry, which so irritated their keepers, "Ex-pen-da-ble! Ex-pen-da-ble!" echoing through the place. Once Lucinda, motorized, chased him, recklessly, trapped him in a corner, but in the process of several jerking starts and stops in her manoeuvring, jarred herself badly. Weeping painfully, she scolded him, told him it was bad and mean and cowardly to do things like that and run away, just because he could run away and they couldn't chase him. Goonie started to bawl, so of course Lucinda put her little arms around him to comfort him, and they were caught that way by a pastel who was disgusted by what she perceived them to be up to, and when Lucinda continued to cough and weep after Gordon had been shame shamed off, the pastel was not in the least taken in by what would serve her right even if it was genuine.

Josh was drawn to but still afraid of the relentless arrow recognitions of Lucinda's mind. What he thought and what he felt did not seem, often, to belong together any better than what he wanted to say and the way his mouth and tongue made him say it, or the way he wanted to move and his earth body's maddening subversions. He had been too young to understand his earth parents' antiphonal explanation of why they were sending him away, his mother's emotional assertion that he was a very special child, his father's well-turned complement, a child who deserved every chance they could get for him, the melancholy triumph of his mother's discovery that there was a place where he could be better

looked after, his father's wry joke that he had always wished he'd been able to have a private schooling himself, and their strong choral assertion that they believed he could do it, that they would always be there for him, and that whatever it was that this was all about would depend on himself. It all translated to the question with which he wept himself to sleep for months, a felt question words could only approximate: "What did I do that was so bad that it made them bring me here and leave me?"

When it came to explaining things to Goonie, later on, however, Josh was never at a loss. "It is the tradition of the upper classes that the noblest children are sent away to be educated in special schools." Josh loved big words, high-sounding words that had the twist and roll of meaning mastered in them. The harder they were to get out the more ardently he urged his tongue to wrestle them down. Gordon hardly ever understood his good big words, though Josh sometimes broke them up into little bites for him. He didn't necessarily understand them any better that way, but could say them better when he was trying to speak for Josh. "In these special schools things are not made especially easy for you. The experience prepares the upper classes for their re-spon-si-bi-li-ties as visible exemplars, ex-em-plars of their kind. When they know the rules and have learned to adjust to the life, they can enjoy making their way from help-less-ness to mas-ter-y within their con-text and hence, given a stable system, emerge as masters of the greater con-text. Now we, Goonie, you and I, according to un-im-pea-cha-bly au-thor-i-ta-tive sources, are even now in such a school. Hence, we specials will un-doubt-ed-ly emerge as the a-ris-to-crats of the system, its tit-u-lar leaders, the flowers of the race."

"Flowers can't run," said Gordie, who sometimes asserted himself unexpectedly with random connections.

"What?"

"What does it mean?"

"It means that we aliens are an a-ris-to-cra-cy in the making, my dear boy, and this rat-fucking hole is merely a stage in the journey to a role of su-preme sig-ni-fi-cance in the universe. Ha ha

for us."

"No Josh, that word, 'tit you' something, what does it mean?"

"Tit you?"

"You said 'tit.'" Gordie was leering over from the other bed.

"Tit-brain! You haven't been paying attention! You have tits on the pea-brain."

"But you said 'tit you.'"

"And I said true, my Goonie boy. I said tit-u-lar, and you're the only boob in it. I'm trying to explain why we're special. That's what you asked me in the first place, why they keep telling the volunteers we're special. And of course you show interest in what has after all the only possibility of arousing interest in the whole pile of crap. You're a natural, Goonie, in more ways than one. You have a natural genius for what counts in life, in titso veritas. Go to sleep. Dream on it!"

"Aw Joshy, I'm not sleepy."

"Dragoon, ta rum ta rum."

After the dragon passed, Josh called out softly, "Help help! There's a whale in my sardine!" Goonie was beside him and under the covers in an instant. He grabbed Josh's hand and closed it around his own sardine, holding it firmly. With his other hand he groped for Josh's sardine and clasped it. Squeezing and pumping, they chanted softly, "Help help, save the sardine, spit out the whale, save the sardine, spit out the whale, save the sardine, spit out the whale, spit out the whale spit out the whale spitoutthewhalespitoutthewhalespitoutthewhalespitoutthewhalespitoutspitoutspitoutspitspitspitspspspspspspspsssssssssss...."

Afterwards, Goonie giggled his way back to his cot. It was a riddle he loved, that was its own solution. You didn't have to guess. You just worked it out.

*

Very early in the morning was Josh's private time. Bent over the

227

small table, stick in mouth, he wrestled with an open book. When it behaved he was oblivious to his earth world for hours. But sometimes a page got stuck and wouldn't separate to turn over. He would try every which way to separate it, even manoeuvring his chin down on it. Once, when he was trying to work the pages apart, his lip took the slicing edge. Ignoring the smart, he lunged his face forward again, and by the time he pulled his head back, there was a blood-and-spittle smear on the page and blood taste in his mouth. His lip stung. "Damn machinery! Fuck damn machinery!"

Gordie was still asleep, his breath whistling and cheeping because with his out-of-alignment face it got trapped up his nose. Soon the dragon would come along. Gordie would awaken and that would be it for his read in private.

"Is it a good book?" The dragon's quiet voice surprised him back to earth. She waited, not snapping the thermometer while he fought the words out. "All right."

"He says 'all right,'" Gordie, not one to miss the social action, chirruped from his bed.

"Good," she said in a neutral voice, her scaly face impassive around moist, mutely voluble brown eyes.

Sure she shaves, Josh decided for the thousandth time as she pulled the thermometer from his mouth. His expression was faintly derisive. He was not sure what it was that he knew about her. It carried with it a vague sense of power and an equally vague sadness which irritated him. But it didn't threaten. He was not afraid, as he would have been with some of the others, that she would find out how much he wanted to read, all the time, how swiftly the voices and feelings on the page and in his head conversed without intermediaries. Was he uneasy because she so often seemed to assume, correctly, that she knew things about him? Let her love Gordie, the little cuddler. One earth mother to cry over him was enough for Josh.

"Damn machinery," he said to Goonie, when the dragon had passed to the next room. "I'm so bloody fed up with this science fiction life." "Me too," said Goonie cheerfully.

"You too? Oh no, it cannot be! It must not be! What have

they done to Mr. Happiness? I can't go on this way!"

"Me too! Me too! Mr. Happiness! I can't!"

"Keep your cool, soldier. Save your breath. We must alert the guardian of the innergalaxies. This is a case for that riproaring renegade, that jack of all dimensions, that miraculous astrohead, that spectacular astromind, our very own modest, self-effacing Captain Dr. Yehoshua Bobalong Astrofix. Hello hello hello, did somebody call? I just happened to be hanging around, reading a very interesting mind, when I heard this shunt dripping in the next bed. What? I says to myself, a rebel shunt in Moon Minor?"

"Me, me!"

"Hush hush, young sir, ears everywhere! Let's have a sensor of you now. Hum hum, aha, mechanically extersurfaces are in pretty snappy shape; dimension regulator needs some fine connector tuning; printing impression's a little light; erratic feedline; problems in inter-organic intactics characteristic of all supra-dimensional breakthroughs. Trifling matters enough from a superior point of view, but here we must yet again contend with the rampant, the vir-u-lent selective perfectionism of a backward planet. Take, for instance, just yesterday, when the depot pedagogue, who should have known better, remarked, 'You're mooning again, Gordon.'

"'Yes teacher.'

"'Try to pay attention!' The earthling ped-a-gogue's a fool. To expect attention of our Goonie is to contradict his terms of reference. Nevertheless our hero obediently opens his mouth to activate his make-space and perks his eyes to listen-focus. This automatically shuts off his attention valve.

"'I hear something but I can't put a make on it,' says the Goon to the great Captain Bobalong.

"To which the Immortal Wisdom replies, 'Go forth beyond mind, young Sir Moongoon the Valiant. Fear not your shunt; there shall be no slip of the drip. Go forth boldly; go forth proudly. And remember, divulge nothing to earthlings. Keep bright smile on face even when out-to-lunch with Moonmum. Eyes open. Glassy stare. And off to school we go, ho ho.'"

*

There was not much room for school in Goonie's makespace. Even when they were all still supposedly going to school in classrooms on the premises, Josh regularly mislaid the Goon at some point between the time they set out for their classrooms and the time Josh arrived. Sometimes they got mislaid together. When the weather turned balmy they would slip off into the nearby bush to see how Gordie's treasures had weathered the winter. Usually the stuff had disappeared. Maybe the Goon couldn't remember exactly where he'd put things; half the time he couldn't remember exactly what the things were that he had found in the city's garbages during his nights of wandering. The small suitcase with the yellow stone banana in it and the red stone apple, both real, were still there, and the two of them hefted and admired, and Gordie almost reverently replaced them and covered the mouldy little cardboard box over with plastic and rocks again. Other things turned up, too, rusted odds and ends for which Josh's enthusiasm was moderate. But he paid his compliments. "Getting the itch?" Goonie smiled dreamily.

"Wait till it gets warmer." Josh was getting chilly. "And remember you promised. Next time you'll bring me a girlie magazine. And the time after you'll bring me a girlie." Laughing uproariously they rounded the corner of the facility.

Several middle-aged earthlings, debarking from three automobiles, looked up to see, lurching towards them, a tousle-headed young alien, his mouth open, his voice wowing unintelligibly, his hand awkwardly upraised, his walk a splayed stagger. Behind him, holding the air in his hand as in a cup, and shaking it as he repeated, "clink clink, clink clink," marched another, a skinny, twisted little fellow balancing a huge, distorted head with beaming, diagonal face set askew, on a delicate neck.

"Aaaaalms for the love of AAAAAllllllaaaaaahh!" Goonie picked up and repeated Josh's cry.

"Tell them we're collecting for our trip," Josh instructed, and went on without pausing. "Our big ambition is to travel around

the world, leading the romantic ex-is-tence of the scummy men-di-cant. Clink clink."

Rolling his big head on his skinny neck, shaking the invisible cup in his hand, Goonie at random, "Our trip around the world...romantic...scummy...clink clink."

"I want to see what it's like," bawled Josh, "to live helpless and destitute in every godforsaken hole on this planet. I want to be the first Astronix to take a begging cup to the moon. Oh God I have dreams!"

"See what it's like...helpless hole...cup to the moon...oh God...clink clink clink." Goonie made up with clink clinks the words he had missed.

When they had passed, still gabbling, the Members of the Board made their way to the front entrance of the facility without comment and went in to their meeting.

"Listen, Goonie, did I ever tell you in the olden days in Greece they would have tied you by the feet and taken you up into the hills for wolf food? There was a great prince got left that way once only he got saved by a farmer, just like the garbage man saved you. In Africa or someplace like that they would have recognized I was the Voice of God and you were my Priest, see, my Mouthpiece, and they would have treated us better than kings. They would have given us crazy juice to drink so I could talk better 'ogledy-boobledy-maidenly-yummily' and you could translate for me, 'The Gods Want Mixed Dorms For All Crips!' Giggledygiggledy-Goonily."

Inside, while the spring-sprung young aliens were clowning about without, the Board was appreciating the desire of some elements to see a degree of integration of their clients with the community at large, regardless of the pain that such exposure to comparison might bring to those involved. Regardless, as well, of manifest unsuitability, inability to compete, and not even considering the further loss of revenue from government sources that sending more clients out to city high schools after the initial experimental period would entail, the Board deplored mildly, rationally, the unfeasible idealism of thinking which urged the setting up

of elaborate support systems to enable their charges an even greater degree of the individual autonomy within the community which some mistakenly equated with freedom. The Board was by no means convinced that the subjects themselves even wanted all this, or were capable of coping with it. It was not a kindly world even for those who belonged out there. It came down, as always, to the stubbornness and impracticality of a few who were personally, emotionally involved.

Lucinda's mother was one of the most persistent of those few, an unprepossessing little widow so anxious to keep fences mended between staff and her lippy daughter, that some staff laughed at her behind her back. "She's here again, cookies for coffee break!" She it was, nevertheless, who had canvassed and won over enough parents to upset Board policy and budgetary arrangements, at least for the tightlipped time being.

Lucinda got to see her mother more than Josh saw his family. Of course they had only each other. Also her mother could come in from the country regularly, on her days off. And Lucinda was often sick, and her mother always came running. Josh's people lived here in the city, so if they couldn't come one time they knew they could always come another and make it up. And there were three perfect earthling kids in his family, so something was always coming up that they had to do with them, and that made it harder. Sometimes they took Josh on outings he was suitable for, though, especially in the early days, but it was always so hard to part with him. He tried not to but he always ended up getting panicky towards the end of having fun, and begging to stay with them. He made his mother cry and his father start cursing the doctors all over again. And when his little sister cried too, and clung to him, that was it for his father. Why should Josh be upset and everybody have to end up feeling bad and little Naomi cry all the way home, over and over again, always the same thing? Later on, when they had all developed understanding, they would be able to see more of each other.

For his part Josh could have put up with a good deal more of the upset involved in contact, and though, as time passed, he

often told himself they could stay away for all he cared, he was almost beside himself with anticipation when he expected a visit, and totally, greedily out of control inside when they actually came. Sometimes, rarely but sometimes, his mother brought Naomi unexpectedly, just the two of them, because Naomi had nagged so much for so long. And his mother looked at him in that funny begging way, as though she wanted his approval, but it was Naomi he turned to, Naomi who had known him as he was all her life, and loved him anyway, as he was.

Those were the times, the family visit times, when he really did wish the Goon would piss off, run away, disappear. You couldn't even have your own family to yourself with him around, performing, performing every minute. And Naomi played with him, what did she know, she was just a little kid. Even Lucinda wouldn't have put up with it, Lucinda who had once introduced him to her mother, but had made it clear that he wasn't to hang around. Well, he didn't blame her. And then to hear his own earth mother inviting the Goon home with them for Thanksgiving, chatty chatty, fun fun for Joshua to have his friend home for a visit. And then looking at Josh as though she expected him to fall on her neck and bless her. And getting so upset when Josh burst into tears instead. And Naomi hugging him and crying too, she didn't know why. And his father getting mad. Josh was never satisfied, whatever you did for him; what was bothering him now? And his mother turning on his father, and his brothers the perfect peoplekins watching, and Josh wishing, yes, wishing, and so frightened with it, wishing they'd all go away, but only for a moment, so he could remember how to want them back.

And of course they did go away, and didn't come again till they came to pick him and Goonie up for the holiday weekend. Expect them to forget a promise to a perfect stranger? And every day in between the Goon reminding him, and wanting him to tell the story in advance, Goonie who'd forget his own life story if Josh didn't make it up for him, muscling in and welcome welcome, now we don't have to wonder what to do with Josh for a whole long weekend. Fat chance hoping he'd forget, singing himself to

sleep with "Going to Joshy's house. Goonie's going to Joshy's house for holidays."

In the end it wasn't even so bad, only different. Josh experienced the weekend through a filter. He was even distantly glad the Goon was having such a good time. Once or twice he caught his mother's eye on him, and ignored a tremulous smile. But when they left he even let her hug him, and hugged her back, hard. And he hadn't upset his father, not once.

Soon after that holiday, he told Lucinda that he couldn't wait, not only to get through high school, but to take the life skills courses and blow this coop altogether. It was getting on for time to think of infiltrating the native scene. He even set himself a preliminary territorial objective. "We belong here too," Lucinda had told him fiercely, the first time they had crossed out of bounds and penetrated, together, a short way into administrative territory during a time of day when, according to their keepers, they had no business to be there. Josh, as a challenge to his own timidity, had formulated a plan to extend their territory in a way that all earth creatures understood. It was to be an undercover operation, to map, unsuspected, the geography of conquest with the spoor of the conqueror, a sneaked piss in the staff toilet. He saw it as a trophy to bring Lucinda, imagined himself saying, "and when I looked up there was Gorp standing next to me, hunting around in his pants for his little sliver."

The last thing he actually wanted was to encounter Gorp, to encounter anyone. He managed to make it right to the door of the john and was somewhat tentatively leaning against it, bracing himself with his excuse of frantic need in case someone should be in there, when he became aware of purposeful steps and a concerned voice, "Are you all right?"

Josh's hams began to tremble and he sagged, scared, against the door. He swivelled his eyes upwards and sideways pleadingly and his mouth opened and twisted in the effort preliminary to speech.

"Here, we'll get that door open." She suited shove to word; the door opened suddenly, and Josh, still leaning against it, fell

forward with it. There followed a tangled scramble half in half out of the john, with her bracing and supporting him, all the while apologizing and encouraging him back onto his feet. Briefly stupefied, Josh found himself standing at the pissoir beside a buxom, well-dressed and artfully coiffed, if slightly dishevelled woman who stood braced, ready to catch him should he show any signs of falling again. No wonder Goonie liked the way they smelled. One more whiff and he'd be yummy mummying himself. Why not?

"If you're going to hang around," Josh ventured politely, and she inclined her head and strained her attention to make sense of his utterance, "reach into my fly will you? My balls get heat prickly in this weather. Just give 'em a little flap if you want to be helpful." Spittle had begun to form and dip at the down corner of his mouth.

"Yes," she nodded and smiled encouragingly, wondering whether it would be offensive if she just used her hanky...of course he wasn't contagious.

Josh suddenly emitted a wordless cry, and began to scrabble at his fly with disjointed, ineffectual movements of his hands. "Huuuuehehehehlp!" he squalled, his eyes enlarged and fixed in the panic of anticipating an impending disaster.

To her credit, she hesitated only an instant before she rose to the occasion and was fumbling at his fly. She was a little nervous, and finally had to use two hands, but she managed to pull his penis efficiently clear of his trousers and aim it at the drain.

"Hohohoh-oold!" Josh implored, and stoically, she hung on with firmed fingertips while it too rose to the occasion.

Still fixed on the porcelain in front of him, Josh's eyes rolled in crazy delight. Sneaking a glance he saw his spittle dancing, just missing her hand, her gold bracelet dangling, just missing his penis, felt something — which? he was afraid to look again — cold tickle his cock as they stood there for a moment of quietly delicious eternity. Something he had read started to run through his head, only he couldn't get it quite right, 'The palm is to the brave? The palm is to the bold? The palm is to the prick!' A sound, half chuckle, half happy little moan escaped him. He felt her

sudden glance.

"If you shake it," he suggested hopefully, and felt her puzzling over his words. Somehow, perhaps through the medium of their impromptu connection, he could sense what she was feeling. 'What am I doing here? How can I get out of this? How did this happen to me?' But surely she must feel something else, too, how well he was hung, and the silkiness over his thick, pebbly stick. Later on, with her husband, who was probably as old as she was, she might wish....

Did he only imagine, for an instant, that she was actually tugging him a bit towards her? Real or imagined, it was enough. A sudden, dancing spasm, and she was staring at the jellied porcelain, at what was shrinking in her hand, and had for the first time really understood what she heard, Josh dreamily wowing, "Thank you." She fled, leaving Josh still too bemused to move swiftly enough to prevent himself from pissing down his pant leg.

No matter. His hams even more wobbly now, he had a difficult time getting the heavy door open from the inside, and manoeuvring himself around it. But he didn't panic. And he knew there would be no unpleasant encounters on his way back through the danger zone. He just knew it.

*

"The highest honours go to those who continue to test the most dangerous machines in the field. Those intrepid volunteers trapped in unreliable, malfunctioning crypto selves in target worlds are our most valuable agents. They cannot be seduced away from their mission by the comfortable not-good-enoughs of indigenous populations. They alone sustain the dream of the evolutionary leap as an ever potential phenomenon of the present tense. It could happen to you tonight, as you root among the garbage cans, scold the worm pickers, stand guard for your friends with the little dog on the long leash, over the broken bicycles and old car batteries you've helped them scavenge, and then ride triumphant beside the old man in the truck to where the old woman will give you fatty

sandwiches and let you sleep on one of the many old couches piled up in their Aladdin's cave. You could wake up tomorrow trans-formed, transmogrified, grown up."

"Pays me," chuckled Goonie.

"I envy you, Gord." Josh's cry was heartfelt, and it made him feel better to admit it. Goonie had led him to a treasure trove of girlie magazines he'd stashed in the bush, three of them, from the old man's shop, that he'd given the Goon in part payment for helping him rummage the streets at night. The old man had talked of fixing up and teaching him to ride one of the junk bicycles some-day, of making him his helper. According to Gordie the old man knew all kinds of stuff, even the name of the masked, humpy-arsed animals he had so often encountered, and learned not to get too close to. Them little gangsters were Ra-goons, Goonie quoted, bolstering the uncertainty of memory with the authority of kin-ship. The old woman had fed him lard and dripping sandwiches that first time, and had let him stay until he felt better; the dog had slept with him. Goonie, with a couple of earned bucks in his pocket, wore a new ease that sat surprisingly on him, almost a sophistica-tion.

He was still afraid to be seen on the streets of the city in the daylight. Not much taller than a child himself, even in adoles-cence, he was leery of encountering children particularly. Long ago, in his early wanderings, he had been drawn by the wonder of see-ing children playing in a schoolyard during recess. He had entered among them with shy delight, and before he knew it was surrounded by a crowd of stiffened forefingers, poke poke poking all over his lumpy head, and all the pretty children, with excited cries, vying with each other to get another jab at the now helplessly weeping little alien. The sobbing Goonie had been rescued, finally, by a teacher. He had been brought back that time with a bloodshot eye and little bruises all over his face and head, discoloured swellings that had rendered even more grotesque his sweet-natured face. He had wept again when he had tried to tell Joshy what had hap-pened, acting out the stiff fingers poking at him from every direc-tion. Josh had become very upset, crying and sobbing and hurtling

himself about the room as he echoed Gordie's story. "Bad children! Bad children! Stay away from little Gordon! Don't you ever go near bad children again!" Goonie henceforth had clung to the night, and Josh, even now, among the many strong and perfect earthlings of his high school, was never very far from the possibility of being afraid.

"I hate to see them having to suffer us," he told Lucinda, irritated as much when they didn't look as when they looked quickly away. Almost, it was better when they stared, and you could guess their feelings from their faces, but at least they were out in the open, and even, in a way, communicating. The fact was they had got quickly used to his presence and largely ignored him.

"I don't mind seeing them suffer by comparison," replied Lucinda. So far she had managed to stay consistently at the top of her class, despite her long sickness-enforced absences. What good did it do him to get good marks too? Somehow she also managed to make friends. They listened to her. Josh, hovering, was dismayed to feel jealousy in his heart, not only jealousy because she was paying so much attention to them, but baser jealousy, because they were paying attention to her. He was bitterly ashamed, even more so because sometimes Lucinda set it up for him so they had to listen. Sometimes she called out to him in front of the others, "What do you think Josh?" and made them listen by listening herself, and even unobtrusively clarified by repeating, as if to get his ideas right.

Josh tried to rid himself of his bad feelings as he had always done, by confessing them to Lucinda. She laughed when he told her he was jealous of her popularity. "We're even, Josh. I'm jealous of you too. You're going to live to get out of here." Impatiently, she interrupted his shocked attempts to speak. "You don't have to say anything. I'll do my damnedest to live as long as I can. But you can't have been in this place all these years without noticing who goes, who stays. I'm not afraid to say it. I just want the right to be as alive as I am while I am alive. Josh, it's nothing to cry about, soppy boy. Listen, Bozo, you think I'm so popular now, because a couple of people talk to me, wait till I'm dating the entire rugby team. It's my brains they want to pick, but I figure fair

exchange."

"You wouldn't consider," Josh was crying, but he tried to match her, wrenching it out of himself recklessly, "a well-hung athatoid CP who'll only need a little help?"

She had wheeled herself around with her back to him, her sun-mist hair haloing her wheelchair, and was already moving off as she called over her shoulder, "I'll consider the prospect if you'll consider the logistics. Where. When. How."

"I will!" He yelled after her. "I will! I will!"

"Someday," Lucinda sang down the corridor, "my prince will come."

"He's coming already!" Josh bayed after her, and was rewarded by her briefly heard laughter. Did she mean it? Or was it just more Lucinda repartee? Fired by what she had said he waylaid her everywhere, plotted encounters, snatched liberties, squirmed under the constraint of knowing that if it was discovered they wanted to be together it would be made impossible. Where, when, how, became the refrain of his existence.

<p style="text-align:center">*</p>

While Lucinda and Joshua were getting their high school education, and the possibility of university was beginning to scroll into view for them, Gordon failed two sheltered workshops but led a fairly busy and productive night life downtown. He sometimes had a buck or two in his pocket from stuff he'd found and brought to the old man, who usually got him to do a garbage round with him in his truck, when he turned up. Goonie had also discovered the track, and with an outsized knitted cap the old man had found for him, covering his upper bulges, he roamed and lurked its streets, admiring the girls, some of whom, when they spotted him, weren't even afraid, but talked to him and teased him a little, in ways which made him glow. He picked up the odd quarter that way too, from getting them their coffee and cigarettes sometimes. He learned to count money pretty well, and knew what the change for coffee and cigarettes should look like. Once, when the price of coffee had

gone up, he stood and bawled in front of the cashier at the café until she gave him another nickel and chased him away. Somehow he managed to absorb much that he had not been observed to learn. And one thing he had in abundance, the highly developed caution of the alien in an unfamiliar world. When the big guy beckoned him over to where he was sitting in his car at the curb and pushed open the door to show him the 'mouthful' he was offering him, Gordie ran. He couldn't believe he heard the guy calling after him he'd pay him five bucks, but he didn't stop to check it out.

Neither could Josh believe it, but it worried him. "How many times have I warned you to be careful who you talk to out there? What good's five bucks when you've choked to death and dislocated your shunt? Even if he paid you it wouldn't be worth it. Was it really that big? He probably thought your whole head was hollow. You'd better watch out, Goonie. You could get a disease fooling around with just anybody. Someday you'll get yourself a nice little girl who'll love just Goonie."

"Just Goonie?"

"Only Goonie. Goonie and Goonie only. Three Goonies. That should be enough for her."

"Ssshh Dragoon!" He hissed into Goonie's laughter. "Snooperina, cut the man talk."

From Gordon the old argument, "She's nice, Joshy."

"Your earth mommy."

"Aw Joshy, she's an alien too." Even Goonly sometimes scored an unexpected point.

"No! She wasn't brought here. She came here on purpose. She belongs here. It's just a job. And she took it because she's hiding out. She's on the run, and who would look for her here? Or she's on a spying mission. She's not an alien. You know what she is? She's a man! That's why she shaves and her chin is blue and flaky with powder on it. She's a man in disguise!" Josh liked the idea so much he was ready to consider it seriously. But he couldn't resist Goonie's laughter.

"A man!" It broke Goonie up. No one could get the giggles

240

like the Gooner. "A MAN, Joshy. But Joshy," Goonie remembered suddenly, "She's got tits! I felt them! A man and she's got tits!"

It was too much for Josh. He broke down too. "Tits and a man," Goonie repeated over and over, squealing with delight.

"When did you feel her tits? Oh you naughty Goonchild, you've been feeling her...ssshhhh, listen, she'll hear us, ixnay! Duck!" With a prolonged rustle Gordie disappeared under the covers. Josh, listening for steps, felt a sudden revulsion. What did he have against her? She was nice. Why wouldn't he admit it?

Goonie rustled to the surface. "Sh! She's coming. Go to sleep!" Josh fought himself noisily around in his cot, with his back to Gordon, and pulled his covers up to his head. "It's only a joke," he argued with himself. "It doesn't make any difference to her." Why did he feel so bad about her all of a sudden? He decided to call out "good night" when she came by. But the dragon, standing nearby in the corridor, did not appear until after the tossing and creaking from his cot had ceased.

By morning, with all he had to think about, Josh had forgotten his brief bout of conscience, and scarcely noticed the dragon, except for the momentary irritation when she appeared and broke his concentration. He remembered, though, when she slipped the thermometer into his mouth, and as she gently pulled his lips shut around it, their eyes met. For no reason tears welled into his own. Blinking, he grunted a closed-mouth "thank you." But Josh couldn't handle too many feelings at once. He had enough with trying to stay ahead of his schoolwork so that his earth parents would have to agree to his long-range plan, and the immediate, everyday exquisite itch of hope for and frustration of his solutions to the where, when and how.

Lucinda finally solved the where and when herself. Her delicate countenance, with its expression of a stranded cherub, her air of having mislaid the connection but of not having entirely forgotten her kinship with seraphic hosts, gave her a certain presence to which some of their earthling keepers responded not unkindly. One security guard even found it reasonable that a nice kid of her age should yearn for some real privacy sometimes, just like a

human being. Between temperature-taking and medications, when it was safe to disappear a while and easy to sneak down halls and through stair exits, Josh and Lucinda found one of the schoolroom doors unlocked and for the first time in their lives were really alone together, and free, in the limited circumstances, to explore how.

*

Gordon's lengthier absences gave Josh more time and privacy for study, particularly since the dragon chose not to notice when his light went on at unorthodox hours during the night. However, especially when Lucinda was ill, Gordon's absence isolated him too. Sure, you couldn't talk to the goon about serious things that really interested you, as you could talk to Lucinda and one or two of the other kids at school who, thanks to Lucinda having taught them to slow down their ears, could now actually hear him well enough, so that some discourse, a word he loved, was possible. But when Lucinda, in her final year and already looking even further forward, though she sure didn't get any encouragement in this place, became seriously ill enough to have to be hospitalized twice during the school term, and was bedridden again now, though not this time in a city hospital, which must mean at least that she wasn't as sick as before, she might as well be miles away as far as them letting Josh in to see her was concerned, even though he brought the class notes a couple of the kids took for her every day, and her assignments, and it would have made her feel better, Josh knew, to see him and to have him at least tell her what was going on. And it would have made him feel better too.

That was when he missed having the Goon around. Of course it was great to have the room to himself, though he was afraid that if Goonie disappeared for good they would put someone else in with him. They had been teamed up in the first place, in their little double cell rather than having to share a four-cot ward, because they were both more able walkies than most, though Josh far less so than Gordon, and could be looked after more easily. It was one of the things he was tempted to ask the dragon about,

what they were planning for Gordon; she'd tell him if she knew, that and why they wouldn't let him see Lucinda. He wasn't afraid to give her his opinion either, that they knew how much school meant to Lucinda down there, and they wouldn't give her the satisfaction, even when she was sick. Sure, they couldn't stop her mother from being with her most of the time, but Josh had rights too, though they were private rites and maybe the dragon might be just foxy enough to catch on if he showed too much interest. So what if she did? Personally he didn't mind if she knew. What if they all knew, and that was why they wouldn't let him see her? Well, it wasn't going to go on much longer. One thing Lucinda had done for him, she had radicalized him so well it made her laugh sometimes. He had the right to see his girl friend. Girl friend. It was the first time he had used the words, even in his head, and they wrapped themselves around the fact warmly. He had the right to see his girl friend soon.

When the Goon turned up Josh made a fuss over him, and they slipped back easily into the old verbal games which had answered so well their separate needs for so long. Josh extrapolated extravagant tales from Goonie's cryptic utterances about a world which hardly impinged on his own, and found himself being corrected far more frequently than before, though mainly, he felt, with respect to niggling details. But, though Josh said some funny things Goonie knew better about, Goonie still recognized and enjoyed being the hero of the vaguely apprehended sequence of his own life. There was more to do and see elsewhere but it was good to be home with Joshy sometimes, especially when he was paying attention to Goonie, and was glad he'd come home. He sure needed Goonie to keep watch at night, or he'd miss everything.

"Josh! Joshy! Ex-pen-da-ble! EX-PEN-DA-BLE! Joshy!" Josh shot awake.

"Quick, Joshy! Ex-pen-da-ble!" Josh crashed to the floor. He didn't hear his own involuntary cry of pain as he forced his recalcitrant machine awkwardly erect and propelled the weight of a suddenly frozen heart toward the window. The rear doors of the dead white ambulance stood open. As the stretcher with the small,

mounded, sheet-covered lump was slotted into the back of the ambulance, Goonie jumped to attention, saluted smartly, holding his fingers across his top eye to his forehead, and sang out, "EX-PEN-DA-BLE! EX-PEN-DA-BLE! THE SA-CRED COM-PA-NY!"

From behind the ambulance, as its doors closed, the figure of a small, stooped woman emerged, and walked hesitantly toward the parking lot as the ambulance drove slowly off.

Goonie was marching around in a circle, still saluting, "Ex-pen-da-ble! Ex-pen-da-ble! The Sa-cred Com-pa-nee!" when Josh hurled himself at him, howling.

By the time the dragon reached them Gordon was face down on the floor, his hands frantically clutching his ears, while Joshua, on top of him, flailed and sobbed, " She's not! She's not expendable! Not Lucinda! Not Lucinda! You stupid waterhead! Lucinda's dead! She's dead!"

*

Long after Gordon had taken off for good, whenever Josh was tempted, with cause, to bask a while in the legitimate arrogance of the alien, he reminded himself of all that was shameful in himself that linked him to the earthling kind, and among the worst of his transgressions what Lucinda would have flayed him for, that he had called the little Goon, with all the contempt of earthlings, a stupid waterhead. All the good stories he had told him, that had bolstered the Goonling's days, all vanished in those words. It was not as though Gordie would necessarily even remember them, but Josh would remember, and remember the look in Gordon's eyes when the dragon pulled them apart. But that came much later, when Josh was finally capable of distinguishing some of the elements of his pain.

First, however, the dragon had to breathe her wholly unsuspected fire into him. She stood by his cot one evening, shortly after she had come on duty. "Tomorrow you are going to get up and go back to school."

"Ffffuck you," said Josh.

"If," she said quietly, "I am to consider that an offer, I will take it under advisement."

Josh's eyes widened incredulously, and he snorted.

She continued imperturbably, only her slightly prominent, oddly moist eyes belying, perhaps unintentionally, the cold impersonality of her words. "I would simply like you to consider, Joshua, that you have spent your childhood and adolescence locked away in this place. I have known other, what do you call them, aliens? no worse off than yourself who have grown up here, as you have, and gone on to spend their manhood in old folks' homes, in lunatic asylums, in other locked facilities. You have drawn enough attention to yourself in the past little while to bring those latter within the range of possibility. We are not well equipped here to detect the fine nuances that distinguish grief from madness, or, for that matter, necessarily to consider them relevant, when behaviour such as yours is unduly prolonged. Tomorrow you must go back to school if you are ever to get out of here."

Humiliatingly, Josh burst into tears. Into his head had popped a memory he'd stowed so far away he'd forgotten it, the feeling of himself, sobbing and very small, clinging to her, before she was the dragon, and saying it over and over, "mommy mommy mommy." To her. Not to his real mommy. And if his real mommy ever found out they'd never take him home again. Bad. Bad. No wonder they had sent him away. After that was when he had begun to notice how ugly she was, and not to be able to remember something.

"I don't even have a life yet and I've fucked it up. She was dying, and I didn't even know it. I didn't want to know it. I should have known. I should have made them let me see her. I made Goonie piss off. The only thing I'm good at is being polite to you." Josh hiccuped a laugh and turned his head away.

The dragon replied in the neutral voice he had heard all his childhood. He was never to hear her speak otherwise than in these quiet, measured tones. "You would not have been allowed to see Lucinda. And as for Gordon, it is probably a lucky thing that he was moved to take the initiative and remove himself finally from care.

Since he was not, apparently, capable of adjusting to the sheltered workshop environment, he was in line for removal to an institution for mentally handicapped...er, aliens, which has a more stringent escape-proof security system in place than ours. He would be safer there, you understand," she added drily, and ignored Josh's snort. "As it is, social services have investigated the couple who have given him a job and a place to stay, and while not ideal, as a fait accompli they are pronounced adequate. You had better get some sleep now. I intend to wake you early. Your legs may be a bit shaky in the morning."

"I can walk." There was the terseness of long habit in his reply. "Miss Nomer," he added, awkwardly trying to soften it.

"Dragon will do." As she turned away he realized that she was the first person who had not only spoken to him but had actually listened to him in all those days he had spent weeping and yammering at the walls of his cell. In time to come he would speculate a good deal, and formulate all kinds of questions about her which he would never again have the temerity to voice. When, of her own will, she would let drop a biographical fact or offer a revealing anecdote, his maturer self would accept it as a compliment, with curiosity but without presumption. But for now he accepted simply that she was offering him an alternative ascent to the end of a childhood that had suddenly been blocked by too giant a step for him to take alone. It was the old Josh who bayed out impulsively, "Captain Bobalong, Innergalactic Astronix Extraordinaire, humbly at your service, Ma'am!" She did not reply, and he felt a little silly, but he knew she had heard, had been listening all along.

*

The cooperation of Josh's parents was not as difficult to win, when the time came, as he had feared. They were almost galvanically eager to be proud of him. And building on Lucinda's research, he had done his homework. Not only did he have his grades, and not only was he already an advanced initiate of the electronic age, with marketable skills not dependent on the blips in his biological

machinery, but he intended further mastery. And he had completed all the twelve steps of the life skills course. From his little sister Naomi he discovered that the plan he had laid before them had jumped the gun on a favourite fantasy of his mother's, that some day, when her other children were grown and independent, she would devote herself entirely to him. Josh nearly alienated his beloved sister by whooping, "What a narrow escape!" But he explained to her gently that what he meant was that as a grownup he no longer wanted his family to have to think of ways to make him happy; he wanted to find his own ways to be happy. What he needed from his family was simply that they cheer him on. He was even able, finally, to get the last word with his father.

"What if you fall?"

"I'll pick myself up."

"What if you get arrested as a drunk by some dumb cop?"

"What if I am drunk?"

More cautious than Lucinda would have been, surprisingly, for, clear-sighted though she was, when Lucinda dreamed she dared dream of aeries and of scraping skies, the attendant-care apartment Josh chose was on the ground floor of an apartment building in the centre of town. He argued with her about it, as he often argued with her, still; much of the time she was still the only one he had to talk to. On this occasion he gave himself the last word: "It isn't so; I'm not just like them, angel." He could call her names like that now, endearments there hadn't been time or place to learn to use then. And he needed someone to shower with endearments. "Why should I pretend, and ask the earthlings to pretend I'm not handicapped in their terms? In case of fire I can't run; I don't even walk too well. The only thing I'd have in common with them under the circumstances on an upper floor is that I sure can't fly, either."

Sometimes, in the earned equality of loneliness of the city, Josh had imagined bumping into Goonie, and maybe even renewing some kind of contact. Once, on Yonge Street, he did catch sight of him. Goonie was not alone. Wrapped around the arm of an impressively large young woman with a good-natured, blunt-

featured face, he was being hauled along, rising and dropping as she dipped her hand into her paper bag of chips and raised her arm to pop each fry into her mouth.

"Hi!" Josh cut impulsively into their path. Goonie, looking up from under his large, brown, rasta knitted cap, seemed, for a moment, dislocated.

"Josh?" he said finally, and Josh realized that there had been an effort of memory involved. Had yesterday been that long ago? But Goonie's girl friend was chatty. "Hi! I'm Cerise. You a friend of Gordon's?"

"He says 'yes,'" Goonie translated automatically.

"Do you know each other long?" she asked.

A slightly puzzled expression crossed Gordon's face. "We...we played," he said. Then, brighteningly, "Fun!" he beamed. "He says 'yes,'" he added authoritatively.

"You ought to come to tea sometime, then," she said graciously, "and talk about old times."

"Yes," Josh managed for the third time, in response to her genuinely pious rote, while Gordie chirruped cheerfully, "She says come to tea!" They parted with only Josh having noticed, a little shaken that he was relieved, that no addresses had been exchanged.

"He was actually, kind of, condescending," Josh told the neatly dressed older woman with the skin condition which he no longer even saw, with whom he was having one of their lengthy, ritual dinners in a Bloor Street café several days later. "And I used to think," he added wryly, "that I was in a way, I guess, giving him a life. I...was giving him...a life," Josh laughed. Neither of them paid any apparent attention to the covert stares of the other customers at the sound of him. She signalled that he was drooling into his soup, and he wiped himself with abstracted awkwardness. Even gripped in his fists the utensils had a way of playing tricks, but his appetite was hearty. "Have you ever noticed," he leaned towards her confidentially, "how the healthiest earthlings are really the most fragile ones? We aliens have to be so careful not to upset them. Their appetites go off. They get nauseated. I don't like to see them unhappy. But I do like to eat out."

248

"They'll survive," she remarked serenely.

"The simple pleasures," Josh gestured enthusiastically and the fork flew out of his hand. He recaptured it. "A good meal, a glass of wine, an hour or so of discourse with a friend. A kind friend," he added, and she demurred with a slight gesture. "Kind," he repeated sternly. His eyes, unfortunately, had not lost their embarrassing tendency to fill with untimely tears. He glared at his food for a moment, and made one or two preoccupied, ineffectual stabs at a coy morsel. Though he had no intention of violating her privacy, he wanted to give her something, acknowledgement, gratitude, a renewed earnest of affection. He wanted to pay her the highest of compliments. "You were one of us all along. I had you all wrong, though I knew there was something. It's a good thing I didn't really know, though," he admitted a trifle wistfully. "I might have blown your cover. But what an awful little prick I must have seemed to you, sometimes."

Much that Josh said was spoken in the code of his childhood. It was not a shorthand code. Josh loved language too much to deny himself its full use in conversation with someone who understood him. But the code allowed him to fly relatively unembarrassed over the minefields life had sown for him, and to avoid appearing to trespass on her terrain.

Although she did not consider herself an imaginative woman, always, since she had endured with him the desolation of his abandonment, she had watched this particular child, had stood and listened, night after night while he fought out each syllable of the elaborate and oddly joyous tales with which he comforted the misery of his small companion. She had hovered unseen, and marvelled at the gallantry of the little self-dubbed alien. Even when, through the years, he had been irritable, and had cast her in the role of dragon-dragoon, she had been unable to relinquish her earliest vision of him, the glimpse she had caught of entrapped, unblemished soul. She had marvelled too that somehow he knew that she had fled as far as she could flee, to this place from which others dreamed of escaping, that here she served not only their needs but her own. Here too, for all that she had lived most of her life in a

model of flight, something inside of her had turned to make its stand. Though no one could accuse Miss Nomer of being anything but a thoroughgoing professional, or of even questioning, much less challenging the principle that keepers must not have special pets, here she had at last allowed herself to love. Demanding nothing, expecting nothing, signalling nothing, here she had loved secretly, richly, extravagantly.

To Josh's surprise she revealed to him now, primly, in her measured speech, and in his own code, her theory of dragonic robotics, of how the innergalactic dragon is protected by her dragon-robot, self-made on the job. She too had something to be grateful for, to the little boy who had taught her to allow herself to play out in the air, though unseen and unheard, the freedom of her innergalactic life.

It was amazing, Josh confessed, how in her company he had discovered that there were long moments of his unspeakable childhood for which he was capable of feeling, even nostalgia, for Godsake. He, Captain Coldblood Grasshopper, Avatar of the Inner Astronuts of Athas, could tell this frozen exterworld, in its own tongue, from his extensive explorations in the field, that even veggies live full twenty-four hours a day, and on a day like this he could personally go to forty.

Later, watching him lurch away, she gauged with a professional eye the motion of his hams, and it crossed her mind with a pang, that the weight of that adult body might yet at some point make motorized help necessary, a machine for his machine; how he would hate it.

Exhilarated still, Josh was aware that people, passing, made wide parentheses around him, but he didn't mind being given, for a change, an extra share of the sidewalks he had been denied so long. He began to compose a silent peroration, a lofty sermon to earthlings. "Fellow expendables. It is not as an alien I reach out to you now, not as a stranger I stalk among you, rife with dreams."

A faint, humming sound became audible to those strollers who, not noticing him, had come too close to those wayward limbs. They veered quickly off.

"Fellow expendables," the words had begun to crowd in his head, and the humming from his slack mouth grew louder and was accompanied by spasmodic gestures of his arms, as Josh pursued his verbal inspiration. "As one to whom it has been given, briefly, to share with you this primitive hinterworld, I would draw your attention, fellow indispensables...." The spittle which had gathered at the corner of his mouth spilled out and began to yo-yo down and up to the rhythm of his slightly bobbing head. Josh caught the stare of a young woman and smiled disarmingly. A look of panic leaped into her eyes and she rushed past.

After a moment, he tried to begin again, but the inner-breath had gone out of him. He paused to fumble for his handkerchief, wondering where, in all the galaxies, his happiness could disappear to so swiftly. Who was he anyway, to hector, even silently, the unreachable indigenous, to harangue and marshall them voicelessly to an order unknown in all the inner and the outer worlds? All he knew was that even the maimed, the incomplete, the scattered, the mistaken, even those who had had every promise broken in the molecule, retained the dream of particle and multiverse. It stirred in him even now, irrepressibly, straining against his loneliness and misery, the dream of a life of great beauty.

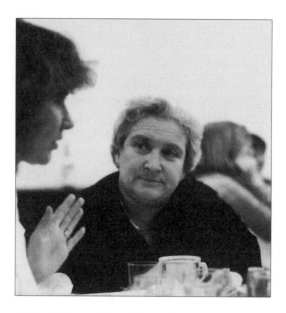

Adele with Janette Turner Hospital.
Photo by Sandra Rutenberg.

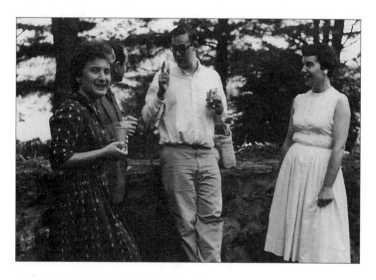

Adele at the MacDowell Colony, July 1960.
Photo courtesy of Tamara Stone.

252

Sketches from the Life: A Log
Ruth Panofsky

21 May, 1928 Born to Chaika (née Rosenberg) and Pesach Waisman (later Wiseman) of Winnipeg, Manitoba. Third of four children: Miriam, Harry, Adele, Morris. The family lives behind her parents' tailor shop.
Attends I.L. Peretz School; Liberty Temple School; Machray School; William White School.

1932 Family moves to 490 Burrows Avenue, their permanent residence in Winnipeg's North End.

1944 Grade 11, Junior Matriculation, St. John's Technical High School. Second prize, short-story contest, *Torch*, St. John's Technical High School.

1945 Grade 12, Senior Matriculation, St. John's Technical High School.

Summers 1945–48 Supervisor, Norquay Park Kiddie Playground, Winnipeg Public Parks Board; salesperson; printing-plant worker.

1946 Sellers Scholarship in Arts, and Delta Phi Epsilon Bursary, University of Manitoba.

Summer 1947 Adele Wiseman and Margaret Laurence meet. Margaret and Jack Laurence move to Burrows Avenue, across the street from the Wisemans.

28 June–13 Sept., 1947 Guest columnist, "Fanfare" (Roland Penner's entertainment column), *Westerner: Truth and Justice for the West.*

1948–49, summer 1949 Tutor and essay marker, Department of English, University of Manitoba.

1949 Honours BA, English (major) and Psychology (minor), University of Manitoba. Studies under Malcolm Ross in her final year. Ross encourages her to develop a short story into her novel *The Sacrifice.*
Chancellor's Prize for "Nor Youth Nor Age" (short story), *Creative Campus: Literature and Arts* (University of Manitoba Students' Union), Spring 1950.

Sept. 1950 Accepted by Graduate College, State University of Iowa, for advanced study in creative writing. Wiseman declines offer.

Aug. 1950–July 1951 Resident worker, Stepney Jewish Girls' (B'nai B'rith) Club and Settlement, London, England. Student Club leader for children ages five to fourteen. Edits newsletter, *Stepney Jester.* Writing *The Sacrifice.*

Aug. 1951–June 1952 Teacher, Overseas School of Rome (grade 5).

Summer 1952 Vice-superintendent, summer school camp, Overseas School of Rome. Completes first draft of *The Sacrifice.*

Fall 1952–Apr. 1955 Tutor and essay marker, Department of English, University of Manitoba.

1953 Technical assistant, Dominion Food Pests Entomological Laboratory, Winnipeg.

1954–30 Apr., 1955 Executive secretary, Royal Winnipeg Ballet, Winnipeg.

28–31 July, 1955 Attends Canadian Writers' Conference, Queen's University, Kingston: "The Writer, His Media, and the Public."

Aug.–Oct. 1955 Apt. 2, 1241 St. Mark, Montreal. Stays with her sister, Miriam.

Oct. 1955–Nov. 1957 16 Barwell House, Cheshire Street, Bethnal Green, London. Revises *The Sacrifice* while working again at Stepney. Edits *Stepney Jester* (July 1956).

27 Oct., 1955 Viking Press of New York offers to publish *The Sacrifice*. When this offer is finalized, Macmillan of Toronto offers to publish the novel as well.

8 Nov., 1955 Margaret Stobie reads an excerpt from *The Sacrifice* on "Anthology," CBC Radio.

22 Mar., 1956 Victor Gollancz of London offers to publish *The Sacrifice*.

May 1956 Trip to Italy.

13 Sept., 1956 *The Sacrifice* is published simultaneously in New York and Toronto; London publication follows on 22 October.

1956 Governor General's Award.

1957 National Conference of Christians and Jews Brotherhood Award. Beta Sigma Phi Sorority Award. *The Sacrifice* is published in Dutch and Italian translations.

June–July 1957 Trip to Montreal, Winnipeg, and New York. Attends Canadian Authors' Association Convention in Winnipeg. Receives Governor General's Award and Beta Sigma Phi Sorority Award at Winnipeg celebrations.

Nov. 1957 - Jan. 1960 Apt. 12C, 310 West End Avenue, New York. Stays with her friend Amy Zahl. Lives on a Canada Foundation Fellowship in creative writing ($2,700; May 1957–Apr. 1958). Awarded a Guggenheim Fellowship ($3,000 U.S.) to follow that, May 1958–15 May, 1959. Writes *The Lovebound*.

2 Oct.–2 Dec., 1958 Yaddo (writers' colony), Saratoga Springs, New York.

Sept.–Nov. 1959 Trip to Winnipeg.

Oct. 1959–Apr. 1960 Canada Council Arts Scholarship ($1,000 plus travel).

c. 1960 *The Lovebound: A Tragi-Comedy* (play) is printed privately for the author.

5 Jan.–5 Mar., 1960 Yaddo, Saratoga Springs, New York.

15 Apr.–29 July, 1960 MacDowell (Writers') Colony, Peterborough, New Hampshire.

Sept. 1960–June 1961 Apt. 12C, 310 West End Avenue, New York. Stays with Amy Zahl. "Duel in the Kitchen" (short story), *Maclean's,* 7 Jan., 1961.

June 1961 Apt. 1, 3765 Dupuis Avenue, Montreal. Stays with her sister, Miriam. Boards the *S.S. Demosthenes D*, a coal-carrying cargo freighter, at Norfolk, Virginia. Travels through the Panama Canal, along the coast of California, en route to Japan.

She and Amy Zahl, who meets her in Hong Kong, plan to visit China. Completes first revised draft of *The Lovebound* on board ship.

15 June, 1961–16 Jan., 1963 Wiseman's literary agent is Willis Kingsley Wing, 24 East 38th Street, New York.

24 July 1961 Arrives in Tokyo, Japan.

27 July 1961 Sends manuscript of *The Lovebound* to Willis Wing.

By 16 Aug.–Oct. 1961 Has arrived in Hong Kong and is staying at the Helena May Institute, Garden Road. Awaits news about entry to China, which is finally denied. Meets her travelling companion, photographer Amy Zahl, who arrived in Hong Kong earlier. During her stay, Zahl had met and become engaged to David Gottlieb. The couple is married in London in October. Wiseman is alone for most of her stay in Hong Kong. See "Where Learning Means Hope: Hong Kong's Canadian Club Does What It Can to Aid Worthy Pupils," *Weekend Magazine*, 18 May, 1963.

21 Aug., 1961 Agent Willis Wing's response to *The Lovebound* is entirely negative.

By 13 0ct., 1961 –Apr. 1962 35 Cholmley Gardens, London. Stays with Phyllis Gerson, Warden, Stepney Jewish Girls' Club. Visits London to attend Amy Zahl and David Gottlieb's wedding. Becomes seriously ill, has an operation, and recuperates in London.

16 Apr.–May 1962 Back on Dupuis Avenue with her sister, Miriam.

May 1962–Aug. 1963 490 Burrows Avenue, Winnipeg. Writes stories for children.

Apr.–July 1963 Essay marker, Department of English, University of Manitoba.

6 Sept., 1963–Apr. 1964 Back on Dupuis Avenue with her sister, Miriam. Part-time teaching position, first-year Composition, Department of English, Sir George Williams (now Concordia) University. Begins writing *Crackpot.*

Sept. 1963–Aug. 1969 MacDonald College of McGill University. Lecturer, then Assistant Professor of English.

Nov. 1963 Moves to Apt. 21, 1217 Drummond Street, Montreal.

Feb. –Apr. 1964 Part-time instructor, Institute of Jewish Studies, Snowdon YM-YWHA, Montreal.

Nov. 1964 *Old Markets, New World* (illustrated by Joe Rosenthal) is published by Macmillan of Toronto.

1964 Leipzig Book Fair Bronze Medal for *Old Markets, New World.*

Sept. 1966 - Apr. 1967 Awarded a Quebec Ministry of Cultural Affairs grant-in-aid ($3000). Takes one-year unpaid leave from McGill to complete *Crackpot.*

Sept. 1966–Jan. 1967 5975 Southwest 74th Avenue, South Miami, Florida. Stays with her brother, Harry.

Feb. 1967 Back on Drummond Street, Montreal.

June 1967 Addresses the Royal Society of Canada, Carleton University, Ottawa, at a symposium on "Canada: Past, Present, and Future." Gives a talk, "English Writing in Canada: The Future."

See *Proceedings and Transactions of the Royal Society of Canada* 4th ser. 5 (June 1967).

By July 1967 Has met her future spouse, Dmitry Stone, a marine biologist. Stone has three sons from a previous marriage.

3 Oct., 1967 Addresses the Faculty of Library and Information Science, University of Toronto. Gives a talk on creative writing in Canada.

21–24 Oct., 1967 Festival of the Arts, University of Manitoba, Winnipeg. Serves on panel, "In Search of the Modern Novel." Panelists include Jack Ludwig, John Peter, Harold Rosenberg, and Wiseman; chair is Sidney Warhaft.

By Nov. 1967 Wiseman and Stone are living at 2234 Girouard, Montreal.

12 Mar., 1968–5 Dec., 1969 Wiseman's literary agent is Candida Donadio, first with Russell and Volkening, New York, subsequently with Robert Lantz–Candida Donadio Literary Agency, New York.

4 Apr., 1968 Sends part of the manuscript of *Crackpot* to Candida Donadio.

20 May, 1968 Donadio writes an enthusiastic letter in response to *Crackpot* but is unsuccessful in placing it with a publisher.

26 June, 1969 Tamara Reesa Esther Bliss Stone is born; Wiseman is forty-one.

Aug. 1969 Family moves to 50 Palomino Crescent, Willowale, Ontario. Beak Consultants Limited transfers Stone to Ontario; Wiseman completes her teaching year in April 1969 and chooses to stay home with Tamara and write.

Sept. 1969–4 Oct., 1973 Wiseman's literary agent is Matie Molinaro, Canadian Speakers' and Writers' Service, Toronto.

31 Dec., 1969 Wiseman and Stone marry.

17 July, 1970 Longmans Canada makes an offer to publish *Crackpot*, which it subsequently withdraws.

Sept. 1970 Family moves to 29 Monclova Road, Downsview, Ontario.

Oct. 1970–Apr. 1990 Manuscript assessor, Literary Section, Canada Council. Receives $25 per manuscript; then $35; then $45; then $60; then $80.

Summer 1971 Trip to Russia to visit her maternal relatives, in connection with *Old Woman at Play*.

Oct. 1972 Family moves to 1 Rushworth Crescent, Kleinburg, Ontario.

13 Feb., 1973 Mounts first "Doll Show," University of Western Ontario, London.

15–17 June, 1973 Attends Conference of Canadian Writers, Toronto (founding of the Writers' Union of Canada).

Sept. 1973–Aug. 1974 Canada Council Grant, Explorations Program ($5,500). Writes *Testimonial Dinner* and *Old Woman at Play*.

12 Oct., 1973 Jack McClelland of McClelland & Stewart of Toronto invites Wiseman to submit *Crackpot* for consideration. Margaret Laurence has told McClelland about Wiseman's unpublished novel.

29 Oct., 1973 McClelland & Stewart offers to publish *Crackpot*. McClelland objects strongly to the title but Wiseman does not agree to a change.

Sept. 1974 *Crackpot* is published with a serious misprint on the last page: "previence" for "prurience." The error is corrected immediately. The novel is chosen as an Alternate Selection of the Book-of-the-Month Club. Publicity tour includes Toronto, Montreal and Winnipeg.

1974 Canadian Booksellers Association Book Award. J.I. Seal Foundation Award for English-French Literature.

1975–76 Writer-in-residence, Massey College, University of Toronto. Writes *Old Woman at Play*.

21 Jan., 1976 Mounts "Doll Show," University of Toronto.

11 Feb., 1976 Press Porcépic of Erin, Ontario makes an offer to publish *The Lovebound* and *Testimonial Dinner*, which it subsequently withdraws.

May 1976 Attends Writers' Union Conference, Ottawa. Family moves to 8 Gosling Road, Maple, Ontario.

Feb. 1977 Wiseman and Stone purchase 324 Rushton Road, Toronto, a former boarding-house. Her elderly parents live with them.

24 Mar., 1977 Mounts "Doll Show," Centennial Lecture Series, University of Manitoba.

11 Oct., 1977 McClelland & Stewart offers to publish *Old Woman at Play*. Wiseman declines the offer.
19–20 Oct., 1977 Participates in "Writers-in-Residence in Conference," University of Toronto.
1978 Margaret Laurence writes the introduction to *Crackpot*, which is issued by McClelland & Stewart in the New Canadian Library series, no. 144.

23 Feb., 1978 Pesach Waisman dies in Toronto.

May 1978 Clarke, Irwin of Toronto offers to publish *Old Woman at Play*.

1 June, 1978 Mounts "Doll Show," School Librarians' Association, York Memorial Collegiate Institute, Toronto.

Oct. 1978 *Testimonial Dinner* (play) is printed privately for the author by Prototype Press of Toronto.

22 Oct., 1978 To launch *Old Woman at Play*, Wiseman mounts "Doll Show," produced by NDWT Company at the Bathurst Street Theatre, Toronto. Publicity tour includes Winnipeg, Ottawa and London.

3–5 May, 1979 Conference on Regional Literature, University of Regina. Serves on panel, "How Valuable Is Regional Writing?" Panellists include Louis Dudek, Henry Kreisel, Roger Lemelin, and Wiseman.

28 Sept., 1979 "Nursing Explorations: The Experience of Suffering," McGill University, Centre for Continuing Medical Education. Gives a talk, "The Spectrum of Suffering."

19–20 Oct., 1979 Participates in workshop, "Language and Literacy in Canada," Toronto.

2 Jan., 1980 Chaika Waisman dies in Toronto.
Feb. 1980 Participates in Margaret Laurence Program, Saidye Bronfman Centre, Snowdon YM-YWHA & NHS, Montreal.

Mar. 1980–Feb. 1983 Canada Council Long-term Grant ($51,000).

12–13 Sept., 1980 Participates in Third Annual *Fireweed* Festival '80, Harbourfront, Toronto.

1981 "The Country of the Hungry Bird" (fable), *Journal of Canadian Fiction* 31–32 (1981).

1981, 1982 Serves on Governor General's Awards Jury, Fiction (English)

1–14 July, 1981 Trip to China with group invited by the Chinese Writers' Association.
See "How to Go to China: (Core Sample from the Continuous Journey)," *Memoirs of a Book Molesting Childhood*.

23–24 Apr., 1982 Participates in "Who Do We Think We Are? Canadian Women Writers and Women's Consciousness," Ban Righ Foundation Advisory Council Meeting, Queen's University, Kingston.

24–25 Sept., 1982 1982 Humanities Seminar, "The U.S. and Canadian Border: A Cultural Divide?" South Dakota Committee on the Humanities. Gives a talk, "The Writer and Canadian Literature."

19–29 Oct., 1982 Trip to California sponsored by the Canada Council. Gives five readings in the San Francisco Bay area, including Cabrillo College, Kresge College and Sonoma State College.

24–28 Jan., 1983 Writer-in-residence, Trent University, Peterborough.

1983–84 Writer-in-residence, Concordia University.

23 Oct., 1983 Launch of *Old Woman at Play*, videocassette, 28 min. Produced by Howard Rypp, Nephesh Theatre. Harbourfront, Toronto.

5 Dec., 1983 The Porcupine's Quill of Erin, Ontario, makes an offer to publish *Memoirs of a Book Molesting Childhood*, which it subsequently withdraws.

1984–85 Three Guineas Charitable Foundation Agency Award ($20,000). Writes poetry (never published).

1985, 1986 Edits *The Canadian Women Writers Engagement Calendar* (Toronto: Yewdewit Books).

14–20 July, 1985 Participates in Maritime Writers' Workshop, University of New Brunswick, Fredericton.

23 Sept., 1985 The Porcupine's Quill offers to publish *Kenji and the Cricket* (children's book, originally titled *Miko and the Crickets*).

Dec. 1985 Creative Artists in Schools Project, Ontario Arts Council Grant ($1,593).

Mar. 1986 Ontario Arts Council Grant ($500).

6 June, 1986 Oxford University Press of Toronto offers to publish *Memoirs of a Book Molesting Childhood.*

4–6 July, 1986 Participates in "Out of the Everywhere/ Voyage au coeur du récit," Canada Pavilion, Expo 86, Vancouver.
1986–87 Writer-in-residence, University of Western Ontario.

27–29 Oct., 1986 Conference on "L'homme et la forêt," Université de Dijon, France. Gives a talk, "And the Forest?" See *Memoirs of a Book Molesting Childhood.*

31 Mar. –8 Apr., 1987 Participates in "International Conference of Women Writers," Jerusalem, Israel.

Summers 1987–91 Head, Writing Program, Banff Centre.

Fall 1987 Writer-in-residence, University of Prince Edward Island.

Oct. 1987 *Memoirs of a Book Molesting Childhood and Other Essays* (Studies in Canadian Literature series) is published.

1988 J.I. Segal Foundation English-French Literature Award. *Kenji and the Cricket* (illustrated by Shiuye Takashima) is published by The Porcupine's Quill. Wiseman writes the afterword to Margaret Laurence's *The Stone Angel,* issued by McClelland & Stewart in the New Canadian Library series.

22–24 Jan., 1988 Panellist, Canadian Women Writers Seminar, "Stars Out of the North/Les étoiles du nord," College of St. Catherine, St. Paul, Minnesota.

10–12 Mar., 1988 Wiseman opens the Margaret Laurence Tribute, Trent University, with the first annual Margaret Laurence Lecture.

21 Mar., 1988 Participates in "The Adaskin Years: A Conference on Canada's Arts, 1930–1970," University of Victoria.

28–30 July, 1988 Participates in "Women and the Arts/Les femmes et les arts," Spotlight '88, Winnipeg.

1988–91 Writer-in-residence, University of Windsor.

19 Oct., 1989 LLD (hon.), University of Manitoba.

1990 Wiseman and Stone divorce.

21–25 Nov., 1991 Visits Acadia University, Wolfville, N.S. Reads from *Memoirs of a Book Molesting Childhood.*

Mar. 1992 "Goon of the Moon and the Expendables," (short story), *The Malahat Review* 98 (Mar. 1992).

1 June, 1992 Adele Wiseman dies of cancer in Toronto.

1992 *Puccini and the Prowlers* (children's book, illustrated by Kim Lafave), is published by Nightwood Editions of Toronto.

Sept. 1993 *Room of One's Own: A Space for Women's Writing* 16.3 (Sept. 1993). Special issue on Adele Wiseman, guest-edited by Ruth Panofsky.

2–26 Feb., 1995 *Crackpot*, play by Rachel Wyatt, directed by Martin Fishman. Alberta Theatre Projects, playRites '95 Festival. Based on Wiseman's novel.

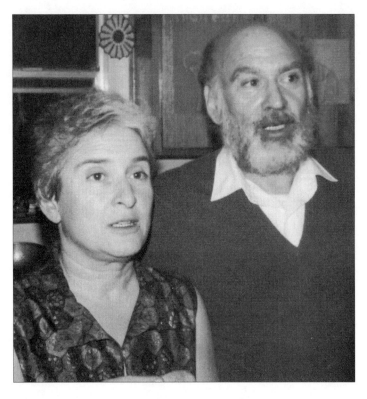

Adele with her brother, Harry Wiseman.
Photo courtesy of Tamara Stone.

"The Country of the Hungry Bird," *Journal of Canadian Fiction* 31–32 (1981). Reprinted in *Room of One's Own* 16.3 (Sept. 1993).

Crackpot. Toronto: McClelland & Stewart, 1974.

"Goon of the Moon and the Expendables." Originally published in *The Malahat Review* 98 (Spring 1992).

Kenji and the Cricket. Erin, Ont: The Porcupine's Quill, 1988.

The Lovebound. Unpublished, *c.* 1960. York University Archives.

Memoirs of a Book Molesting Childhood and Other Essays. Toronto: Oxford, 1987.

Old Markets, New World. Toronto: MacMillan, 1964.

Old Woman at Play. Toronto: Clarke, Irwin, 1978.

"On Wings of Tongue" first published as "Duel in the Kitchen," *Maclean's* (Jan. 7, 1961). Reprinted in *More Stories by Canadian Women*, ed. Rosemary Sullivan, Toronto: Oxford, 1987 and in *Canadian Jewish Short Stories*, ed. Miriam Waddington, Toronto: Oxford, 1990.

Puccini and the Prowlers. Toronto: Nightwood, 1992.

The Sacrifice. Toronto: Macmillan, 1956.

Someday Sam: A Puppet Opera. Unpublished. York University Archives.

Testimonial Dinner. Toronto: Prototype, 1978.

Introduction

Adele's remark to the U.N.B. workshop comes from Alice Terry's unpublished notes from the Maritime Writers' Workshop, July 1985.

The "aims for the highest" quote is from *Memoirs of a Book Molesting Childhood.*

Reena Zeidman's comment on Hoda comes from a lecture in English 269, Queen's University, Jan. 29, 1996.

Michael Greenstein's principal works on Adele Wiseman are "Adele Wiseman (1928–)" in *Canadian Writers and Their Works,* Fiction 6, ed. Robert Lecker, Jack David and Ellen Quigley (Toronto: ECW, 1985), pp. 239–72; "Chapter Six. From Origins to Margins: Adele Wiseman's Immigrants," in *Third Solitudes: Tradition and Discontinuity in Jewish-Canadian Literature* (Kingston: McGill-Queen's, 1989); and "The Fissure Queen: Issues of Gender and Post-Colonialism in *Crackpot*," in *Room of One's Own,* Special Issue on Adele Wiseman, ed. Ruth Panofsky, 16:3 (Sept. 1993), pp. 20–32.

For Gabriella Morisco's views see *I profeti della terza solitudine: Saggi su scrittori ebrei canadesi* (Abano Terme: Piovan Editore, 1992). The Adele Wiseman sections are an article, "L'Arte del Paradosso in *Crackpot*," and an interview, "Il Fascino di un Femminismo 'Non Ortodosso': A Colloquio con la Scrittrice."

For comments on Adele Wiseman's debt to the Kabbalistic tradition, see Kenneth Sherman, "*Crackpot:* A Lurianic Myth," *Waves* 3:1 (Autumn 1974), pp. 4–11; Frances Zichy, "The Lurianic Background: Myths of Fragmentation and Wholeness in Adele Wiseman's *Crackpot*," *ECW* 50, pp. 264–79; and Michael Greenstein, "Secular Chassidism in Canadian Literature: Conclusion,"

Outlook: Canada's Progressive Jewish Magazine, May 1989, pp. 17–18. Francis Zichy, in examining the theme and technique of fragmentation, and Michael Greenstein, in examining the themes of the margins, fragmentation and challenge to authority in his several articles, have laid the foundations for examining Adele as a postmodernist writer.

The interview with Mervin Butovsky, April 22, 1985, appears in *Room of One's Own* 16.3 (Sept. 1993), pp. 5–14.

For the interview with Bruce Meyer and Brian O'Riordan see "The Permissible and the Possible: Adele Wiseman," *Lives & Works: Interviews by Bruce Meyer and Brian O'Riordan* (Windsor, Ont.: Black Moss Press, 1992), pp. 118–127. This is also where Adele Wiseman speaks of "an informed choice" and "awareness," of the founding of Canada being based on a taking away, and of "the edge of the chasm" between permissible and possible.

Wiseman's use of fragmentation is explored in Laura McLauchlan, "The Scrap Toward Knowing in *Old Woman at Play*," *Room of One's Own* 16.3 (Sept. 1993), pp. 3–40.

For Ruth Panofsky's views see *Adele Wiseman: An Annotated Bibliography* (Toronto: ECW, 1992).

Margaret Laurence's letter is quoted by Ruth Panofsky in "'SisterFriend': The Correspondence of Margaret Laurence and Adele Wiseman," *Room of One's Own* 16.3 (Sept. 1993), pp. 58–67.

REMEMBERING
Mary Lou Dickinson: The ending quote is from a poem by Adele Wiseman.

"The Hooded Hawk" (Anne Michaels): The Kathleen Raine quote is from her memoir, *Farewell Happy Fields* (Hamilton, 1973); the Wiseman quote is from *Memoirs of a Book Molesting Childhood*.

A MEMOIR OF MY MOTHER
The essay quoted, "Word Power," appears in *Memoirs of a Book Molesting Childhood*.

MONKEY BUSINESS
All the Wiseman excerpts in this piece are from *Old Woman at Play. Chinada: Memoirs of the Gang of Seven* was published by Quadrant in 1982.

ADELE AT BANFF
Steven Heighton's "An Apparition Play" was published in *Flight Paths of the Emperor* (Erin, Ont.: Porcupine's Quill, *c.* 1992).

EXCERPT FROM THE LAURENCE-WISEMAN CORRESPONDENCE
University of Toronto Press, 1997.
1. Laurence had sent this cable earlier in the day: "FINISHED READING PLAY IT IS TERRIFIC LETTER FOLLOWING LOVE MARGARET."
2. Wiseman's play *The Lovebound: A Tragi-Comedy* is set in late summer 1939 aboard an ancient freighter crowded with Jews who are fleeing Europe and are subsequently refused asylum in the Americas.
3. Ljungh was a producer in the drama department at CBC Toronto.
4. The left-hand corner of the final page of the letter has been torn and lost.

ADAPTING CRACKPOT
Rachel Wyatt's play was published by Playwrights Canada Press, *c.* 1995.

ADELE AS POET AND INSPIRER OF POETRY
The proposed etymology of "wayzgoose" is from "Wayzgoose Pamphlet No. 1," by Crispin and Jan Elsted (Mission, B.C.: Barbarian, 1984).

 The other poets quoted are all associated with the University of Windsor; Lois Smedick is Dean of Graduate Studies, Kate Rogers is a graduate of the M.A. Creative Writing Program and Katherine Quinsey is professor of English Literature.

THE CHARM OF AN UNORTHODOX FEMINISM

One example of a well-known previously published interview is "The Consciousness of a Jewish Artist: An Interview with Adele Wiseman," by Roslyn Belkin (*Journal of Canadian Fiction* 31–32, 1981).

SEVENTY FACES TO A SACRIFICE

All citations in the essay follow the Laurentian Library edition of 1968 (Toronto: Macmillan). "Written law" refers to the Hebrew Bible, while "oral law" refers to all legal and non-legal traditions that are "additions" to the written law. "Oral law" is a slight misnomer because it represents material that has been committed to writing and collected into independent works for hundreds of years. The "oral law" is assumed, by observant Jews, to be the section of the Torah that was revealed to Moses only on a spoken level. Traditional Jews link the written and oral law inextricably, and claim that all traditions emanate from Mount Sinai, lending the latter authority and divinity.

The term "seeking" is first used in the sense of teaching and interpreting the law by Ezra (a Babylonian immigrant to Judaea in the fifth century BCE): "For Ezra had set his heart to study the law of the Lord, and to do it, and to teach his statutes and ordinances in Israel." (Ezra 7:10)

The study employs a number of midrashic texts and secondary sources which collate the texts at hand thematically. Not every source in the oral law is traced. Readers interested in a more exhaustive list of the traditions at hand (one tradition often appears in multiple sources with sometimes substantial variants) can refer to the citation employed, which often lists alternative sources. The only difficulty is that a number of significant sources are not translated into English. This is therefore a list of texts that are "important" (that is, well known and often cited) chosen with the English reader in mind.

Primary sources (all in English)

Dating these sources is a topic debated heavily in the scholarly literature. In brief, they are assumed to be collected and written down (in Hebrew, primarily, with some Aramaic and Greek) in the third to thirteenth centuries CE. Genesis Rabbah is considered to be the "earliest" midrashic compilation. Despite the "late" date of the compilations, the literature, beyond doubt, owes its origins to much earlier generations. The Talmud is generally dated sixth to seventh century and was edited in Babylonia.

The Midrash, Midrash Rabbah, Genesis I. Translated by H. Freedman and Maurice Simon. London: Soncino, 1939, pp. 482–503.

Midrash Tanhuma (Buber). Translated and annotated by John T. Townsend. Hoboken, N.J.: 1989, pp. 122–131.

Pirke de Rabbi Eliezer. Translated and annotated by G. Friedlander. New York: Hermon, 1965, pp. 223–230.

(The style of the three sources above follows the biblical narrative, often citing a biblical line followed by its interpretation.)

Babylonian Talmud. Translated by I. Epstein. London: Soncino, 1936.

Secondary Sources — those which especially pertain to this subject (listed in order of usefulness) or which demonstrate the exegetical tradition as a modern living expression of the Bible (the latter are marked by an asterisk).

H.N. Bialik and Y.H. Ravnitzky. *The Book of Legends: Legends from the Talmud and Midrash*. Translated by W.G. Braude. New York: Schocken, 1992; Hebrew original, Odessa, 1908–1911, pp. 39–42.

Shalom Spiegel. *The Last Trial on the legends and lore of the command to Abraham to offer Isaac as a sacrifice: The akedah*. New York: Pantheon, 1967.

Louis Ginzberg. *The Legends of the Jews*. Translated from the German by Henrietta Szold. Philadelphia: The Jewish Publication Society of America, 1925.

Geza Vermes. *Scripture and Tradition in Judaism: Haggadic Studies*. Leiden: E.J. Brill, 1961.

*Nehama Leibowitz. *Studies in the book of Genesis in the context of ancient and modern Jewish Bible commentary.* Translated and adapted from the Hebrew by A. Newman. Jerusalem: World Zionist Organization, 1972.

Sebastian Brock. "Sarah and the Aqedah," *Le Muséon* v. 87 (1974), pp. 67–72.

Hermann Strack. *Introduction to the Talmud and Midrash.* New York: Atheneum, 1983.

Bibles
Citations are based on the translation of the Jewish Publication Society (Philadelphia, 1986). Also suggested is Aryeh Kaplan, *The Living Torah: The Five Books of Moses* (New York: Maznaim, 1981), for a less literal but more midrashically based translation.

Re "Isaac": The actual death of Isaac is recorded in only one text, a solitary opinion. Others note that he was not killed but went to study in the talmudic academy of Shem (Noah's son) while Abraham went to seek a bride for him (Genesis Rabbah, p. 502. The next episode in fact discusses the arranged marriage to Rebecca). Others have Isaac experiencing some sort of wound where he spills a certain amount of blood. Each tradition takes precedence over the others in certain times, by certain individuals and under certain circumstances. Spiegel, for one, describes how the survivors of the crusades (eleventh century, Rhine valley) used the image of the resurrection of Isaac to mirror their own miraculous resurgence after the atrocities they experienced. The quote about Isaac's ashes is from the Babylonian Talmud, Zebahim 62a, cited in Spiegel, pp. 43–44.

The quote about Isaac and the dew is from Shibbole ha-Leket, 9a-b, authored by R. Tzidkiyah HaRofei. Cf. Spiegel, p. 33. See the expanded version of this text, which includes a more visceral account of Abraham killing his son (Spiegel, p. 37).

In contrast, there are traditions that recognize the metaphoric death that Isaac suffered. Sefer ha-Yashar (a medieval retelling of the Bible), reads, "Although Isaac did not die, Scripture

accounts it to him as though he had died and his ashes lay on top of the altar" (p. 81, and Spiegel, p. 41).

The quote beginning "Whenever the children" is from Tanhuma We-Yera 23 (end, cited in Spiegel, p. 42).

The quote beginning "O, do thou" is from Ed. Heidenheim (Vienna, 1827), 80a, cited in Spiegel, p. 38.

Re the ageing of Isaac, Pirke de Rabbi Eliezer dates him to thirty-seven (p. 225). Other traditions, such as Josephus (first century CE), claim that he was twenty-five when the episode occurred. *Jewish Antiquities* I, 227 (Loeb Classical Library, English translation: H. St. J. Thackeray, [London: William Heinemann, 1926], V.iv, p. 113. Tradition "ages" Isaac because it is assumed that the near-sacrifice was accomplished right before Sarah's death (at 127 years of age) and we know that Isaac was born when she was 90.

The quote beginning "When Abraham was about" is from Tanhuma, p. 130 (on Genesis 22:9); cited in Bialik/Ravnitzky, p. 41, as are the two following quotes.

Re "Sarah": midrash grants her a role in Abraham's thoughts as well: "Abraham meditated in his heart, saying: What am I do to? Shall I tell Sarah [about the command]? Women tend to think lightly of God's commands. If I do not tell her and simply take off with him — afterward, when she does not see him, she will strangle herself." Tanhuma (not Buber) Wa-Yera 21 (not in all additions). Translation by Bialik/Ravnitzky.

The quote beginning "Satan left Abraham" is from Tanhuma, p. 129, cited in Bialik/Ravnitzky, p. 40. The quote beginning "Satan went to Sarah" is from p. 42 of the same source; the author has been unable to locate the source as it appears in Bialik/Ravnitzky, but did find a variant in Pirke de Rabbi Eliezer (p. 234) where Sarah's death is linked to the news brought by Samael (Satan). The quote beginning "Father, hurry" is from p. 41 of the same source (primary source not located). The quote beginning "Then Isaac said" is from Midrash Ha-Gadol, 22:10 (author unable to locate an English translation of this source, but it is cited in Bialik/Ravnitzky, p. 41).

Re "Conclusion": the final quote is from *Galut* (New York: Schocken,1947), translated by Robert Warshow, pp. 117–118.

CRACKPOT: A LURIANIC MYTH
Epigraph adapted by Adele Wiseman from a quote by Isaac Luria.

Gershom Scholem. *Major Trends in Jewish Mysticism.* New York: Schocken, 1961.

———. *On the Kabbalah and Its Symbolism.* Translated by Ralph Manheim. London: Routledge and Kegan Paul, *c.* 1965.

THE FISSURE QUEEN
The author is indebted to the creative inspiration of Adele's friends Shel Krakofsky and Ken Sherman.

The quotes from Patricia Waugh are from *Feminine Fictious: Revisiting the Postmodern* (London: Routledge, 1989), pp. 4 and 10.

The quote from Wilson Harris is from *The Womb of Space: The Cross-Cultural Imagination* (Westport, CT: Greenwood, 1983), pp. 69–70. This section also draws on Linda Hutcheon's *Splitting Images: Contemporary Canadian Ironies* (Toronto: Oxford, 1990), and Stephen Slemon's "Magic Realism As Post-Colonial Discourse," in *Canadian Literature* 116 (Spring 1988), pp. 9–24.

The quote from Annis Pratt is from *Archetypal Patterns in Women's Fiction* (Bloomington: Indiana U.P., 1981), p. 31.

The quote from Elizabeth Abel is from *The Voyage In: Fictions in Female Development* (Hanover: U.P. of New England, 1983), ed. Elizabeth Abel, p. 11.

The quote from Ellen Cronan Rose is from "Through the Looking Glass: When Women Tell Fairy Tales," in Abel, *The Voyage In*, pp. 209–27.

Re the verandah's "wooden wave," other instances of water imagery in the novel suggest an uncontainable female abundance. At the dance hall Hoda releases herself, "swelling and rolling and rippling with the unselfconscious ease and rhythmic insistence of

some ocean surface, and attracting, eventually, would-be navigators of crest and wave." At Pipick's birth Hoda's world seems "to contain nothing but her body, awash on her bed, a world that was her body trying to turn itself inside out, struggling with a bowel movement that was the evacuation of continents. The ocean had already burst forth." On dilation, see Patricia Parker, *Literary Fat Ladies: Rhetoric, Gender, Property* (London: Methuen, 1987); on domestic space, see Paula E. Geyh, "Burning Down the House? Domestic Space and Feminine Subjectivity in Marilynne Robinson's 'Housekeeping'" in *Contemporary Literature* 34.1 (Spring 1993), pp. 103–22.

The Victor Turner quote is from *The Ritual Process: Structure and Anti-Structure* (Ithaca: Cornell U.P., 1977), p. 95.

Works Cited:

Abel, Elizabeth, ed. *The Voyage In: Fictions in Female Development.* Hanover: UP of New England, 1983.

Geyh, Paula E. "Burning Down the House? Domestic Space and Feminine Subjectivity in Marilynne Robinson's 'Housekeeping.'" *Contemporary Literature* 34.1 (Spring 1993): 103-22.

Harris, Wilson. *The Womb of Space: The Cross-Cultural Imagination.* Westport, CT: Greenwood, 1983.

Hutcheon, Linda. *Splitting Images: Contemporary Canadian Ironies.* Toronto: Oxford UP, 1990.

Parker, Patricia. *Literary Fat Ladies: Rhetoric, Gender, Property.* London: Methuen, 1987.

Pratt, Annis. *Archetypal Patterns in Women's Fiction.* Bloomington: Indiana UP, 1981.

Rose, Ellen Cronan. "Through the Looking Glass: When Women Tell Fairy Tales." *The Voyage In: Fictions in Female Development.* ed. Elizabeth Abel. Hanover: UP of New England, 1983, 209-27.

Slemon, Stephen. "Magic Realism as Post-Colonial Discourse." *Canadian Literature* 116 (Spring 1988): 9-24.

Turner, Victor. *The Ritual Process: Structure and Anti-Structure.*

Ithaca: Cornell UP, 1977.

Waugh, Patricia. *Feminine Fictions: Revisiting the Postmodern.* London: Routledge, 1989.

Wiseman, Adele. *Crackpot.* Toronto: McClelland & Stewart, 1974.

ADELE WISEMAN'S POETRY AND THE GENESIS OF "GOON"

The poetry files referred to at York University Archives are boxes 1991/012/013, 014 and 015 in the Adele Wiseman Fonds in the Rare Book Room and Archives, W. B. Scott Library. The idea notes for "Goon of the Moon and the Expendables" are also at York University Archives, box 1991/012/015; the drafts are in the archives as well, box 1991/012/077.

In *Adele Wiseman: The Annotated Bibliography* (Toronto: ECW, 1992), Ruth Panofsky lists eight published poems, including "Ascent," "Roofers" and "Space," which appeared in *Poetry by Canadian Women*, ed. Rosemary Sullivan (Toronto: Oxford, 1989, pp. 130–132), and two untitled poems from the 1990 and 1991 Annual Grand Wayzgoose anthologies. In addition, six of her poems were set to music by Jack Behrens (*Some Music for Soprano— B Clarinet—Piano.* Waterloo, Ont.: Waterloo Music, 1987).

The Dylan Thomas epigraph for "Goon of the Moon" is from "Fern Hill," in *Selected Poems*, ed. Walford Davies (London: J.M. Dent [Everyman], 1974). Thomas's line is actually "Though I sang in my chains like the sea" — obviously inappropriate for a story about four central characters. The C.S. Lewis quote is from *The Discarded Image* (Cambridge, England: Cambridge, 1964). The phrase "kindely enclyning" is originally Chaucer's, from "The Hous of Fame" (Lewis includes the quotation in his text), and bending, or inclining, according to the innate nature of an essence or being, also carries an overtone of gentleness or orderliness.

The e.e. cummings phrase is from his introduction to *New Poems, Collected Poems*, pp. 331–2.

Adele recorded the tape of the beginning of "Goon of the Moon" for CKUA Radio (Alberta) in 1991.

Re the third-person narrator and the better balance between male and female: according to Kenneth Sherman and Reena

Zeidman, Kabbalistic wisdom calls for a union of male and female. The structure of both *Crackpot* and "Goon of the Moon" depends on this synthesis. Although many of Greene's students have objected to Hoda's impending marriage at the end of *Crackpot* (and an undertone of sadness in the writing supports them), the story *has* to end with marriage, just as "Goon of the Moon" *has* to end with a temporary union (and more solid understanding) between Josh and Miss Nomer.

Constance Rooke's remark came at the conclusion of a session on "Mourning Canadian Contemporaries: Bronwen Wallace and Adele Wiseman" at the Association of Canadian College and University Teachers of English meetings in Ottawa, June 1, 1993. Tom Marshall's remark is from a note to Elizabeth Greene, Oct. 22, 1992. The Ted Hughes remark is quoted in Jacqueline Rose, *The Haunting of Sylvia Plath* (Cambridge, Mass.: Harvard, 1991), p. xii.

Works Cited:

Coles, Don. "Adele at Banff," 89.

cummings, e.e. *Poems 1923-54*. New York: Harcourt, Brace & World [n.d.].

Kristeva, Julia. *Powers of Horror: An Essay On Abjection*, tr. Leon S. Roudiez. New York: Columbia University Press, 1982.

Lewis, C.S. *The Discarded Image*. Cambridge, England: CambridgeUniversity Press, 1964.

Marshall, Joyce. "Remembering Adele," 36-37.

Marshall, Tom. note to author, Oct. 22, 1992.

Morisco, Gabriella. "The Charm of a Non-Orthodox Feminism" — originally published as "Il Fascino di un Femminismo 'Non Ortodosso': A Colloquio Con La Scrittrice" in *I profeti della terza solitudine: Saggi su scrittori ebrei canadese*. Abano Terme: Piovan Editore, 1992, 99-124.

Panofsky, Ruth. *Adele Wiseman: The Annotated Bibliography*. Toronto: ECW Press, 1992.

Rose, Jacqueline. *The Haunting of Sylvia Plath*. Cambridge, Mass.: Harvard University Press, 1991.

Thomas, Dylan. *Selected Poems*, ed. Walford Davies. London: J.M. Dent (Everyman), 1974 (reprinted 1995).

Wiseman, Adele. *Crackpot.* Toronto: McClelland & Stewart, 1974.

— . *Old Woman at Play.* Toronto: Clarke, Irwin & Co., 1978.

— . "Lucky Mom: On Suffering," *Memoirs of a Book-Molesting Childhood and Other Essays.* Toronto: Oxford, 1987, 159-85.

— . "Goon of the Moon and the Expendables."

— . idea notes for "Goon of the Moon and the Expendables." Adele Wiseman Fonds, Rare Book Room and Archives, W. B. Scott Library, York University, Box 1991/012/015.

— . drafts of "Goon and the Moon and the Expendables." Adele Wiseman Fonds, Rare Book Room and Archives, W. B. Scott Library, York University.

— . *Someday Sam: A Puppet Opera.* Adele Wiseman Fonds, Rare Book Room and Archives, W. B. Scott Library, York University.

— . poems. Adele Wiseman Fonds, Rare Book Room and Archives, W. B. Scott Library, York University.

Caroline Adderson is the author of *Bad Imaginings* (The Porcupine's Quill, 1993), which was nominated for a Governor General's Award, for the 1994 Commonwealth Book Prize and for the 1995 CNIB Talking Book of the Year Award. It won the 1994 B.C. Book Awards' Ethel Wilson Prize for Fiction. *A History of Forgetting*, her first novel, is soon to be published.

Ven Begamudré's three books from Oolichan are the short-story collections *Laterna Magika* (1997) and *A Planet of Eccentrics* (1990) and the novel *Van de Graaff Days* (1993). He was the 1995–96 Canada–Scotland Exchange writer-in-residence.

Colin Bernhardt has acted at Stratford, helped develop Banff's Music Theatre Program, and taught at Banff for many years. He now teaches acting and speech at Acadia University. He is a co-founder of the Atlantic Theatre Festival in Wolfville, Nova Scotia.

Stella Body's first book of poems, *Noddfa*, was published in Wales by David Hopkins in 1966. In Canada she has been published in *The Fiddlehead, Event, In Touch* and *Catalyst*. She is currently working on a collection of object poems, *Objects of Desire*.

Mary Cameron has published poetry in *The Malahat Review, Tessera, Canadian Literature* and in a recent anthology of new poets, *The Last Word* (Insomniac, 1995). She is a former editor of *Quarry Magazine*. Her collection of poetry, *Clouds without heaven* (Beach Holme), will appear in 1998.

Don Coles won the Governor General's Award for Poetry in 1993 for his book *Forests of the Medieval World* (The Porcupine's Quill). He teaches at York University.

Mary Lou Dickinson has published fiction and book reviews. She has recently completed a collection of short stories, *Hello Angel,* and a novel, *Once She Stole a Horse.*

Sylvia Fraser is the author of *Pandora* (McClelland & Stewart, 1972), *The Candy Factory* (McClelland & Stewart, 1975), *My Father's House* (Doubleday, 1987), *Berlin Solstice* (McClelland & Stewart, 1984), *The Book of Strange* (Doubleday in 1992, then republished by Key Porter in 1994 as *The Quest for the Fourth Monkey*) and *The Ancestral Suitcase* (Key Porter, 1996). She is vice-president of The Writers' Development Trust.

Gary Geddes's most recent titles are *Active Trading: Selected Poems 1970-1995* (Goose Lane, 1996), *The Perfect Cold Warrior* (Quarry Press, 1995), and the fourth edition of *20th-Century Poetry & Poetics* (Oxford University Press, 1996). He teaches English and Creative Writing at Concordia University and divides his time between Montreal, rural Ontario, and the west coast.

Elizabeth Greene is a co-editor of *The Window of Dreams: New Canadian Writing for Children* (Methuen, 1986), author of articles on *Beowulf* and Adele Wiseman and of stories in *Quarry, Room of One's Own* and *Descant.* Her fiction has been anthologized in *Written in Stone* (Quarry, 1993) and *Vital Signs* (Oberon, 1997, a selection of work by new Canadian women writers). She teaches courses on modern poetry, contemporary literature and women writers at Queen's University.

Michael Greenstein is a pioneer critic of Adele Wiseman. He has taught at the Université de Sherbrooke and the University of Toronto, and is the author of *Third Solitudes: Tradition and Discontinuity in Jewish-Canadian Literature* (McGill-Queen's, 1989) and

many articles on Victorian, American, Canadian and Jewish literature.

Steven Heighton is the author of three books of poetry, including *The Ecstasy of Skeptics* (Anansi, 1995), which was nominated for the Governor General's Award, and two books of fiction, most recently *On Earth As It Is* (The Porcupine's Quill, *c.* 1995). His fiction books are published in England by Granta Press. His book of essays, *The Admen Move on Lhasa*, was published by Anansi in the spring of 1997. He is currently completing a novel.

Arlene Lampert, a former Executive Director of the League of Canadian Poets, was one of Adele Wiseman's closest friends. She and her husband, Gerald, created Platform for the Arts, a touring agency for writers, poets and playwrights. After the LCP was formed, Arlene became their first Executive Director and Jerry became a great publicist and promoter of poetry and poets. The LCP still honours him with an annual award for best first book of poems.

Lenore Langs teaches creative writing at the University of Windsor and co-ordinates the Wayzgoose interuniversity reading series. Her poems have appeared in a number of literary journals, including *Contemporary Verse 2*, *The New Quarterly* and *Onionhead*. In partnership with Laurie Smith, she has recently established Cranberry Tree Press.

Margaret Laurence was the author of many classic Canadian novels, including *The Stone Angel* (1964), *A Jest of God* (1966), and *The Diviners* (1974). An autobiography, *Dance on the Earth* (1989), includes a poem for Adele Wiseman on her fiftieth birthday. (All McClelland & Stewart.)

John Lennox is the editor of *Margaret Laurence–Al Purdy: A Friendship in Letters* (McClelland & Stewart 1993) and is co-editor, with Ruth Panofsky, of the Margaret Laurence–Adele Wiseman correspondence. Lennox teaches in York University's Department of

English.

Ingrid MacDonald is a writer and illustrator. She is the author of *Catherine, Catherine* (Women's Press, 1991), several short stories variously published and a play, *The Catherine Wheel.*

Joyce Marshall is a writer of fiction and a translator. Her most recent publications are *Any Time at All and Other Stories* (McClelland & Stewart, 1993) and *Blood and Bone/en chair et en os* (Mosaic, 1995).

Seymour Mayne is the author, editor and translator of more than thirty books and monographs. His collection *Name* (Press Porcépic, 1975) won the J.I. Segal Prize, and a later volume of poetry and prose, *Killing Time* (Mosaic, 1992), was awarded the Jewish Book Committee Prize. His writings have been translated into Spanish, French, Greek, Yiddish, Polish, Italian and Hebrew. A selection of his biblical poems, *The Song of Moses* (Concertina/Menard Press 1995), was published in both electronic (Internet) and print editions.

Anne Michaels' novel *Fugitive Pieces* (McClelland & Stewart, 1996) was nominated for the 1996 Giller Prize. It won the Trillium Award, the Chapters/*Books in Canada* First Novel Award and the Orange Prize (UK). Rights to it have been sold in 15 countries. Her last book of poetry, *Miner's Pond* (McClelland & Stewart, 1991), won the Canadian Authors' Association Award for Poetry and was nominated for the Governor General's Award for Poetry and the Trillium Award. In 1991 she received the National Magazine Award (Gold) for poetry. Her first book, *The Weight of Oranges* (Coach House Press, 1985), won the Commonwealth Poetry Prize for the Americas and has been recorded as a Talking Book.

Gabriella Morisco is Professor of Anglo-American Literature at the University of Urbino and the author of *I profeti della terza solitudine. Saggi su scrittori ebrei canadesi* (Piovan, 1992); *La reticenza e lo*

squardo. Visione, soggettività e processo creativo nella poesia di Elizabeth Bishop (Patron, 1990). She is editor with Guido Fink of two books on Jewish American Writers: *Il recupero del testo* (Clueb, 1988) and *Memoria e tradizione* (Clueb, 1990). One of her essays, "Bernard Malamud, an American reading of Fedor Dostoevsky", has been published in *Studies in American Jewish Literature* (vol. 14, 1995). She has translated into Italian, and edited with critical introductions, books of poems by Sylvia Plath, May Swenson and Seamus Heaney.

Ruth Panofsky is co-editor with John Lennox of *Selected Letters of Margaret Laurence and Adele Wiseman* (University of Toronto Press, 1997) and author of *Adele Wiseman: An Annotated Bibliography* (ECW Press, 1992). She guest-edited the Adele Wiseman special issue of *Room of One's Own* (Sept. 1993). Currently she teaches at Ryerson Polytechnic University.

Kenneth Sherman is the author of several books of poetry, including *Words for Elephant Man* (Mosaic, 1983) and *Open to Currents* (Wolsak and Wynn, 1992), and many articles. He edited the anthology *Relations*, a collection of Canadian poems on family members. A new book of poetry, *Clusters*, and a collection of essays, *Void and Voice*, will be published in 1997 by Mosaic Press.

Tamara Stone, Adele Wiseman's daughter, is a Toronto artist.

Miriam Waddington is a poet and critic who lives in Vancouver. Her numerous poetry collections include *The Glass Trumpet* (Oxford, 1966), *The Visitants* (Oxford, 1981), and *The Last Landscape* (Oxford, 1992); *Summer at Lonely Beach and Other Stories* (Mosaic, 1982) is a collection of short fiction; *Apartment Seven: Essays New and Selected* was published by Oxford in 1989.

Rachel Wyatt, director of the Writing Programmes at Banff, is the author of novels and plays and many radio scripts. Her adaptation of Adele Wiseman's *Crackpot* has been performed in Calgary,

Philadelphia, Winnipeg and Victoria. Her most recent book is *The Day Marlene Dietrich Died* (Oolichan, 1996).

Reena Zeidman, Director of Jewish Studies at Queen's University, is co-editing a book of essays, *The Bible Unveiled: Female Biblical Images in Midrash* and working on a co-authored study *Concord and Discord in Judaism* (forthcoming from JAI Press). She also publishes articles on early Jewish legal literature.